A CAMERA ON THE BANKS

Abby,

...on,
and some pieces you
would wish we had
been, pp 96-99, esp.
p 119. g

A CAMERA ON THE BANKS
Frederick William Wallace and the Fishermen of Nova Scotia

M. BROOK TAYLOR

Front cover: The crew of the *Effie M. Morrissey* assemble aft for a smoke and a photograph (detail) MMA WPA B 12; The *Effie M. Morrissey* doing sixteen knots (image reversed) MMA WPA B3
Back cover: Wallace aboard the *Dorothy M. Smart*, March 1912 MMA WPA BE 2

Edited by Barry Norris.
Cover and interior design by Julie Scriver.
Printed in Canada.
10 9 8 7 6 5 4 3 2 1

Goose Lane Editions acknowledges the financial support of the Canada Council for the Arts, the Government of Canada through the Book Publishing Industry Development Program (BPIDP), and the New Brunswick Department of Wellness, Culture and Sport for its publishing activities.

Goose Lane Editions
500 Beaverbrook Court
Fredericton, New Brunswick
CANADA E3B 5X4
www.gooselane.com

Library and Archives Canada Cataloguing in Publication

Taylor, M. Brook (Martin Brook), 1951-
 A camera on the Banks: Frederick William Wallace and the fishermen of Nova Scotia / M. Brook Taylor.

Includes index.
ISBN 0-86492-441-0

1. Wallace, Frederick William, 1886-1958.
2. Fisheries — Nova Scotia.
3. Fisheries — Nova Scotia — Pictorial works.
I. Wallace, Frederick William, 1886-1958. II. Title.

SH224.N8T39 2006 639.2'09718 C2006-900482-X

CONTENTS

For my sons, Christian and Corddry

INTRODUCTION

Between 1911 and 1916, Frederick William Wallace, a young journalist based in Montreal, made seven voyages aboard fishing schooners to the banks off the coast of Nova Scotia. Along with pencils and notebooks, he took with him a "simple box camera" in order to record the men, the vessels, and the work. The resultant record of words and images provides a unique window on a way of life at the moment of its passing. The central purpose of *A Camera on the Banks* is to open the window and introduce readers to the captains and crews and their working world aboard the banks schooners. The subjects are neither faceless nor nameless. The port from which Wallace sailed was Digby. The captains with whom he sailed were Harry Ross, Arthur Longmire, John Apt, and Ansel Snow. Among the crew were the likes of Judson Handspiker, Jim Tidd, Oscar Comeau, and the cook Jerry Boudreau. The schooners were the *Dorothy M. Smart*, the *Effie M. Morrissey*, the *Albert J. Lutz*, and the *Dorothy G. Snow*. Each voyage was a tale of its own, and collectively they illustrate how longline trawling from two-man dories was conducted in the last age of unassisted sail. There is no comparable contemporary collection.

There is a parallel story in what follows. In 1911 Frederick William Wallace was a freelance journalist at loose ends trying to make a living in Montreal. The son of a sea captain, he idealized the rough and tumble way of life of the great square riggers that were even then a thing of the past. His own life was office-bound and anything but adventurous. Much of what he wrote had the quality of a daydream, a dream of a life on the ocean like his father's. Serendipity intervened. Through a chance encounter, in August he was invited to cover a race between fishing schooners in Digby. This was an open door to experiences he craved, and he walked through. Over the next five years he did more than research stories; he transformed his life. He found a professional role, personal fulfillment, and a direction for the future. The life of the man behind the camera is integral to an understanding of the way he portrayed what was in front of him. In what follows otherwise unattributed direct quotations, whether in the text or in captions, are his. Some of Wallace's photographs have been cropped or detailed in their reincarnation in book form.

The Racquette

Green Point

Digby

The Joggins

0 miles 5

0 kilometres 5

Youngs Cove

Parkers Cove

BAY OF FUNDY

Hillsburn

Litchfield

Delaps Cove

Annapolis R

MOUNTAIN

Annapolis Royal

Port Royal

Victoria Beach

Goat I.

Point Prim Light

Port Wade

N

Culloden

NORTH

Annapolis Basin

Mount Pleasant

Digby Gut

Digby

Smiths Cove

NEW BRUNSWICK

P.E.I.

Bear River

NOVA SCOTIA

ATLANTIC OCEAN

Christopher Hoyt

PROLOGUE

The weather, that Saturday, 12 August 1911, was fortunate for the Digby organizers of the first Fishermen's Regatta of Southwestern Nova Scotia. Friday's cold, rain, and low cloud had moved off to the southeast to reveal clear skies and just enough wind out of the northwest to make sailing interesting. The banners arched across the streets and dressing store windows had dried out, and flags had gone up all over town. Families from the backcountry round about poured in by boat, buggy, wagon, ox cart, and on foot; a few of the well-to-do came by automobile. Onlookers from further afield alighted from the Dominion Atlantic Railway, which connected Digby to Yarmouth to the southwest and Halifax to the east. Others made the four-hour journey across the Bay of Fundy from Saint John on the steam paddlewheeler *Prince Rupert*. Summer residents and resort guests fleeing the heat of urban centres in the New England states and eastern Canada mixed with the locals along Water Street and crowded the wharves. All were dressed in their Sunday best, for summer festivals were signal occasions.

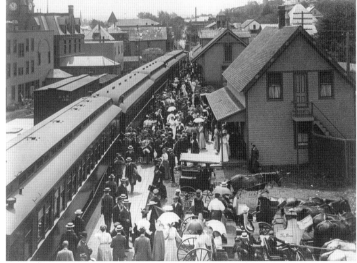

In the summer, Digby Railway Station bustled with vacationers drawn by the beauty of the basin setting and the cool breezes off the Bay of Fundy. The wagon in the foreground awaits guests for the Pines Hotel, one of the wide array of lodges, cottages, hotels, and inns to be found in the town and on the surrounding shores and hills. MYP 8-45

Harry Short, Digby's mayor, and Oakes Dunham, editor of the *Digby Courier*, had taken the lead in organizing the Regatta. For years, the Digby Yacht Club, of which Dunham was commodore, had held races as part of the town's Dominion Day celebrations; they were an enjoyable outlet for the local elite and for well-heeled summer visitors. Less formal races were also common among the fishing communities around the Annapolis Basin and along the Fundy Shore. Challenges were issued almost any time more than one dory, boat, or schooner inhabited a harbour.

The Fisherman's Regatta was intended to combine all levels of racing in one late-summer event. In this effort, Short and Dunham had the enthusiastic support of the newly formed Maritime Fish Corporation, of which, not coincidentally, Short was a director. Digby was home to the corporation's base

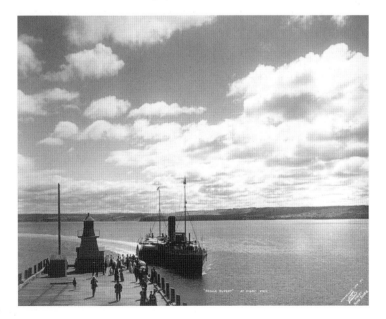

of operations in southwestern Nova Scotia, and its local superintendent, Captain Howard Anderson, helped to make the day a success by ensuring the active participation of the corporation's vessels and crews. Indeed, its general manager, Alfred H. Brittain, had come down from the head office in Montreal bearing the Brittain Trophy, an elaborate silver cup, for the winner of the schooner race, and a silver Maritime Shield for the winner of the fishermen's motorboat races. With Brittain was a young Montreal journalist, Frederick William Wallace.

The day's events involved every class of seagoing vessel within range of the town. At seven in the morning, a fleet of motorboat fishermen started things off by racing from the fishing village of Tiverton on Long Island, thirty-five miles down the Bay of Fundy. Villagers along the shore followed the contestants' unmuffled progress, and the throngs on the Digby wharves cheered the *Ethel Maud* across the finish line shortly after ten o'clock. Lobstermen, inshore boat fishermen, and other groups took turns racing around the basin, their "rakish, white-hulled, gasoline-engined open boats, fine-lined and fast, competed with one another in speed and noise," Wallace reported. Closer to shore, dory men, stripped to the waist, pulled to a chorus of shouts from friends and rivals. Sirens, bells, and foghorns added to the din. "Even summer 'rusticators,' Americans mostly, caught the spirit of the thing and yelled, cheered, and betted with enthusiastic impartiality." The

The steam paddlewheeler *Prince Rupert* at the Digby wharf. Operated by the Dominion Atlantic Railway, it made the journey from Saint John to Digby in just over four hours at a top speed of 21 knots. Frederick William Wallace was a frequent passenger. MYP 8-35

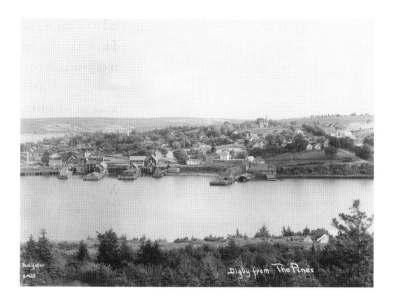

local Mi'kmaq of Bear River provided the one break in the noise and heat of competition, paddling their canoes in silent procession behind their chief and splitting the cash prize when they completed the course.

Wallace noted the commotion, but without enthusiasm. "The motorboat races held little interest for me. They were a matter of mechanics, I thought, and not of seamanship. So while other events were going on, I slipped away to view something that held more charm." The young journalist turned his attention away from the Digby waterfront to the back

Digby from the Pines Hotel, about August 1911. The Maritime Fish Corporation's wharves and buildings, to the left of centre, are distinguished by their fresh paint. The main harbour and the Annapolis Basin are just visible over the town on the left. A Mi'kmaq summer encampment appears in the right foreground. MYP 8-403

harbour known as the Racquette, where the Maritime Fish Corporation's facilities were located. Here, Wallace's curiosity turned to a sleek schooner.

> Alongside the wharf of the Maritime Fish Corporation in the Racquette Cove lay a trim fishing schooner of ninety-three tons. Her black hull shone glossy in the sun; her red-copper-painted underbody, naked in the low tide, was smooth and fresh from the brush. Decks, rails, houses and spars were bright in new applied paint and varnish. She looked like a yacht, not only in surface cleanliness, but also in the fine lines of her, the lofty masts and long mainboom. In gilt letters on her bows and stern her name — *Dorothy M. Smart.*

The first schooner built to order for the corporation, the *Dorothy M. Smart* was named for the daughter of its president, Colonel Charles A. Smart. Registered at ninety-four (not ninety-three) tons, a hundred feet long, with a beam of twenty-three feet, sporting a main boom of sixty-five feet, and carrying a total sail area of 2,600 yards, it had been built at the Joseph McGill shipyards at Shelburne, Nova Scotia, at a cost of $10,000 and launched the previous August. The *Smart* was based on a model by legendary American schooner designer Thomas F. McManus called the Indian Head (because the first schooners ordered were named after New England Native peoples). His speedy and agile designs were ideally suited for fast returns with fresh fish from the Grand Banks, unlike the broad, deep, burdensome schooners favoured for summer salt banking and winter cargo runs to the West Indies. As the *Digby*

Yates
Digby

Courier enthused upon the launch, "In hull, rig and outfit she embraces every known improvement and nothing has been left undone to make her the finest and handsomest fishing vessel ever built in Canada." At Port Wade, just across the Annapolis Basin, however, someone disagreed.

John D. Apt was the proud captain and part owner of the *Albert J. Lutz* (pronounced Lootz), a schooner launched in 1908 for a consortium that included Apt, Captain Howard Anderson, and Mayor Harry Short, then still independent fish wholesalers, and named for the consortium's major shareholder, a real estate agent from Moncton who spent his summers at Digby. The *Lutz* was one ton larger than the *Smart* and two feet longer, but in other respects was a close match. It had been built at the same shipyard and based on the same design for the same purposes as the *Smart*.

No sooner had the *Lutz* arrived in Digby than Captain Apt issued a challenge in the pages of the *Courier* "to race any fishing vessel from the ports of Digby and Yarmouth to Cape Cod and return." There were no takers, until the *Smart* arrived in the autumn of 1910. Although a race to Cape Cod and back proved impossible to organize, the two vessels did take each other on informally when returning from the banks in October. They met in Westport harbour, Brier Island, and departed for Digby at six in the evening, the *Lutz* under the command of Captain Apt and the *Smart* under the young driver Harry Ross. A strong northeast breeze made the fifty-mile trip a dead beat to windward. "The *Courier* was telephoned at once," the paper reported, "and a close lookout was kept all along the shore, the racers making a handsome marine picture in the moon-light, with their lee rails awash." The *Lutz* made

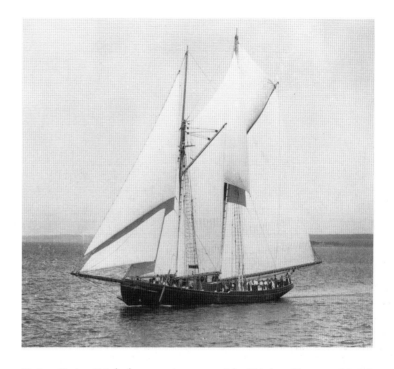

Point Prim Lighthouse, just outside Digby Gut, at 12:30 a.m., the *Smart* trailing twenty minutes behind. Catching the incoming tide, the *Lutz* picked up another sixteen minutes inside the basin before dropping anchor. "No marine race ever held in these parts has created such an excitement," related the *Courier*, "and many stayed up late on purpose to see the vessels arrive."

The newly launched *Albert J. Lutz* arriving at its homeport, 29 August 1908. MMA PY MP 10.54.2

Opposite: The *Dorothy M. Smart*, about August 1911. MMA PY MP 10.55.2

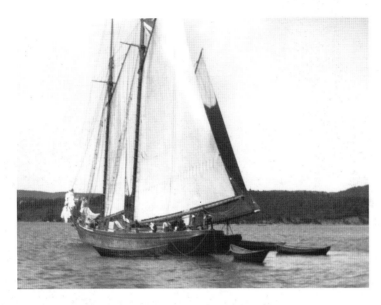

The *Albert J. Lutz*, 12 August 1911, showing the wear of a summer on the banks. MMA WPA A16

A rematch was inevitable. This time, the Regatta organizers wanted the public to be able to view the spectacle, so they set out a course within the confines of the basin, running eleven miles from the government wharf at Digby to a buoy anchored off Goat Island, just opposite Port Royal, and back. The race, scheduled for 1:30 p.m., was to be the centrepiece of the day, with the Brittain Trophy going to the winner.

The *Dorothy M. Smart* was certainly ready. Like most schooners then operating out of Digby, it spent most of June and July in port being overhauled, having its hull scraped and painted, new halyards and sheets reeved, and sails bent. When Wallace found the vessel on race day, it looked as new as the day it was launched. Even so, Captain Harry Ross had

his Digby crew toiling with last-minute adjustments, and was not all that pleased with the many dignitaries and onlookers who were crowding round and getting in the way. Thirty were still aboard when the tide made the dock and the *Smart* came afloat, and Wallace was happy to be among them. A small motorboat came alongside and eased the *Smart* out of the Racquette and around to the main harbour. And here the young Montreal journalist had his first view of the *Albert J. Lutz*. It was quite a contrast. John Apt was one of the few Digby masters to make frequent summer trips to the banks for salt rather than fresh fish. He had just come in and was still off-loading excess salt. The *Lutz's* sides were scarred and scraped clear of paint by the work of the dories, the sails and lines worn and slack, and the bottom foul. Nonetheless, with John Apt at the wheel and a lean Port Wade crew of seven, the vessel remained a formidable opponent.

A preparatory gun was fired at 1:25, and five minutes later Commodore Dunham aboard his yacht *Oakesella* hoisted the starting signal. The *Smart* crossed the starting line first, the *Lutz* a short distance behind. The course inside the protected confines of the basin was hardly challenging, but the young journalist found it a great experience. "Though I had sailed in plenty of steamers and had handled many sailing yachts, this fishing schooner trip was something new. My eyes took in spars, sails, running gear, and I made mental notes of equipment and the manner in which the vessel was handled." The *Smart* eased well ahead of its opponent in the run to Goat Island, and the mixed crowd of crew and dignitaries aboard entered into a festive mood, with one "patriarchal fisherman" producing a fiddle. Taking advantage of the relaxed

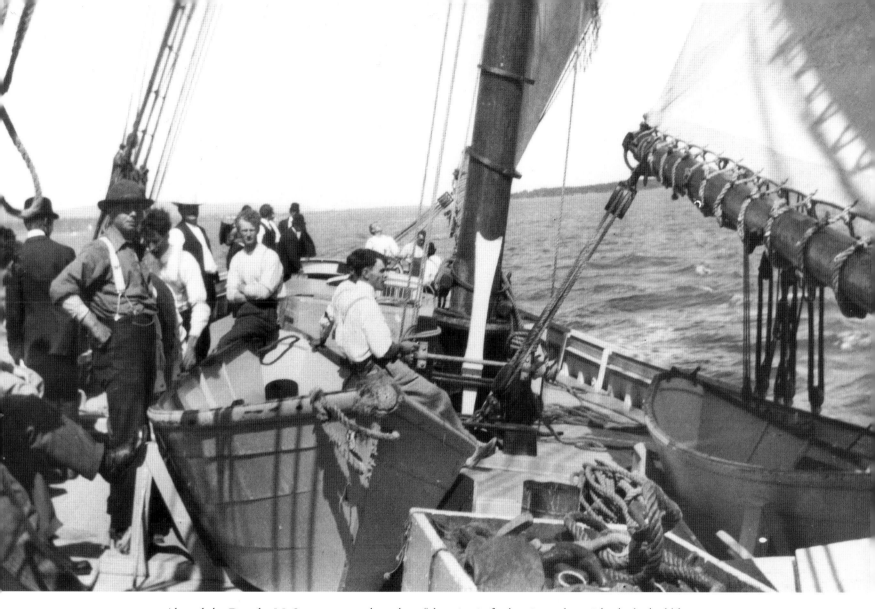

Aboard the *Dorothy M. Smart* on race day, when, "gleaming in fresh paint and varnish, she looked like a yacht." The sheets of the foreboom and mainboom are eased off to port so that the large sails can catch the wind. The crotch in which the foreboom rests when not in use is at the base of the mainmast. The two dories provide seating. MMA WPA MP 10.55.23

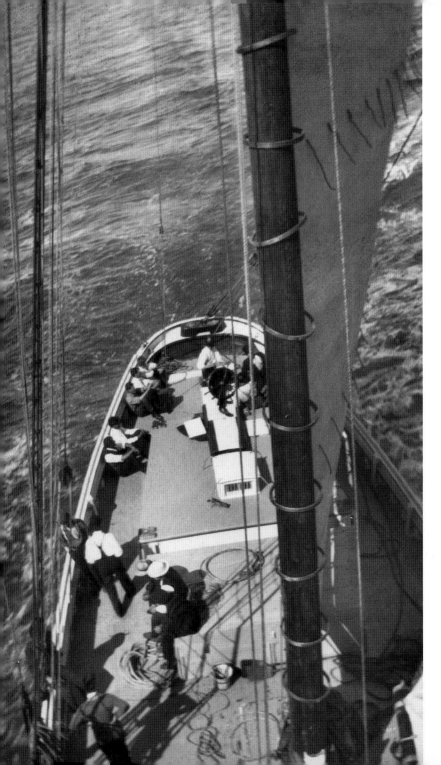

atmosphere, Wallace climbed the wire stays used to brace the foremast to catch a better view and take a few remarkable photographs.

The tide of the race was, however, about to turn. The *Smart* made the Goat Island buoy four minutes ahead of its opponent, but then its crew noticed the *Lutz* beginning to close up on the return leg to Digby. "Our gang," Wallace noted, "lined up on the weather rail, revealed their anxiety. The bragging and disparaging remarks ceased." Heads swivelled between the charging *Lutz* and the committee boat *Oakesella*, which marked the fast-approaching finish line. "For a minute or so, absolute silence reigned on our decks. Everyone stood in his place, tense. The skipper's face betrayed no emotion as he held the wheel. Then a syren shrieked; the Committee yacht rolled in our wash, and we rushed across the line to the roar of steam whistles and the cheers of the watching crowds. The *Smart* had trimmed the redoubtable *Lutz*." The difference was one minute and thirty-five seconds.

Wallace spent Sunday at the Digby Pines writing up his race-day story for *Canadian Century* magazine back in Montreal. All the while, he could not stop thinking about what an adventure it would be to make a real fishing voyage aboard the *Dorothy M. Smart*. The next day, presuming on

From atop the foremast rigging. The crew and guests aboard the *Dorothy M. Smart* relax around the aft rail. Above-deck protrudes the cabin house with a small skylight. Forward of the cabin house, two men sit on the gurry-kid. The mainmast hoops to which the leading edge of the mainsail is attached are spaced about a yard apart, and two lines of reef points dangle from the sail itself. MMA WPA A10

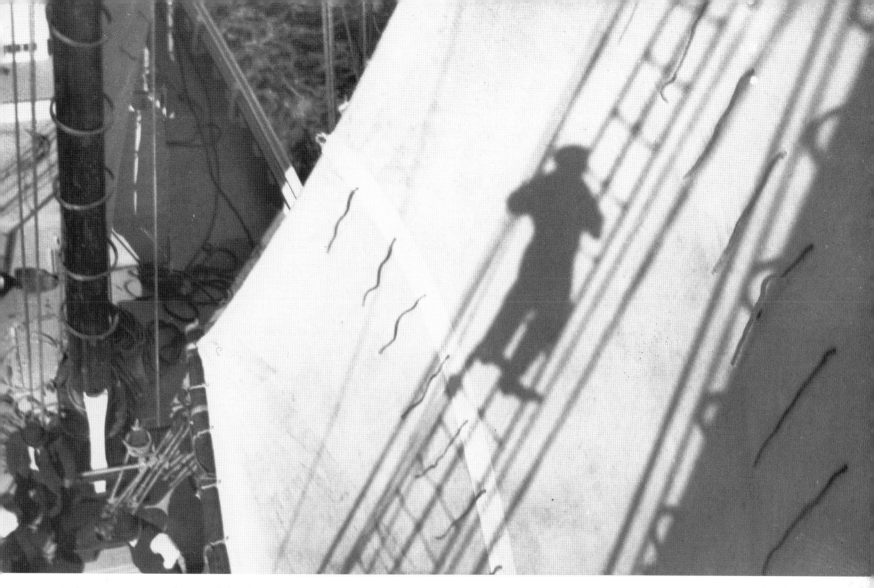

The man behind the camera, Frederick William Wallace, catches his own shadow in the belly of the foresail, the only image we have of this remarkable photographer taking a photograph. MMA WPA A12

his connection with the Maritime Fish Corporation, he went to seek permission to go from Captain Howard Anderson, who told him, "As far as I'm concerned, you're welcome to go, but we'll have to see Captain Ross." The subsequent interview aboard the *Smart* was awkward. Harry Ross and his crew were in the business of catching fish, and anything or anyone that got in the way was a liability. The lightweight "city feller" did not inspire confidence. On the other hand, it was difficult for the captain to refuse a journalist who had Alfred H. Brittain and Howard Anderson behind him. Wallace struggled to allay the skipper's fears. "Don't worry...I won't be sea-sick. And as for comfort. I've toughed it out before now. If I give you any trouble, just throw me overboard." Ross laughed. "Oh, we won't do that. But if you've set your mind on coming, then it's alright with me." And with that the young man's life took a fateful turn.

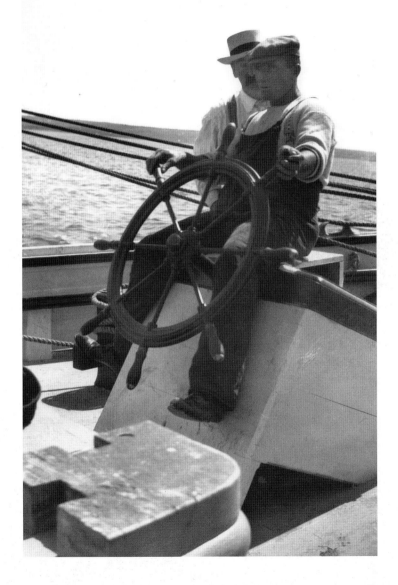

Captain Harry Ross at the wheel of the *Dorothy M. Smart*. "Aw, ye're all right, Harry," declared one of the crowd. "He'll never overhaul ye now..." "All right be damned!" yelled Captain Ross. "The race ain't won yet. Get those sheets trimmed. You're sailing against John Apt, don't forget."
MMA WPA A9

Opposite: The *Albert J. Lutz* under full sail. "Glancing astern, we saw the *Lutz* coming along like smoke — a creaming froth at her forefoot, her sails set as though carved from marble." MMA WPA A2

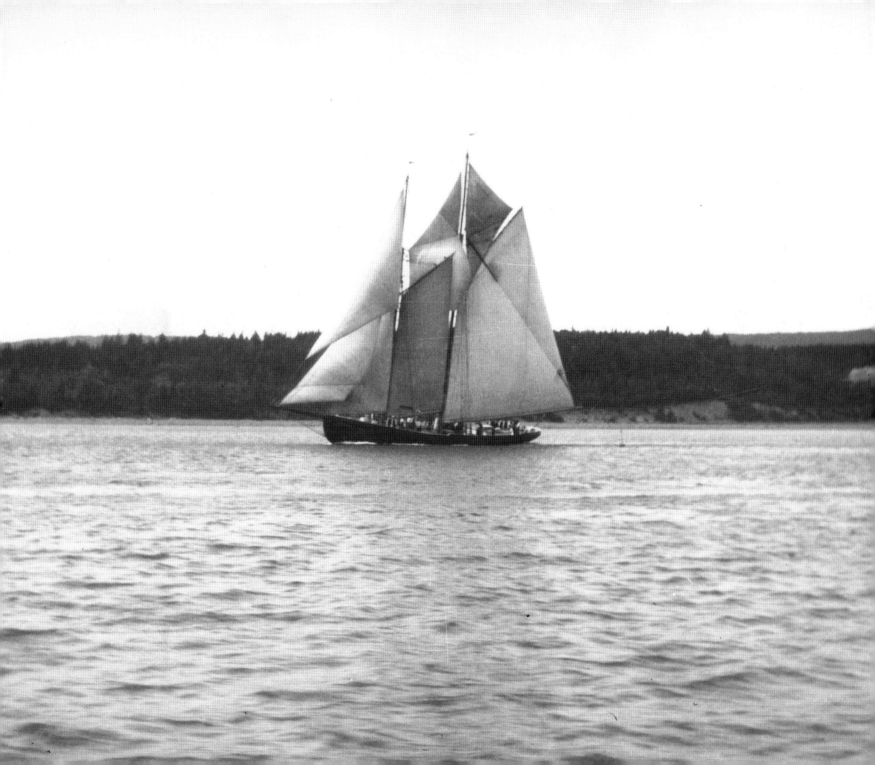

Chapter One
THE MAN BEHIND THE CAMERA

In the summer of 1907, the man behind the camera stands on the bridge of the *Hungarian* in Montreal harbour. With straw boater, high collar, short tie, fresh face, and a tentative grip on the engine room telegraph, Frederick William Wallace looks very much what he is: a twenty-year-old clerk in the freight department of Canadian Pacific and Oceans Steamships. For five years now, he has held a succession of posts obtained through the influence of his father, William Wallace, a captain of the Allan Line Steamship Company. The *Hungarian* is his father's command. "Occasionally," Wallace writes of an earlier voyage with his father, "I would be allowed to come up on the bridge, but I was cautioned not to touch anything and not to go near the compass." In his diary, he records his height as five feet six inches and his weight as six stone eight and a half pounds (under a hundred pounds). His health had been rather delicate as a child, but he demonstrated an unusual talent as an artist. His parents hoped he would, in time, become an architect.

Opposite: Frederick William Wallace aboard the *Hungarian*, Montreal harbour, 1907. MMA WPA N-17,772

Fred's father, William, was born in 1847 on Cairngarroch, a farm near the tip of the Rhins of Galloway, a peninsula on the southwest coast of Scotland. The peninsula confronts the Irish Sea to the west with a shoulder of high cliffs that fall gently away on the reverse slope to the shallow waters of Luce Bay and the small harbour town of Drummore. William was named after his uncle, the childless master of Cairngarroch, who took him in at the age of three following the death of his father, Peter, a small tenant farmer who had been kicked in the head by a horse. In the natural course of events, the prosperous farm would have fallen to the boy. But a life with what he called "dirty boots" held no attraction. William was instead captivated by the seafaring life a walk down the lane at nearby Drummore. At age fifteen, he ran off on the coaster *Carrick Maid* to prove the point. Reluctantly, the family acquiesced and, two years later, on 18 October 1864, paid a fee of £30 to have him apprenticed to C.W. & F. Shand of Liverpool as a seaman. To mark the occasion, seventeen-year-old William visited a Liverpool photographer's studio. The contrast with his son's 1907 photograph could not be more stark. Though

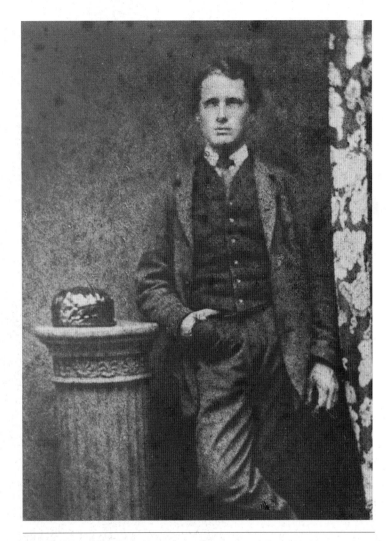

William Wallace, Liverpool, England, October 1864.
MMA WPA MP 400.170.4

Opposite: First Mate William Wallace (in dark jacket), stands at the base of the mast of the *Agnes Sutherland*, San Francisco harbour, 1880. MMA WPA MP 400.170.1

William was three years younger than Fred when their pictures were taken, the contrived studio setting cannot contain him. The gaze is direct, the posture self-confident verging on the cocky, and the body, particularly the hands, powerful.

The son was in awe of the father, a man whose career read like a contemporary boy's adventure story. In the two decades following his apprenticeship, William Wallace sailed to North and South America, the West and East Indies, South Asia and the Antipodes, rounding dangerous Cape Horn more than a dozen times. He panned for gold in Australia, came down with smallpox in Surinam, and tended bar in Montevideo. In telling his son these stories, though, he didn't mention that he had deserted his ship to pan for gold, been disciplined frequently, and discharged for drunkenness at least once. He washed up in Montevideo after he and another crew member had, in the words of their captain, "so abused each other" in a fight as to require hospitalization, whereupon it was discovered that he was suffering from a venereal disease. Still, William Wallace was more often discharged with a high rating and never had trouble finding a position. As he later told his son, "I seldom made more than one round voyage in a ship. I had no ties and could give free rein to my desire to rove about." By the early 1880s, he stood five feet eight inches tall, weighed a hundred and seventy pounds, and had bracelets tattooed around his wrists and a small gold wire in each ear. He was a respected and feared "bucko" mate, one who drove men to work by force when required. "No man could teach him his work," Fred later wrote. "He had been through the mill and come out ground."

Whatever pride William Wallace took in his work with

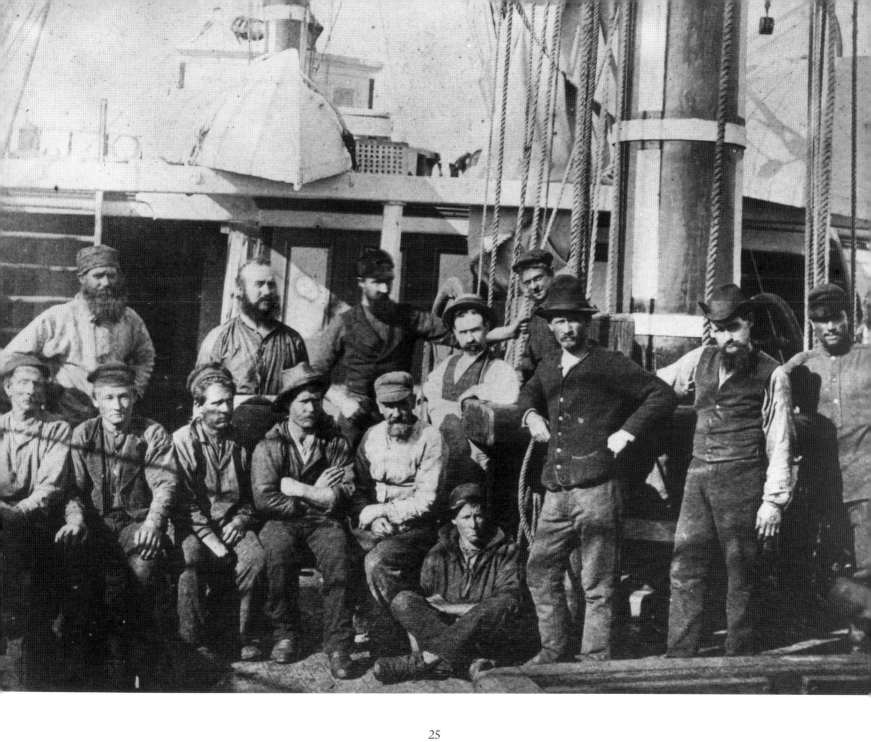

wind and sail or joy in the freedom his roving afforded, it was a difficult life to sustain into middle age and impossible in old. The only way to remain at sea was to take master's papers, enter the service of a major shipping line, and begin the frustrating process of moving up the ladder. This was not just a matter of moving from wood and wind to iron and steam; it was also a shift from irregular to regular habits, from flannels to a uniform. In July 1881, approaching his mid-thirties, William swallowed his pride, gave up his meandering habits, and entered the service of the Allan Line as a lowly fourth officer on the *Austrian*. The work was steady, running goods and passengers from Glasgow, Liverpool, and London to Montreal, Boston, and New York, with the occasional run further south. Possessed of knowledge, skill, and now patience, William settled in for the long haul, making third mate within a year, second mate a year later, and first mate in late 1884.

By then, William had met his future bride, Frances Catherine Hurditch, a native of Walton-in-Gordano, near Clevedon, Somerset. One of at least twelve children born to the wife of the gardener on the estate of Sir William Miles, Frances met William during an Atlantic crossing on the *Scandinavian* in 1883. She was accompanying her younger sister Rosina, who had married Joseph Birtwell, a wealthy Boston businessman. The Birtwells were taking Frances to Boston ostensibly to manage their house, but really to find her a good match of her own. Their definition of a good match did not include a second mate. Nevertheless, William and Frances fell in love and corresponded over the next two years. Birtwell's response was to threaten to shoot William if he ever showed his face. The traditional solution was followed: in 1885 Frances

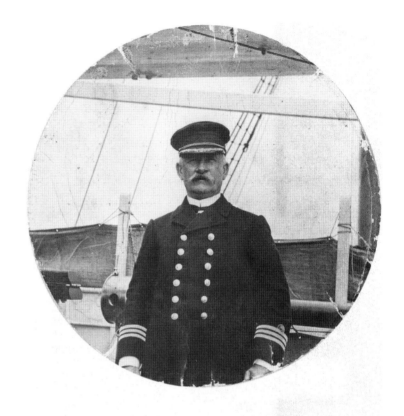

and William married in secret in Boston, then eloped to Glasgow.

Frances quickly established a home. Working with the £10 a month William made as second mate, then the £12 he got as first mate, she manoeuvred them up through the Glasgow rental market, beginning with a single room in the working-class district of Govan and finally emerging with a flat in new, middle-class Langside. For the first time in his life, William had a home. Visits between voyages could be as short as a day or two and rarely lasted more than a week, but they were precious times for William. Without outward regret, the rover of

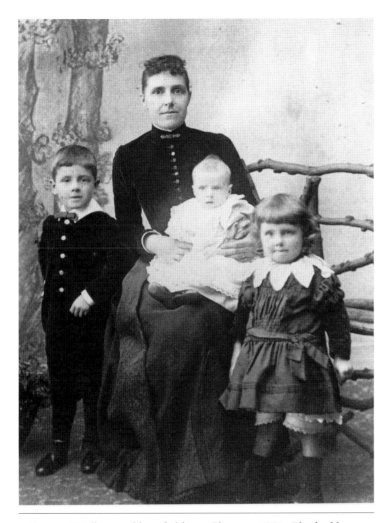

Frances Wallace and her children, Glasgow, 1892. Flanked by six-year-old Fred and young Frances, age five, mother holds Florence, who would die of scarlet fever before her first birthday.
MMA WPA N-17,770

Opposite: Captain William Wallace aboard the *Sicilian*, 1910.
MMA WPA MP 400.170.8

younger years settled into a routine. In 1896, after a frustratingly long wait, came the capstone: command, at a salary of £17 a month.

Promotion and social advancement were accompanied by a growing family. Frederick William, born 11 December 1886, was the first-born, followed in quick succession by three daughters and another son, also called William to add to the confusion. The parents were determined that their children would not work with their hands. For the daughters, that meant good marriages; for the boys, education and a profession.

Fred went to public schools in crowded Govan, first at Copeland Street Public School and later at Lorne Street, which had more than thirteen hundred students, with a hundred or more squeezed into classrooms that would hold thirty today. Fred found his "English" first name, selected by his mother over the captain's objections, a handicap, and it did not help that she insisted he wear shoes, rather than boots, and clean shirts with a collar. The result was frequent scrapes with local boys. But he was not always in school. "I was bothered," Wallace later wrote, "by a weak digestion and became very sickly. The old family doctor saw me quite often, and I was up and down with frequent sicknesses." This condition kept him at home for lengthy periods "in the society of his mother." As if in compensation, he developed a passion for drawing, "and my father indulged my artistic ability by giving me paints, drawing-books, etc." The captain also bought a piano, and Fred and his two surviving sisters took lessons. His taste ran to sea shanties, rather than Chopin, much to his mother's dismay and his father's delight. Indeed, the indulgent

captain's short home visits often undermined Frances's daily efforts at discipline. As Fred remembered, "when mother refused us anything we had set our hearts upon, we always felt that we could wheedle it out of father."

On one thing, however, both parents insisted: Fred was not to aspire to a life at sea. Inevitably, though, the young boy found the white-collar professional life of their imagining dreary and tiresome. Like his father in his own youth, Fred was captivated by his environment. All the family's homes, on Percy and Harvie Streets and South Avenue in Govan, were within a minute's walk of the River Clyde and the world of ocean-going commerce. It seemed as if everyone in the neighbourhood was employed in one way or another in the industry. "We were a seafaring community," Fred wrote, "living in a world of our own in which shipping was a main topic of conversation." Copeland Street School was up against the Govan Graving Docks and Lorne Street School abutted the Prince's Dock, both "splendidly situated for the adventure of cargo raiding" and "dock haunting." Young eyes were drawn to schoolroom windows, following the maritime comings and goings:

> Being raised in a seafaring community among other boys whose fathers followed the sea, or had been to sea, familiarity with ships was only natural. But when we started to wander around the docks looking critically at the ships, we boys always tried to outdo each other in our ship knowledge, which led us into an intensive study of rigging, ships lines, house-flags, etc. As we all intended to go to sea, the acquisition of this knowledge seemed to be necessary to fit us for our future voca-

tions, so that we questioned seamen, read books, and scanned the shipping with absorbing enthusiasm.

His father unwittingly inspired much of Fred's determination to go to sea. Each visit home meant a new round of stories from the captain's vast repertoire, a new shanty, a new curio from parts unknown. The captain's repeated injunctions that it was a "dog's life" were undone by his obvious enthusiasm and pride for his chosen world. Furthermore, he was a figure of respect, not only for his wife but within the community. Fred got the chance to sample that world in 1895, when he made his first transatlantic voyage with his father, and his childhood sketchbooks, filled with increasingly fine and detailed drawings of the workings of sail and steam, attest to the boy's critical eye.

More serious obstacles than his parents' wishes stood in the way of young Fred's seafaring plans, however, not the least of which were his precarious health and slight build. Other barriers were common to all boys of his generation. Frustratingly for Fred and his friends, the great age of sail was passing, replaced by more efficient but less romantic steam. How could they be sailors when only seamen were wanted? How were they to prove themselves as men, when the manliness they had been raised to respect was disappearing?

In 1900, the family moved to suburban Langside, and Fred enrolled in the private Allan Glenn School. His mother was pleased when Fred began winning prizes for writing, history, and art. Upon graduation in 1902, however, the young man put his foot down. Writing many years later to a nephew on the verge of a similar decision, he said, "Father and Mother

RUNNING FOR THE MAIL

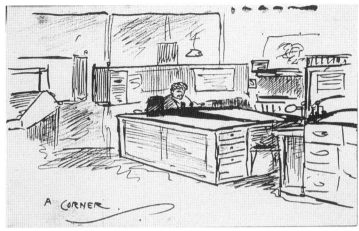

A CORNER

wanted me to go to the University, but I thought that I had had enough of schooling and I wouldn't go." Instead, he took a clerk's job in the passenger department of the Allan Line. It was a dispiriting start, as cartoons in Fred's sketchbook attest.

William Wallace, too, was frustrated. Despite his elevation to captain, the move to Langside, and the general improvement in the family's financial well-being, it was proving difficult to secure a comfortable place in the Scottish middle class. The captain was never at ease in the society of people who did not know the sea. And although he did not want his children to become manual labourers, he held the "book-learned" in some contempt. Frances, for her part, remained concerned about their children's health in Glasgow.

Then Captain Wallace developed the notion that he would like to move to Canada, the western terminus of most of his voyages. Frances agreed, as long as she was not "buried in the woods." In the spring of 1904, father and son crossed the Atlantic aboard the *Hungarian*, commissioned find a home in the country around Montreal. By autumn, the captain had settled on a twelve-acre property in the village of Hudson, on the Lake of Two Mountains, about thirty-two miles by train outside the city. He purchased the land and house outright, and called it Cairngarroch, after his birthplace. The rest of the family followed in 1905. Over time, the "brick cottage" with a barn out back was renovated to five bedrooms, with a large kitchen, indoor running water, and a toilet. Outside, an orchard and kitchen garden were laid out, ornamental shrubs and flower beds planted, and a chicken coop erected, all ordered and designed by the captain and cared for by Frances, the children, and hired help. Visiting colleagues exclaimed, "By the Lord Harry, Wallace, but you're a lucky man with a place like this to lay back in."

Frederick William Wallace was, however, still at loose

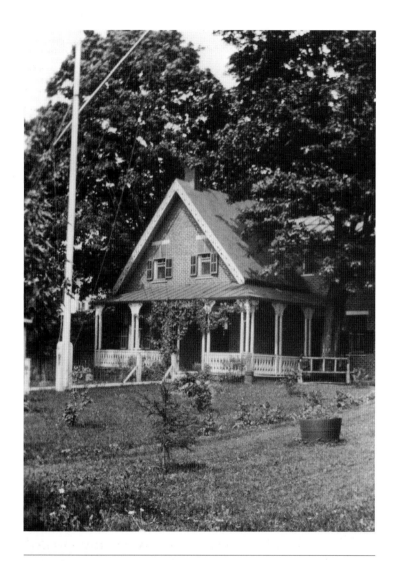

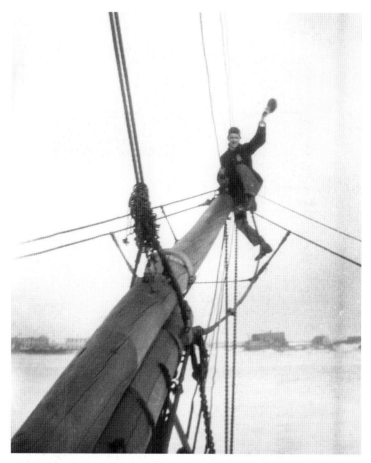

Opposite, top to bottom: Wallace at the tiller of his own yacht and, below, paddling a birchbark canoe on the Lake of Two Mountains. MMA WPA N-17,767, 1.10a, 1.10c

The intrepid woodsmen Howe, Wallace, and Spink.
MMA WPA 1.11a.

"Mother and sisters bring lunch. Hudson, May 1908."
MMA WPA MP 400.234.13

Above: Cairngarroch, Hudson, Quebec, about 1910.
MMA WPA MP 400.170.12

Right: Wallace waving his cap to the world from the bowsprit of an unidentified vessel along the St. Lawrence. MMA WPA 1.9

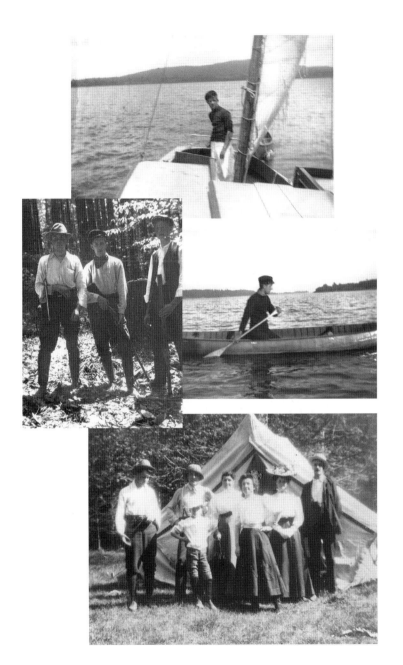

ends. Despite the move from Glasgow to Montreal, his work-aday environment remained unchanged: on arriving in the new city, he went straight back into an office, first as a waybill clerk for Canadian National and then to the freight department of Canadian Pacific. Yet, some things were different. On week-days, he may have been tethered to his desk, but nights and weekends were his own, and Montreal's waterfront offered ample opportunities for dock haunting. More liberating were the waters and woods around his new home in Hudson. The Lake of Two Mountains is twenty-one miles long and up to three miles wide, and connects the Ottawa and St. Lawrence rivers. "I spent a good deal of my time on the lake," Fred re-membered, "and it served to allay my restlessness and to keep me in touch with boats and the water." He and his friends also took to the woods to camp, hunt, and fish. His diary entry about a 1908 Victoria Day weekend camping trip with his friends Howe and Spink and younger brother Bill reads like the record of a great expedition: "After seeing the sunset, we made tracks for camp again, making an immense camp fire, smoked our pipes and cigars, and sang all the songs we knew. Myself playing the mouth organ between smokes." They were in a clearing only two miles from home, however, and Fred's mother and sisters delivered lunch.

A wide gap remained between the life Fred dreamed of and the one he led. By 1908, he had become a renewals clerk for the Liverpool and London and Globe Insurance Company, but his mind was often elsewhere. As Fred later told a repor-ter for the *Montreal Herald*, he delighted "his fellow workers by throwing off, for their edification, bits of impromptu verse

of the red-blooded kind with which Robert W. Service first broke into fame." Some of these early verses and short stories survive in his notebooks and cover everything from the Wild West to the Boer War, but more often than not the heroic deeds were set aboard windjammers on the high seas.

His colleagues' reception of these literary efforts inspired Fred to think of commercial publication. A market certainly existed for such work: turn-of-the century offices were filled with young men with desk-bound frustrations similar to Fred's. Many escaped the routine of their lives by turning to adventure stories, dreaming of a rugged life out of doors. To meet this demand came a proliferation of cheap novels and magazines such as *Adventure, Argosy, Canadian Countryman, Outing Magazine,* and *Rod and Gun in Canada.* Sufficiently encouraged by his friends and discouraged by his job, Fred quit insurance and embarked on life as a freelance writer, journalist, and illustrator. He bought a typewriter for $40, put up a trestle table in his attic bedroom, and set to work, often writing late into the night by oil lamp. Here he turned out his first publication, "The Phantom Ship: An Adventure Off the Bird Rocks," which appeared in the June 1908 issue of *Dominion Magazine.*

Where did Fred get his stories? Where he had always sought them: Captain William Wallace. Only now, the endless questions of younger years were transformed into organized and comprehensive interrogatories of his father's career. Shanties and songs were transcribed. "Do you remember," he asked, "any unusual characters among the ship's carpenters you have known, any special stories about any feats these men carried out that I might use in fictional characterizations?" The

son even inspired the captain to write down autobiographical fragments, reminiscences that re-emerged in fiction and non-fiction, prose and verse. Fred also illustrated his stories with photographs from his father's early career.

This was not all young Fred wrote, of course. As a journalist and reporter for various Montreal newspapers and journals, he covered the comings and goings of vessels in the port. Less fortunate were the verses he wrote in the guise of "a Habitant"; two titles, "Dat Vote for Womans" and "Dat Canadien Navee" provide a flavour. He also did a substantial line of illustrating, most notably for Max Aitken's *Canadian Century.*

Still, it was the life of his father the captain, not his own experiences, that Fred relied on for most of his tales. Indeed, Fred had none to retail. Now heading toward his mid-twenties, living at home and in part financially dependent on his family, he had yet to find a meaningful career or prove himself. It was a vicarious existence, and his search for useful material from his own life was occasionally strained, even desperate. In September 1907, through a friend who worked for the Dominion Coal Company, Fred took passage for a dollar a day aboard the coal steamer *Christian Knudsen* on a ten-day voyage from Montreal to Sydney, Nova Scotia, and back to Quebec City. Although his father said Fred knew as much about seafaring as any first mate, he went, sadly, as a mere passenger — an observer, not a participant.

Sadder still is the short account Fred wrote of a trip to Boston in August 1909 to visit his Birtwell cousins, the two families having been reconciled. During an overnight stay in Portland, Maine, Fred booked into a "seaman's hotel," changed into "a sailor's jersey and cap," then "beachcombed" the wharves

in search of "local colour," eating at a "seaman's restaurant." In this guise, he spent most of the morning watching yacht club races in the harbour. A few days later, he repeated the procedure at Boston's T-Wharf, famous home to a fleet of fishing schooners. Although he took a number of splendid photographs to document the visit, he does not relate that he boarded any of the schooners or spoke to their crews. He remained an onlooker, without experience of his own or the authoritative voice it would have conferred.

Then, on 30 April 1911, Captain Wallace died. With the family's finances suffering from the loss of the father's income, Frances found it difficult to maintain the house. Young Bill left school to find work, and daughter Mabel did her best to assist at home. But the other daughter, Frances junior, was seeing a man of whom the family disapproved and whom she ultimately would marry against the family's wishes; she would

The *Christian Knudsen*, September 1907. The Norwegian-owned steamer fell victim to the German submarine U-53 on 8 October 1916. MMA WPA MP 18.257.4

not help and became estranged. That left Fred, as the eldest son, to take the lead, even though his freelance writing was an uncertain source of income.

Fate then intervened. *Canadian Century* assigned Fred to write a series of articles on the Canadian fisheries. That many of the major players in the industry were headquartered in Montreal was a sign of the shifting balance of economic power from the Maritimes to central Canada. Among Fred's sources was Alfred H. Brittain, managing director of the Maritime Fish Corporation. The relationship between the two men was mutually beneficial. Brittain recognized the value of publicity, and Fred obtained good copy. Then, Fred says:

> During one of my visits to his office in the summer of 1911 he suddenly declared: "Look, Mr. Wallace, if you want to get some first-hand dope on Nova Scotia fisheries, you'd better come down with me to Digby in August. They're holding a Fishermen's Regatta there then and a couple of schooners are going to race for a cup which I'm presenting. If you'd like to come along and write up the story, I'll see that you get on one of the schooners in the race."

Fred immediately agreed to go. As he would write close to the end of his life, "Little did I think at that moment that I had unconsciously embarked on a series of events which were destined to influence my future career."

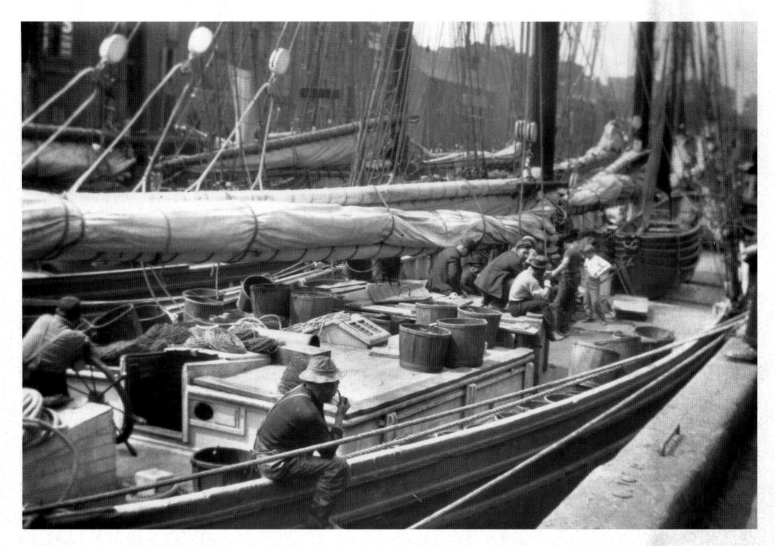

T-Wharf, Boston, August 1909. Nested dories and tubs of trawl scattered on the cabin house and deck identify the vessel as a banks fishing schooner. The crew lounging on the deck are oblivious to the man behind the camera. MMA WPA AE 19

Opposite: T-Wharf, Boston, August 1909. The *Washakie*, built in 1908, was one of a new breed of knockabout schooners by famed designer Thomas F. McManus. MMA WPA AE 21

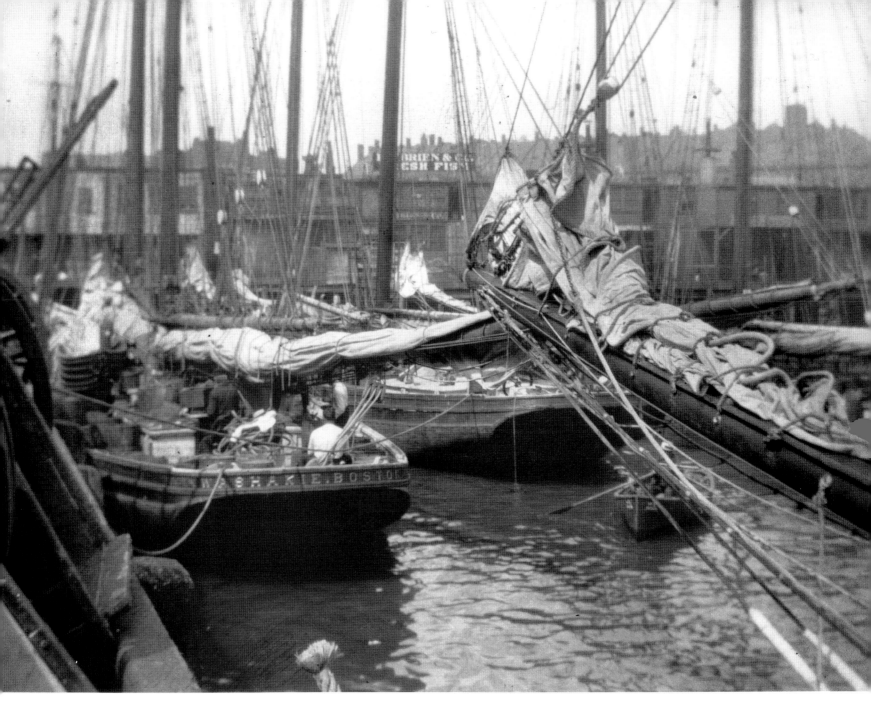

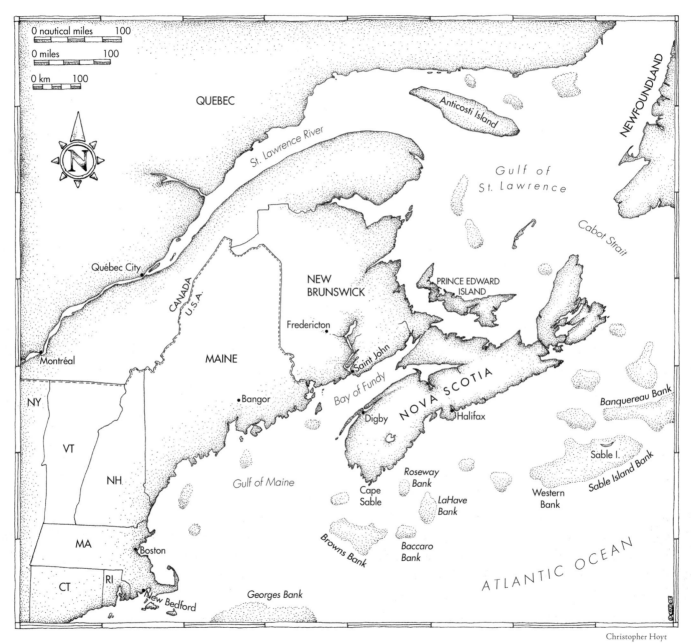

QUEBEC

0 nautical miles 100

0 miles 100

0 km 100

N

St. Lawrence River

Anticosti Island

Gulf of St. Lawrence

NEWFOUNDLAND

Cabot Strait

Québec City

CANADA
U.S.A.

NEW
BRUNSWICK

PRINCE EDWARD
ISLAND

Montréal

Fredericton

Saint John

NOVA SCOTIA

Banquereau Bank

NY

MAINE

Bangor

Bay of Fundy

Digby

Halifax

VT

NH

Gulf of Maine

Roseway
Bank

Sable I.

Western
Bank

Sable Island Bank

Cape
Sable

LaHave
Bank

MA

Boston

Browns Bank

Baccaro
Bank

ATLANTIC OCEAN

CT

RI

New Bedford

Georges Bank

Christopher Hoyt

Chapter Two
FISHING

The Digby fishing community into which Frederick William Wallace insinuated himself in the late summer of 1911 was relatively small, specialized, and prosperous. The calm beauty of the Annapolis Basin had long provided a secure harbour from which to pursue a profitable inshore boat fishery. Catches from the communities of the exposed Fundy Shore to the east, Digby Neck to the west, and the sheltered Granville Shore across the basin funnelled through the independent fish buyers of the town of Digby, where they were variously dried, salted, smoked, and canned.

In the late nineteenth century, improved steamship connections between Yarmouth and Boston, Digby and Saint John, and the coming of the Dominion Atlantic Railway had opened new markets for the fresh fish trade and local specialties like finnan haddie. In their search for haddock, hake, halibut, cod, cusk, pollock, and other groundfish to supply the growing trade, Digby's fishermen expanded their efforts to the offshore grounds of the Gulf of Maine, the so-called home banks of Cape Sable, Browns, Baccaro, Roseway, LaHave, and Georges. Trips to these banks typically required ten days to three weeks and the use of longline trawls from schooner-based dories. Occasionally, Digby schooners would venture further, to the Banquereau Bank, Grand Banks, and the Gulf of St. Lawrence, particularly in search of halibut. To capitalize on this expanded fishery, Montreal-based Maritime Fish Corporation, which had been formed in April 1910, made Digby its base in western Nova Scotia, absorbing local fish buyers Captain Howard Anderson and Short & Ellis.

The Digby schooner fleet was small compared with those of Yarmouth, Shelburne, and especially Lunenburg. Wallace, the young journalist Maritime Fish brought down from Montreal, found only a handful of Digby-based schooners actively engaged in the banks fishery: the *Dorothy M. Smart*, *Albert J. Lutz*, *Alcyone*, *Cora May*, *Loran B. Snow*, *Wilfred L. Snow*, and *Dorothy G. Snow*, all built in Canada, and the American-built *Effie M. Morrissey*, *Quickstep*, and *Harvester*. In contrast, Lunenburg had more than a hundred schooners, mostly engaged in the salt fish trade for the Caribbean market.

The Lunenburg fleet started out for the Grand Banks in March and made three or four trips for codfish during a sea-

Frederick William Wallace's Seven Voyages aboard Banks Schooners

Dorothy M. Smart, Captain Harry Ross: departed Digby 25 August 1911, returned 14 September 1911 (21 days)

Dorothy M. Smart, Captain Arthur Longmire: departed Digby 13 March 1912, returned 25 March 1912 (13 days)

Effie M. Morrissey, Captain Harry Ross: departed Portland, Maine, 10 December 1912, returned 20 December 1912 (11 days)

Albert J. Lutz, Captain John D. Apt: departed Digby 6 May 1913, returned to Canso 9 June 1913 (35 days)

Dorothy G. Snow, Captain Ansel Snow: departed Digby, 22 March 1914, returned 29 March 1914 (8 days)

Albert J. Lutz, Captain John D. Apt: departed Yarmouth, 4 January 1915, returned 15 January 1915 (12 days)

Dorothy G. Snow, Captain Ansel Snow: departed Digby, 12 March 1916, returned to Shelburne, 25 March 1916 (14 days)

son that ended in September or October. The Digby fleet's pursuit of fresh fish followed a different annual cycle. Just as the Lunenburg salt fishery came to a close in August and September, the Digby schooners set out for the home banks with their holds full of ice. In late October, schooners would adopt a winter rig in preparation for longer voyages in harsher weather by having their maintopmast and foretopmast lowered and stored ashore, along with the balloon, staysail, and topsail. Over the course of the winter, the schooners shifted east toward Browns Bank in search of spawning haddock. By April, most of the fleet came home for a thorough overhaul, repair, and repainting. Few Digby fishermen ventured to the home banks in the summer, when dogfish crowded more profitable species; instead, they switched to the inshore boat fishery or went home. Almost all had a bit of land, perhaps with chickens, goats, cows, or sheep. Many had hay to bring in or helped others who did. They chopped wood and left everything in readiness for wives and children to manage in their winter absence. Only occasionally did a Digby schooner fit out for summer salt fishing, as the *Albert J. Lutz* had in the weeks before the Brittain Trophy Race, and some tried looking for halibut in the Gulf of St. Lawrence.

Between 1911 and 1916, Wallace made seven voyages aboard banks schooners. Six times he went to the home banks, so-called shacking trips, in pursuit of a variety of groundfish. Only once did he go in the summer, a twenty-one day trip aboard the *Dorothy M. Smart* with Captain Harry Ross. His other five home banks voyages were undertaken in the harsh Atlantic winter and lasted from eight to fourteen days. One other trip, of thirty five days aboard the *Albert J. Lutz* with

Captain John D. Apt, ventured to the Gulf of St. Lawrence in search of halibut in May and June 1913.

Each voyage had its unique elements: vessels, captains, and crews had their own character and varying rates of success; the weather was unpredictable; summer and winter trawling varied slightly, and the gear used to catch halibut differed from that used for other species. Fishing procedures were, however, substantially the same: longlines were baited, dories off-loaded, trawls set, fish caught and dressed, and catches landed. On his first voyage to the banks, in August-September 1911 with Captain Ross aboard the *Smart*, Wallace learned the basics of dory fishing. On his second voyage, the following March, again aboard the *Smart* but this time with Captain Arthur Longmire, he learned how practices had to be modified to accommodate the harsh realities of winter fishing. Wallace's fourth voyage, with Captain Apt aboard the *Lutz* in the spring of 1913, taught him the specialized techniques of halibut fishing. Through experiences such as these, Wallace learned first-hand how the fresh fishery was conducted on the open seas off Nova Scotia in the last days of the age of unassisted sail.

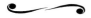

Having wrung permission from Captain Harry Ross in the wake of the Fishermen's Regatta to join the *Dorothy M. Smart* on a fishing trip to the banks, Wallace found himself with ten days to kill before the voyage. As yet without friend in Digby, he spent his time exploring the ports of Nova Scotia looking for "local colour." He took the Dominion Atlantic Railway to Halifax for three days, then retraced his steps through Digby

and on to Yarmouth for a few days more. He returned to Digby on 21 August, only to find the *Smart* still fitting out, so he took a steamer to Annapolis Royal and back, then spent two days touring the immediate area by automobile. On 24 August he took his dunnage aboard the *Smart* at last, and examined the vessel that would be his home for the next three weeks.

The *Dorothy M. Smart*, fresh from a summer refit, a coat of paint, and victory over the *Albert J. Lutz*, looked as new as the day it was launched the previous year. Below decks, the *Smart* was as up-to-date and comfortable as was likely in a banks schooner of the day. Its crew of twenty fishermen to man the ten double dories, spare hand, cook, and captain were accommodated in the forecastle and the cabin aft. The forecastle was forty feet long, running under the deck from just aft of the base of the foremast to the bow, with upper and lower tiers of bunks, port and starboard, to sleep fifteen. Around the lower bunks were lockers upon which the men ate and relaxed. At the aft end of the forecastle, close to the companionway, was the galley, with a stove and freshwater pump connected to a 1,400-gallon tank under the deck. A round hatch over the galley gave ventilation and light to the cook. The shaft of the foremast and the square timber of the windlass pawlpost pierced the room from deckhead to deck and supported folding meal tables. Leftovers, as well as cold meat, doughnuts, and slices of bread, butter, and jam were kept in the galley "shack locker" to be eaten in off-meal hours. The locker would become a favourite haunt of Wallace's, who used it as the title for his first collection of short stories. Above the deck and topped with a skylight protruded the cabin house aft, containing three

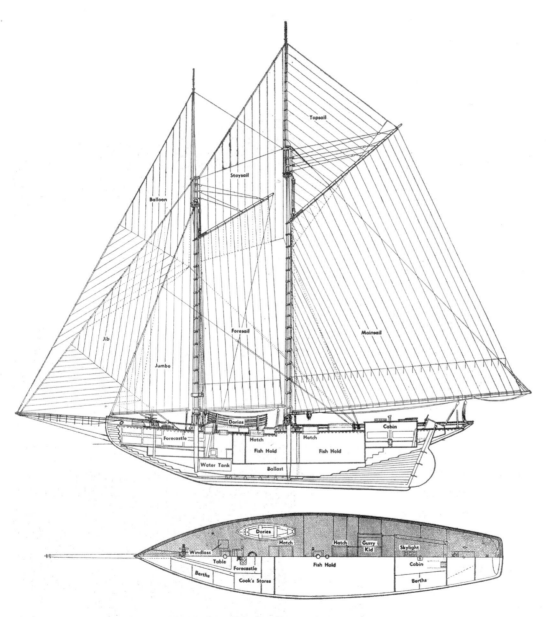

Layout and sail plan of the schooner *Albert J. Lutz*. When Frederick William Wallace asked the artist George A. Cuthbertson to prepare a cross section of a typical banks schooner of the period around 1910, he suggested his favourite vessel, the *Albert J. Lutz*, as a model. Based on the Indian Head design of Thomas F. McManus, the schooner was one hundred and two feet long from the stemhead at the bow to the stern taffrail, twenty-three feet wide, and drew up to thirteen feet when loaded. The net registered capacity was ninety-five tons. The mainmast including topmast rose one hundred and fifteen feet from the deck, the mainboom stretched sixty-five feet from the mast and the maingaff forty-two. The bowsprit extended twenty-five feet beyond the stemhead. With all sails set, the schooner carried approximately eight thousand square feet of canvas. As depicted here, the rudder is slightly too large and the dory-chocks are placed too close to the rail, but otherwise this sketch is a fair rendering of the schooners aboard which Wallace sailed.

Nova Scotia deep-sea fishing schooner, 1914. MWW FWWP 10

double berths and two singles, one reserved for the captain, and a pot-bellied stove. Both the forecastle and cabin were "nicely finished in panelled hardwood, varnished, and with white-painted ceilings and deckheads." Between them was the main hold for fish, containing twenty-eight bins for icing the catch.

If the schooner took some getting used to, so, too, did the captain and crew. Captain Ross had been hesitant to take a "city feller" out to the banks and remained so; his job was to catch fish, and any time spent running a seasick journalist back to port was time lost. Ross, the third of at least eleven children, had been born at the village of Culloden, on the Bay of Fundy at the base of Digby Neck, in 1886, the same year as Wallace. His father Alexander was a "mariner" and most of his brothers would become so. Ross's own rise to command was extraordinary. The most common claim to command of a fishing schooner was part ownership through a system of sixty-four shares. A would-be captain could maintain such a claim, however, only if he was able to attract a crew of skilled fishermen to follow him. Ross must have had leadership qualities to make up for his lack of capital. Without owning a single share, he obtained command of the fifty-ton schooner *Alcyone* in 1908 at the age of just twenty-one. Within months, he purchased eight shares in the eighty-seven ton *James W. Cousins*, only to lose the schooner, but not the crew, on Old Man's Ledge off the southwest coast in January 1909. The loss might have been

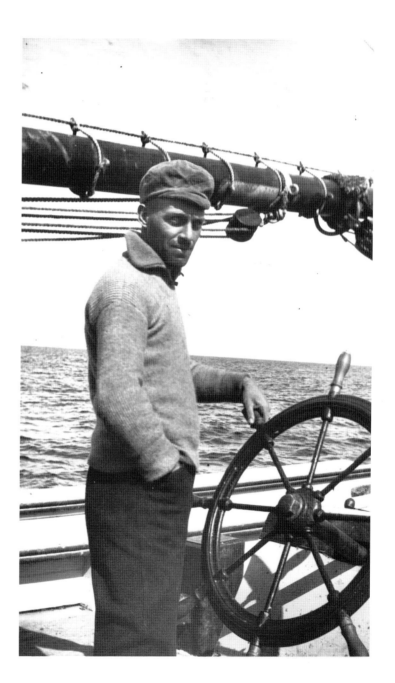

Captain Harry Ross at the wheel of the *Dorothy M. Smart*. With grey eyes and reddish blond hair, he was "a big strong fellow, about 175 pounds, of bone, sinew, and muscle."
MMA WPA A 14

Crew List

Master	Harry C. Ross
Cook	Georg Dreimann, Digby
Hand	Frederick W. Wallace, Hudson, Quebec
Dory 1	Judson Handspiker, Digby
	James Tidd, Digby
Dory 3	Aubrey S. Post, Digby
	Oscar Comeau, Digby
Dory 4	Ensley Ross, Digby
	Loren Slattery, Digby
Dory 5	Wiley Ross, Digby
	W.J. Murphy, c/o Capt. Harry Ross,
	Digby
Dory 6	Handford Daley, Digby
	Alexander Phinney, Digby
Dory 7	W.P. Ross, Culloden
	James Coutreau, Digby
Dory 8	Wallace Abbott, Marshalltown
	Arthur Dugan, Marshalltown
Dory 9	Walter Barnes, Digby
	Hillyard Barnes, Digby
Dory 10	Earnest Gilliland
	Burton E. Stark, Digby

Frederick William Wallace Papers, Vol. III, Journals and Logbooks, Item 22], from the log book of the *Dorothy M. Smart*, August-September 1911

enough to stall the career a lesser man, but Ross immediately received a new command, and many of the *Cousins's* crew followed him. In May 1910, the *Alcyone*, Captain Ross commanding, delivered 60,000 pounds of mixed fish to the new Maritime Fish Corporation, the largest haul the little schooner had ever landed. When the corporation built the much larger *Dorothy M. Smart* two years later, Ross was the natural man to put in charge of the new flagship schooner. His reputation as a "fish killer," "a driver," and "a hustler" was firmly established.

The crewmen who followed Captain Ross were those who knew him best, his relatives, neighbours, and friends. On the crew list Wallace kept for the voyage of the *Smart* in August-September 1911, most gave their home as Digby, although almost all came from the base of Digby Neck, out on either the Lighthouse Road toward Bayview and Point Prim Lighthouse or Mount Pleasant Road over North Mountain to Culloden on the Bay of Fundy Shore. Three of the men, William Percy, Ensley, and Wiley, were Harry's brothers; another, W.J. Murphy, his brother-in-law. The men of Dory 8 came from slightly further afield: Marshalltown, a village on the southwest outskirts of Digby. The only clearly identifiable outsider was Georg Dreimann (variously spelled), a Russian "who had come to Digby in a sailing ship many years before" and never left. Most of the crewmen were older than their captain: Judson Handspiker by seven years, his dory mate James Tidd by six, and Harry's brother Percy by thirteen. Ensley and Wiley were younger.

This community of men trusted Harry Ross to make quick trips with a high probability of a good catch. Their livelihood depended on it. All the fishermen were paid as sharesmen.

Typically, the costs of victualling, ice, salt, bait, and wages of the cook and spare hand were taken from the gross proceeds of the catch. The vessel's owners would then claim a quarter or a fifth of the profit, out of which the costs of insurance and maintenance would have to be paid. The crew split the remainder, either as even shares or "by the count"; the former split the profit equally among the crew, the latter according to each dory's catch. The captain, often part owner, drew a share and a percentage. Everyone relied on the captain to manage the voyage carefully, find fish quickly, and bring home a large and fresh "high line" catch. Captain Harry Ross never had trouble finding a crew; owners of other Digby vessels were frequently forced to keep their schooners hauled up for want of crew. Captain Howard Anderson sold little *Alcyone* to the Lockeport fleet in 1912 for just this reason.

Wallace's first encounter with the crew was friendly if slightly wary. Awaiting the delivery of twenty-five tons of block ice, which had to be drawn by oxen from the country back of Digby, the crew were scattered around the deck, some making and painting tubs to hold their trawl from flour-barrels sawn in half, others slinging trawl buoys. On the wharf, still others were overhauling their dories, splicing a new painter, and the like. One man was waterproofing his suit of yellow oilskins by painting them with linseed oil. "My shipmates-to-be," Wallace recalled, "revealed no curiosity as to my motives in making a trip with them, nor did they ask me directly who I was, where I came from, or the nature of my business." All they knew was that he was an Upper Canadian, a writer of some kind, "a reporter." They asked the inevitable series of "half-shy questions": "You ain't never bin afishin'?" "Ain't bothered with sea-sick-

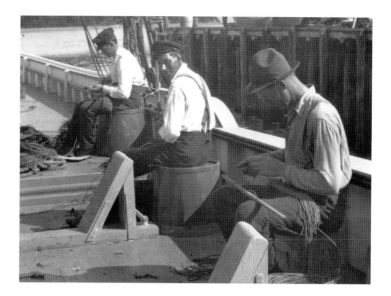

ness?" Wallace responded in the negative to both. The men told him tales, tall and otherwise, of fast ships and big catches, and engaged in heated political debates about the upcoming federal election, which centred on the issue of free trade. When they exhausted these topics, the men retailed scandals of the first families of the county, "the skeletons being dragged out of the cupboards and literally kicked around the decks."

Sitting atop inverted trawl tubs, three crew members, two still in shore clothes, rig up new fishing gear aboard the *Dorothy M. Smart*, 1911. This involved splicing two-foot lengths of line called gangen, or snoods, every thirty-two to thirty-six inches along the heavier back or groundline of tarred cotton coiled by his side; the man in the foreground has perhaps twenty gangen draped over his lap. Hooks would be hitched to the free end of each gangen. In the foreground are the chocks in which the portside nest of five dories would rest. MMA WPA A6

Cooks

A good cook was almost as essential to the running of a successful schooner as a good captain. From his swaying domain of the galley, the cook produced three meals a day for up to twenty-four men without assistance. He set and cleared tables, washed all dishes, baked fresh bread, doughnuts, and ginger cake, and daily prepared a range of soups and stews, all to the irregular hours dictated by the setting of trawl. Breakfast could be anytime in the morning from two a.m. on. He also had to be prepared for an assault on the shack locker at any time of the day or night, as men coming off watch or late from a dory looked for a "mug-up" of food and hot tea or coffee. The cook prepared the list of stores to be purchased before departure and had to keep an account of quantities consumed during the voyage. In particular, he had to keep a close eye on fresh water in the tank below the forecastle. From an adjacent tank, he fetched oil for the cabin and forecastle lamps, the port and starboard sidelights, the anchor light, and the binnacle lamp. The cook was also expected to help the spare hand tend dories as they came and went,

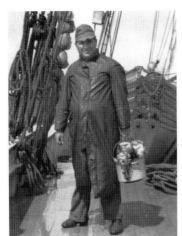

Georg Dreimann aboard the *Dorothy M. Smart*, August-September 1911. MMA WPA A 32

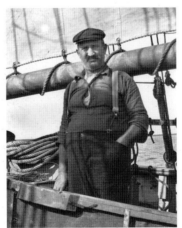

Jerry Boudreau aboard the *Albert J. Lutz*, May-June 1913. MMA WPA C 24

and occasionally even spell the captain at the wheel.

One mark of a good captain was his ability to find and hold a good cook. Captain Harry Ross's cook was Georg Dreimann. Wallace called him "neat and clean and an excellent cook." Wallace thought the best cook on the banks was the Acadian Jerry Boudreau, whom he described as "a stout middle-aged man, hard as nails, and very energetic." As Jerry told it, "I wasn't trained as a ham-and-egg fryer like a lot of them vessel cooks. I've been cook in Boston restaurants and I've worked in bakeries. I could get a job ashore anytime, but I like goin' off in the vessels." John Apt captained the schooner, but in the galley "Jerry was the undisputed boss and woe betide any man who carelessly 'mussed things up' or got rummaging around in his stores." He was a busy man, and had little time to wash an assortment of plates, so the men were limited to one mug, one plate, a knife, fork, and spoon. "Salt fish and beans are eaten off the same plate as tapioca or bread pudding, but what does it matter? It all has to go the same way anyhow, and the lingering flavour of fish and beans in the dessert is not noticeable when a man is hungry."

All this was enough to work up an appetite, and at 4:30 the cook came up from below to call, "Supper." The galley's small size meant the crew had to divide into two sittings, and the "first table crowd" asked their new companion to join them. Wallace's first meal aboard a fishing schooner was an eye-opener. Far from the plain food indifferently cooked he had expected, the table was crowded with dishes and basins of vegetable soup with doughballs, stewed beef with potatoes and carrots, bread, butter, jam, doughnuts, ginger cakes, and tapioca. The men consumed it all in twenty minutes and made way for the "second table." After a brief pipe of tobacco on deck, the men went back to work until sunset.

On this trip, Captain Ross was running only nine two-man dories, rather than the usual ten, which meant there were two free berths available in the forecastle, and Wallace expected to sleep in one of them. Much to his embarrassment, however, Ross insisted on giving him the captain's wide single berth in the cabin. "No, no, Mister," he said graciously. "You stay aft with me. I want you to be comfortable. I'll turn into one of the double berths with my brother in the cabin here." Wallace was abashed at the continuing solicitude that set him apart.

By noon the next day, Friday, 25 August, the ice was finally all stowed below, the dories dragged off the wharf and nested, and the tide was sufficiently high to permit departure. Mayor Harry Short and Captain Howard Anderson of the Maritime Fish Corporation were on hand to see Wallace off. "Take care of him, Harry," cautioned Mayor Short. "Oh, I'll do my best to see he don't come to no harm," replied Captain Ross. And so the *Smart* slipped away from the wharf, taking Wallace on his first adventure to the banks. While the crew set the four lower

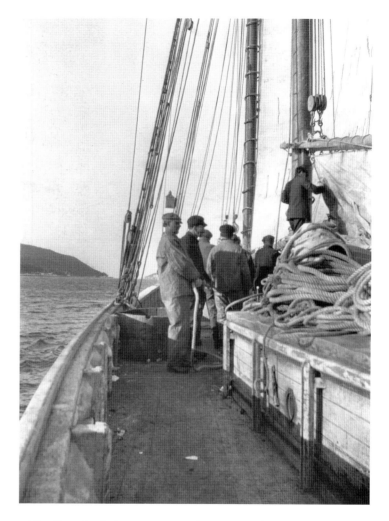

The *Dorothy G. Snow* navigates the notoriously narrow passage of the Gut with its turbulent tidal currents, May 1914. The man at the base of the mainmast is clearing the mainsail so that the crew can raise the maingaff by hauling the halyard. Inserting boards between the vertical slots in the side of the cabin house and the matching slots in the rail would create fish pens to hold the catch pitched up from the dories. MMA WPA D 4

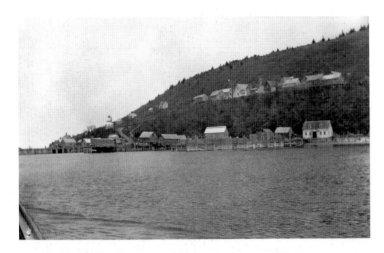

The *Dorothy M. Smart* threads through the Gut past the small community of Victoria Beach perched on the side of North Mountain, 25 August 1911. MMA WPA A 33

Right: Setting the topsail on the *Albert J. Lutz*, about May-June 1913. MMA WPA C 47

Opposite top: "The keeper saluted us with a farewell blast from his diaphone foghorn as we sailed out." Point Prim Light, Digby County, from the *Dorothy G. Snow*, March 1914. MMA WPA D 11

Opposite, right (see also pages 48, 49): The *Dorothy M. Smart* in the Bay of Fundy, March 1912, from the tip of the bowsprit. Forward of the two nests of dories are the drums of the hand operated windlass for raising and lowering the anchors. The shafts of the two fishing anchors cut their way across the frame, one from left to right resting on the bow rails, the other angling vertically outside the starboard rail. Fishing anchors had wooden stocks and usually used rope, rather than chain lines, making their loss less expensive; a smaller club anchor usually had an iron stock and chain line for use in harbour. The tip of the jib sail is held by chain sheets, as rope would soon chafe through on the wire stay along which the sheets ran. WPA BE 7

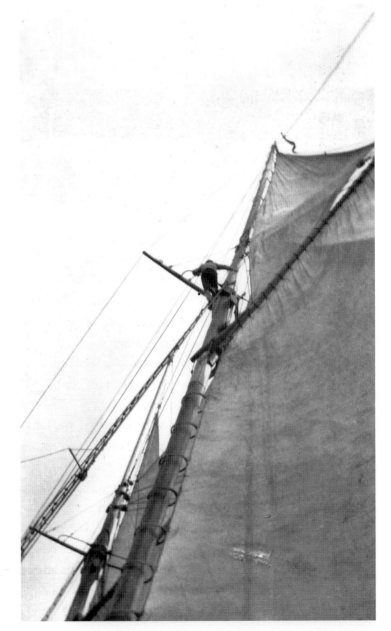

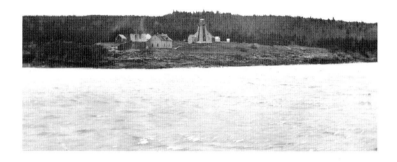

sails, Wallace trailed in the wake of the spare hand, coiling rope and straightening gear away on the deck. The not-yet-familiar run through the Gut lay before them. Victoria Beach passed by first, on the starboard, then Point Prim Lighthouse on the port. Off Point Prim, the captain ordered the light sails set, requiring a man to climb aloft to cast the topsail adrift. Wallace joined the others in sending up the staysail and balloon. The *Smart* then worked its way down the Bay of Fundy heading toward Yarmouth for bait, with Digby Neck, Long Island, and Brier Island passing in succession along the port side.

The crew turned in around ten o'clock, instructing Wallace to keep his underwear, shirt, trousers, and socks on: "Never take all yer clothes off aboard a vessel. You never know when you have to turn out in a hurry. And always keep yer boots, coat, and oilskins handy and ready to pull on." It was advice well taken. At four a.m. Captain Ross shouted down the cabin gangway, "All out! Get yer light sails in." In the darkness,

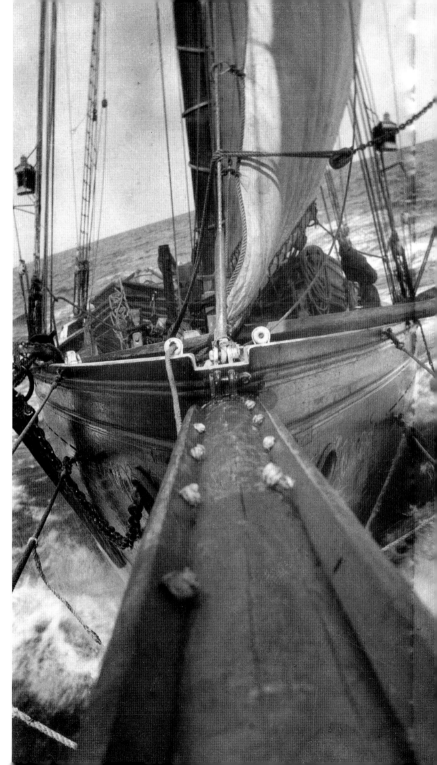

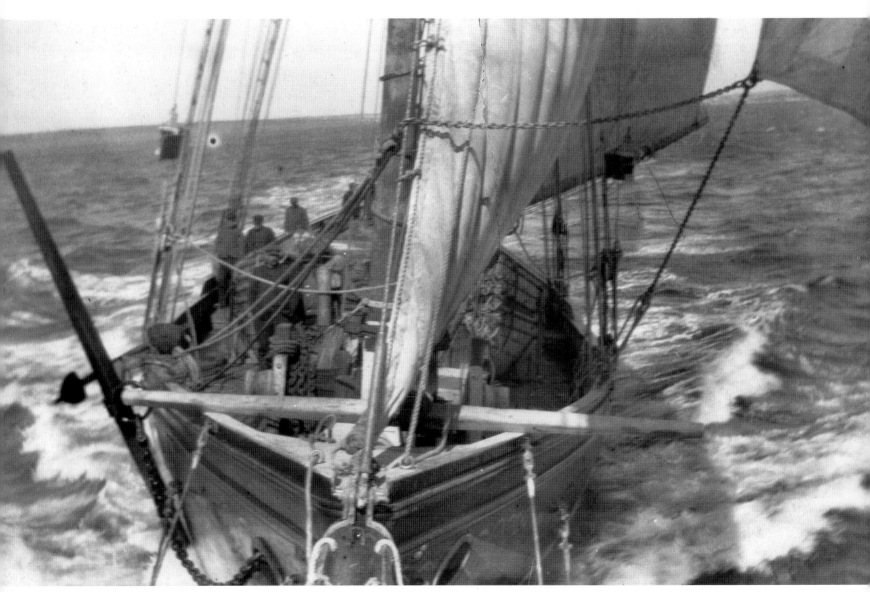

The *Dorothy M. Smart* in the Bay of Fundy, March 1912. WPA BE 16

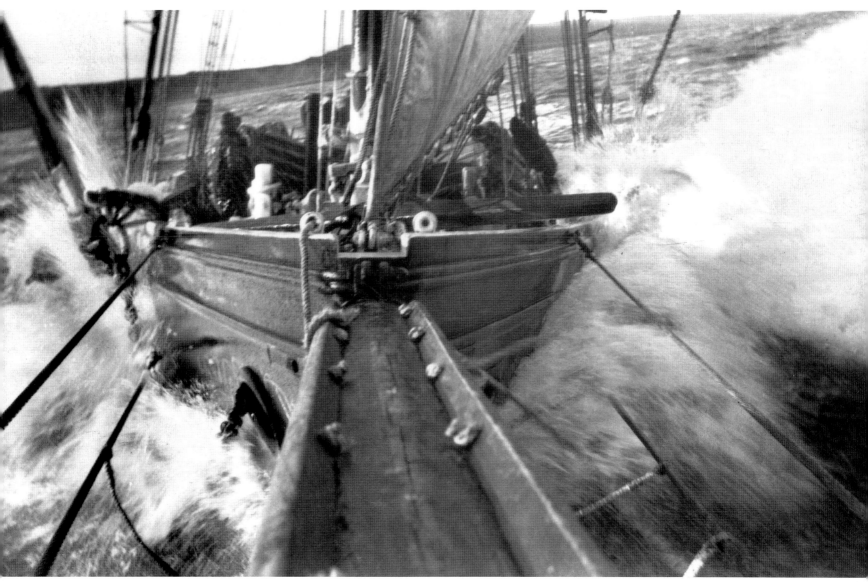

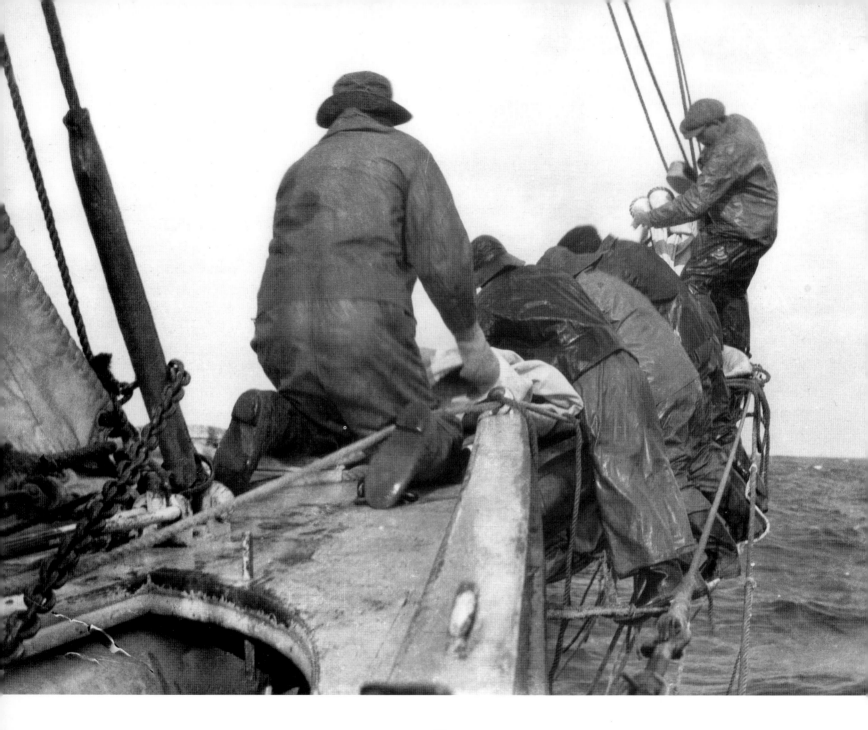

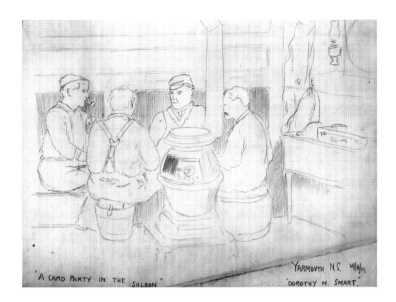

A CARD PARTY IN THE SALOON" YARMOUTH N.S. 29/8/11.
 "DOROTHY M. SMART".

Wallace fell out with the others and made his way forward in a southwest wind and heavy rain. "I clambered over the stemhead and along the foot ropes of the bowsprit. The balloon jib had been hauled down and I helped in pounding the wind out of the canvas and rolling it up." His neighbour on the foot ropes turned and peered curiously. "Oh, it's you, is it? I thought it was Wiley." And when the work was done, he followed with an invitation, "Let's go have a mug-up." Down in the forecastle, a steaming mug of tea in his hand, the shipmate observed, "You ain't a stranger to vessels." A few minutes later,

"A Card Party in the Saloon," *Dorothy M. Smart*, Yarmouth, Nova Scotia, 29 August 1911. Sketch by Frederick William Wallace. MMA WP Box 6, Folder 2

Opposite: Making the jib fast on the *Dorothy M. Smart*, August-September 1911. MMA WPA B 21

the captain came down to find Wallace sitting oiled-up with the crew. "What are you doing out of your bunk at this time in the morning? Hell, man, I didn't mean for you to turn out." Wallace's new companion responded, "Don't think you need worry about this lad, Skipper. Him and me stowed the balloon. He knows the ropes." No words could have meant more to Wallace. "From that moment all [the Skipper's] paternal solicitude on my behalf ceased, and for the rest of the trip I turned out and gave a hand at whatever was ordered." After so many years of trying, Wallace had made the transition from observer and guest to participant and shipmate.

Saturday at noon, the *Smart* entered an eerie, fog-shrouded Yarmouth harbour. Here the schooner sat until Thursday in a frustrating wait to obtain herring for bait from local inshore fishermen. No coolers yet existed along the shore in which to keep bait, so skippers were forced to seek out fresh supplies on an individual and often highly competitive basis. Little was being taken in the traps around Yarmouth, and Ross and the crew had to cool their heels. In a typical diary entry, Wallace reported, "Had breakfast and loafed around aboard all day, eating, smoking, yarning, and sleeping." Occasional trips to shore did little to break the monotony. All the while, expenses for food and the spare hand's and cook's wages added up. Then the spare hand was called back to his home in Digby, and Captain Ross, rather than hiring another for $40 a month and board, accepted Wallace's offer to replace the man for free. The journalist moved his gear to the forecastle and became a working member of the crew.

After six days of inactivity in Yarmouth, Captain Ross had had enough. Rather than wait for the inshore fishermen

to come to him, he would go to the inshore fishermen. On Thursday, 31 August, he ordered sails set and made course east for Murder Island, little more than a ridge of boulders and rock at the northern edge of the Tusket Islands, where herring traps were known to be set. Off Chebogue Point, the *Smart* came upon the schooner *Oliver Kilham* out of Beverly, Massachusetts. The American-flagged but Yarmouth-owned clipper-bowed vessel was also looking for bait. Ross rarely needed an excuse to challenge another vessel to a race. "We ain't agoin' to let that fellow get ahead of us," he shouted. The *Smart* surged ahead under four lowers and, making it first to Murder Island, was rewarded with two dories laden with gleaming herring. Bringing the bait aboard, however, was a dirty job, as Wallace relates:

> The fish were full of milt and spawn and the stuff
> smeared us from head to foot. The scales flew about
> like snow as the men dip-netted the herrings over
> the rail and into the deck-pen, and they stuck to our

Left: Daylight from the companionway partially illuminates the crew lounging and smoking in the forecastle. The man in the apron is the cook. MMA WPA N-17,768

Opposite, left: Wallace joins the crew cutting up herring bait atop the cabin house of the *Effie M. Morrissey*, December 1912. MMA WPA B 13

Opposite, right: Wallace holding the dory painter as herring is loaded aboard the *Albert J. Lutz* in May-June 1913, off the Magdalen Islands. MMA WPA C 27

boots and oilskins. By the time we had taken [the load] aboard, we were literally "blinded in scales" and for days afterwards we spent odd moments picking the scales off our garments. As it was my job to tend the dories and pitch the herring down the hatch, I was liberally plastered with the muck and looked as if I had been buried to the ears in fish.

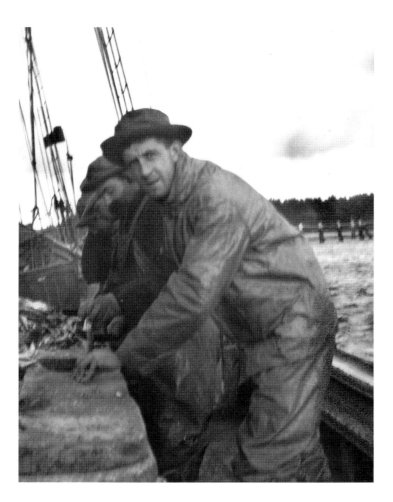

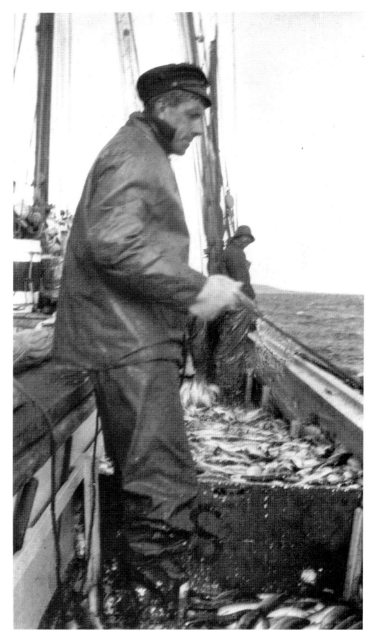

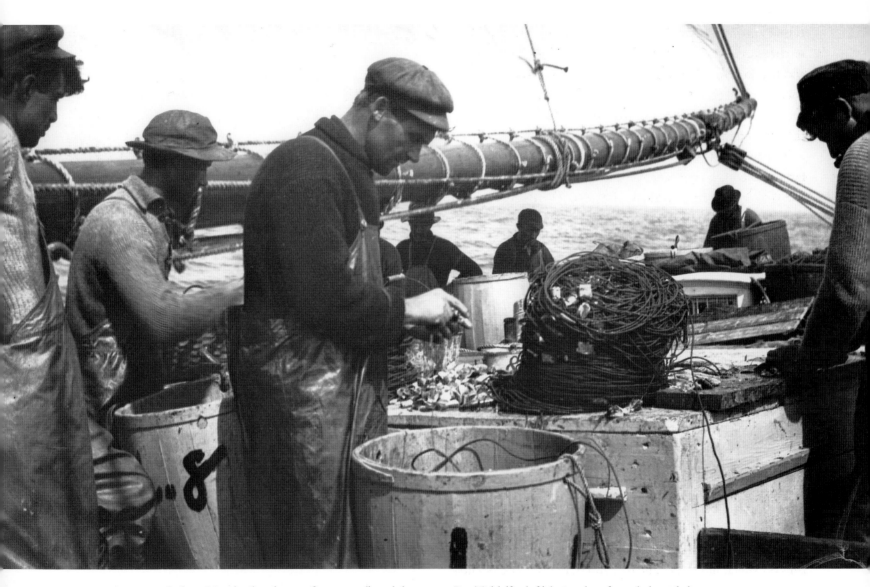

Judson Handspiker (centre foreground) and dory mate Jim Tidd (far left) bait tubs of trawl aboard the *Dorothy M. Smart*, August–September 1911. The tubs bear the dory numbers. MMA WPA A 3

If that were not enough, when manoeuvring to load, the *Smart* fetched up in ten feet of water off the Murder Island beach and had to suffer the indignity of asking the *Kilham* for assistance. Enduring the jeers of their rivals was a small price to pay, though, to get bait at last, and once free the *Smart* made for the fishing grounds near Seal Island, off Cape Sable.

Captain Ross's destination was "The Gully," a seventy-five-fathom depression between the fifty-fathom Cape Shore Bank and the offshore Browns Bank. The *Smart* made the location overnight, but the wind was too high to put dories out the next day. It was not until Saturday, 2 September, therefore, that Wallace was first introduced to the real business of fishing. Activity began in the early hours of the morning with the captain's shout of "Tumble out, boys, and get your breakfast!" After the meal, it was "Bait up!" A simple command for an onerous task. The herring were hoisted up in baskets out of the iced pens in the hold. The crew, wielding bait knives to chop the fish up for the trawl, lined up along the cabin house and the gurry-kid, a wooden box to hold offal when in harbour, where dumping overboard was prohibited.

Longlines started with a 300-foot (fifty-fathom) length of tarred cotton back or groundline called a "shot," seven of which were bent on or tied end-to-end to create one continuous 2,100-foot length of line for a single tub of trawl. Lightweight lines about two feet long called "gangens" (pronounced gan-jens) or "snoods" were hitched into the groundline at 32- to thirty-six-inch intervals. The free end of the snood was knotted into a bowline, which was inserted through the eye of a hook, looped over it, and hauled taut. Each tub of trawl had between 600 and 670 hooks, all of which needed to be baited.

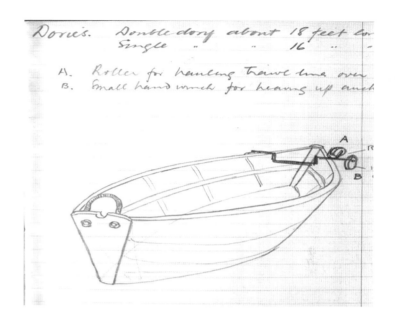

On this voyage, Captain Ross wanted every dory to carry three such tubs of trawl, requiring the dory men to bait from 1,800 to 2,000 hooks at a time. The lines of all three tubs would be bent on to one another when lowered into the water to create a single line 6,300 feet in length. In theory, the nine dories lay enough trawl to cover a distance of almost eleven miles. In practice, the lines were laid slightly aslant, five or six miles separating the first dory from the last. Altogether they placed some 18,000 hooks in the water at each set.

With the trawl ready, attention turned to preparing the dories for swinging over the rails. The two-man dories were

Sketch by Wallace of a two-man, or double, dory. "A" is the roller for hauling trawl line over; "B" is the small hand winch for heaving up the anchor. MMA WP Box 3, Folder 14

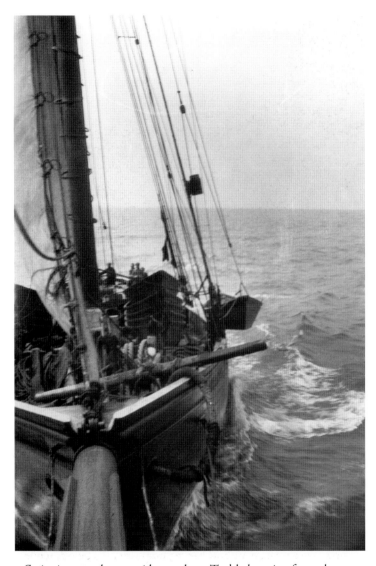

Swinging out the portside top dory. Tackle hanging from the fore and main rigging is hooked into the dory's bow and stern beckets to lift it out of its nest, swing it over the rail, then lower it alongside. MMA WPA MP 10.55.65a

eighteen feet in length and built to standard size to permit nesting on the deck. Heavy, stoutly constructed, and simple to maintain, they could carry two tons and yet were nimble enough to sail fairly well on their own into the wind. They were painted a yellowish orange or "dory buff" to make them easily discernible against the sea, but there were no life jackets, lifebuoys, rafts, or other life-saving devices on board. Safety equipment was generally limited to a good supply of food and water, a sail, and fog trumpet. Dory men also counted on the plug strap, a rope rove through the outside end of the round wooden plug used to close the drain hole in the bottom of the dory. If the dory flipped, the plug strap provided something for the floundering fishermen, few of whom could swim, to grasp. Before the first dory could be lifted out of its nest, those items plus two kedge anchors, trawl buoys and blackballs, pitchforks, a gurdy winch and roller, and, of course, three tubs of trawl had to be assembled. Dory mates had to rely on each other for assistance, a partnership that required an extraordinary level of trust, for matters of life and death as well as profitability were involved. In most cases, the two men were related or close friends hailing from the same town, as on the *Smart*. Between them, they purchased the gear necessary for the dory, and each man shared in the work of baiting the trawl, hooking-up, and overhauling gear. They were also teamed to handle the schooner on the watch-on-watch system. The watches were never of long duration, divided as they were among so many men taking turn in pairs, but whether it was from thirty to ninety minutes, each dory mate took his half of the watch at the wheel and lookout.

The men assigned to the top dories of each nest got their

small crafts ready, putting the thwarts and pen-boards in place, and loading their assembled equipment. Hoisting tackle, which hung from the fore and main rigging, were hooked into the dory's bow and stern beckets (essentially, rope handles). The two men then heaved on each tackle to raise the dory out of the starboard nest, ease it over the rail, and lower it in the water alongside. As the schooner moved slowly through the sea, the spare hand (in this case, Wallace) held the painter attached to the dory's bow while the tackle was released. One dory man clambered aboard and the other passed over the tubs of trawl and any remaining equipment before joining him. As soon as they were squared away, the spare hand holding the painter walked aft toward the stern until the dory drifted into the schooner's wake. There, the top dory from the other nest would join it, and together they would be towed astern, their painters tied to a pin in the taffrail. This procedure was repeated successively for the remaining seven dories until all nine trailed behind the schooner in two strings. When both strings were complete and the captain was satisfied they were over the fishing grounds he had selected, the order went out to "Cast Off!" At this, the trailing dory of the starboard string would release and, after about half a mile, the trailing dory of the port string would let go. Thus alternating, all the dories were free to set their trawl with sufficient room one from another, a disposition known as a "flying set."

One of the captain's most important functions was to determine the best ground on which to have the dories make their sets. This was not simply a matter of finding a spot where the fish were likely to be plentiful, but also where setting trawl was practicable. Rough, rocky bottom could snarl the trawl and

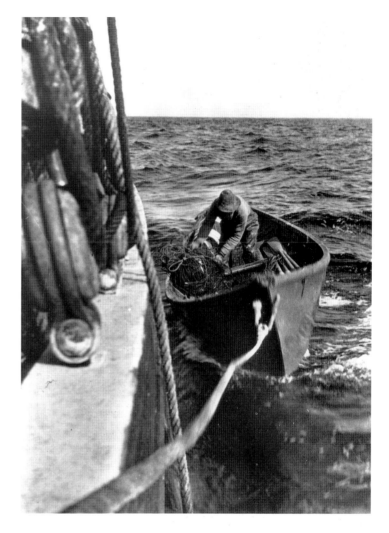

Loading the dory. With the spare hand holding the painter attached to the dory's bow becket, one dory man boards while his mate passes over trawl and other equipment. The heavy trawl indicates that the photograph is from Wallace's halibuting trip aboard the *Albert J. Lutz* in May-June 1913. MMA WPA MP 10.54.26

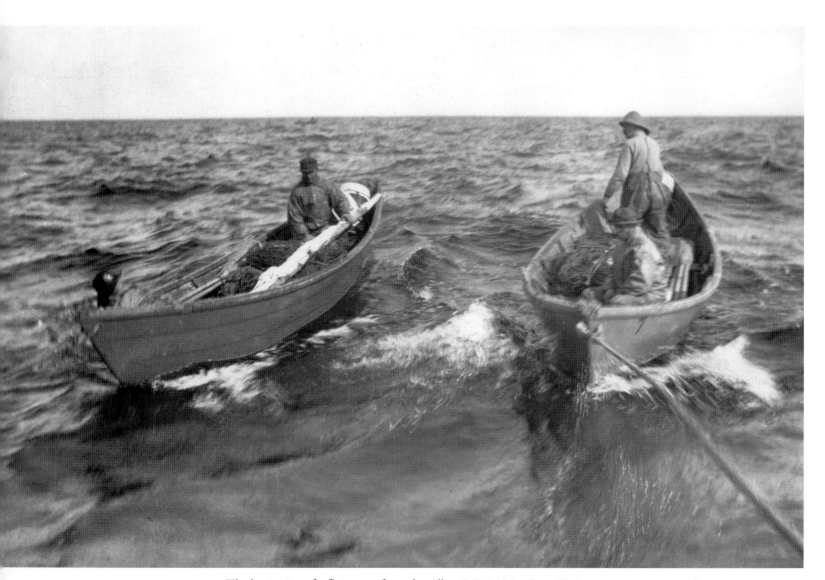

The beginning of a flying set, from the *Albert J. Lutz*, May-June 1913. MMA WPA C 8

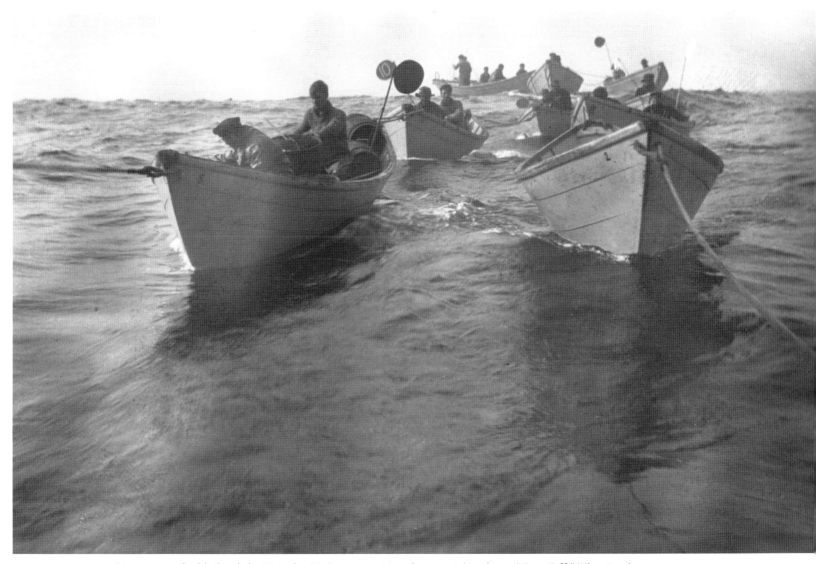

Dories stretched behind the *Dorothy M. Smart* awaiting the captain's order to "Cast Off!" The circular discs floating above each dory are blackballs used to distinguish trawl lines. Made of painted canvas with the dory number inscribed, they are attached to thin poles slotted into a socket on the buoy-keg that would float at one end of the trawl when set. MMA WPA A 7

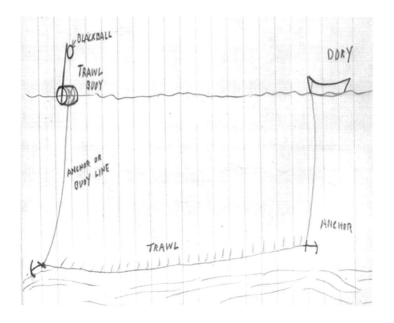

make it difficult, if not impossible, to raise without damage or breakage. The captain also had to know the times of the ebb and flow and direction of tidal currents, the hours of high and low water, and the likelihood of changes in the wind over the period of the set. "It would be too much to expect a couple of fishermen in a dory to haul back their lines with a four-knot tidal current opposing them, and perhaps a stiff wind in their teeth." Above all, the skipper had to read the weather constantly. With dories stretched out in a line miles long, often out of sight of each other as well as of the schooner, the captain had to exercise prudence.

Once over their ground, one man rowed slowly in the

Wallace's sketch of setting trawl from the *Dorothy M. Smart,* August-September 1911. MMA WP Box 3, Folder 14

direction the line was to be set, while his dory mate stood in the stern to lower the trawl. The first step was to throw over the trawl buoy, or buoy-keg, in which a flag-like numbered blackball had been inserted to identify ownership of the line. Attached to the buoy was a light anchor line long enough to reach the sea floor, seventy-five fathoms (450 feet) below. As this line played out, sending the buoy spinning on the surface behind, the first end of the trawl was tied to a seventeen-pound kedge anchor. When ready, the anchor was thrown overboard, simultaneously fixing the buoy in place and plunging the trawl to the ocean floor. With the baited hooks and line coiled down in the tubs before him, the fisherman cast the trawl into the water by means of a short wooden "heaving stick," keeping the line sufficiently airborne to avoid embedding the baited hooks in the dory's gunwale. All the while his partner continued to pull the dory along the course of the set. The last, or tub end, of the trawl was tied to a second anchor and buoy and flung out to end the set. When they had finished, there was a continuous, more-or-less straight line of trawl along the ocean floor, with either end held in place on the seabed by an anchor and marked on the surface by a floating buoy with the dory's number indicated on a blackball. What happened next depended on the circumstances. Once set, trawl was normally given forty-five minutes to an hour and a half before it was hauled. Fishermen might spend this time riding in their dories tied to the last buoy, or they might pull in to the schooner if it was nearby.

On Tuesday, 5 September, Wallace saw this procedure first-hand when he was invited to join Judson Handspiker and Jim Tidd in dory one, making a "three master." After an

hour hanging onto the buoy end, smoking and yarning, Judson announced it was time to haul back. With Jim at the oars, steadying the dory with a strong tide running, Judson donned a pair of woollen gloves called "nippers" to protect his hands as he hauled on the trawl. He then stood and shipped the gurdy winch across the bow gunwales to raise the anchor. When it was up, he freed the trawl end from the anchor and began hauling it over a roller set in the starboard gunwale. Wallace peered anxiously into the clear green water to see what might appear. "Here's one acomin', Fred," announced Judson. "And a halibut at that." In seconds, a twenty-five pound halibut surfaced, struggling to free itself, lashing out with its tail and spinning on the line. Jim had to reach over the gunwale with his two hands and grasp the fish while Judson held on to the line. With a sharp jerk of his wrist, Jim tore the hook free and slapped the fish amidships. Halibut is a fighting fish, and risked breaking either the snood or, worse, the trawl itself. Most other fish on the line (cod, haddock, cusk, pollock) were less troublesome. Dragged up from more than three hundred feet down, they were either half-drowned or choked by their expanding air bladders. These Judson flicked free of the snoods and dropped into the dory for Jim to sort in pens. When confronted with the nuisance of dogfish, he would swear and bang them viciously against the gunwale and slat them free to drop back in the water stunned or dead.

The scene looked two dimensional: a flat ocean from which a variety of fish was hauled up. "But I was beginning to see far beyond that," Wallace reflected. "I was coming to realize what fishermen know. Though their eyes gave them no tangible evidence, yet in the setting and hauling of their trawls they

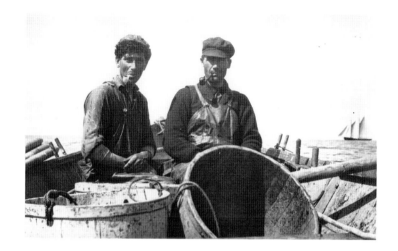

Judson Handspiker takes dory mate Frederick William Wallace's photograph, 5 September 1911. MMA WPA A 27

Top: Dory mates Jim Tidd and Judson Handspiker enjoy a smoke after setting the trawls, with the *Dorothy M. Smart* hovering in the background. MMA WPA A 1

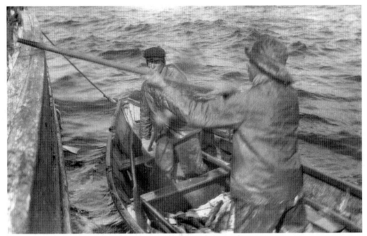

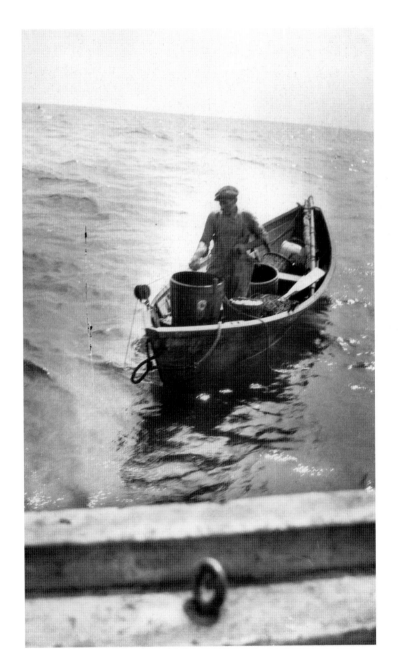

ascertained certain facts. The feel transmitted from below through the sensitive lines to their hands, arms and physical senses, gave them an uncanny insight as to what was the nature of things in the watery void and on the bottom." Jim, who had taken over hauling the line, growled at the nature of the bottom, the rocks snarling the line, and the tide, which added weight to the effort of lifting. "In his mind's eye, he saw the line and its myriad hooks draped over boulders, stones and

Above: Dory mates use two-tined pitchforks to toss their catch aboard the *Dorothy M. Smart*, March 1912. MMA WPA BE 3

Left: Hauling trawl over the roller set in the dory's starboard gunwale. This photograph was likely staged for Wallace's camera. MMA WPA MP 10.55.8a

Opposite: The man in the bow prepares to throw the painter on deck as his mate brings the dory, laden with fish, alongside the *Dorothy G. Snow*, March 1914. MMA WPA D 5

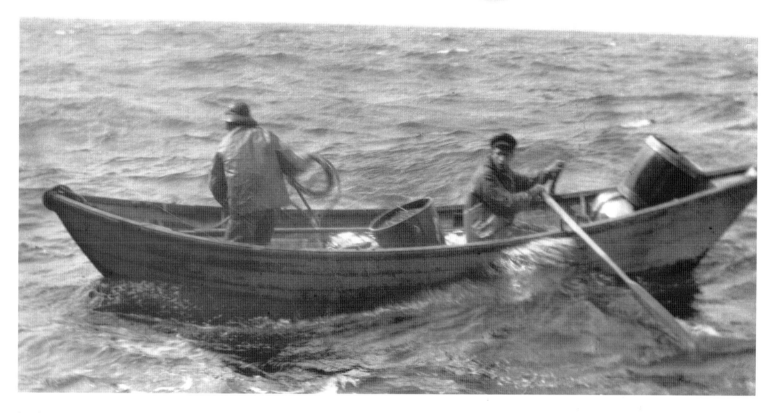

broken, weed-covered rocks — the tide flowing like a solid wall over them and carrying the trawl in bights along with it wherever there was slack enough." Jim pulled, then eased off, nursing the trawl to the surface. "Hell! she's parted!" he cried abruptly, a loose end of line in his hand. Fortunately, their predicament was noticed by Captain Ross, who brought the schooner around like a yacht in the Annapolis Basin to tow the dory down to the floating keg that marked the other end of the trawl. "You're the third dory that's parted," he shouted down from the deck above. The schooner released Wallace and his mates within a lazy stroke or two of the trawl buoy. "A few minutes later, and we were hauling again on several hundred feet of loose line streaming away with the tide."

While the dories were out, Captain Ross and the cook cleared the decks of herring heads and tails with a stiff broom and buckets of salt water dipped from over the side. Then they coiled loose halyards and sheets and partitioned off the deck with wooden pens slotted between the rails and the gurry-kid and cabin house. The captain then circled back on the line of dories and began to pick them up. As each dory approached the schooner, its crew shipped oars and got the painter ready to toss up to the forward deck, where it was grabbed and care-

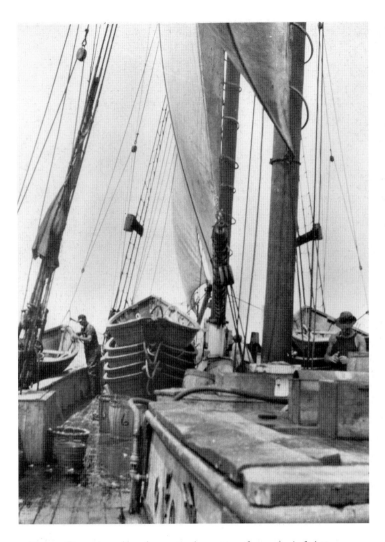

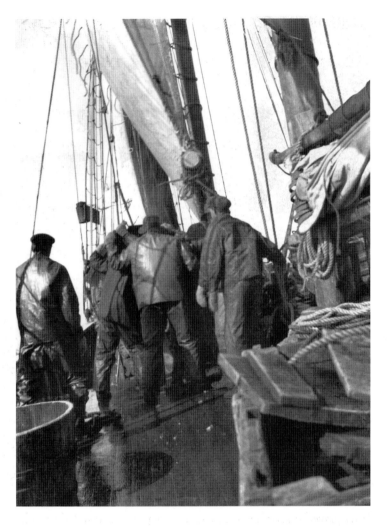

On a calm sunny day, the crew cleans up after a day's fishing. Bait knives are sheathed in beckets fixed to the side of the cabin house. MMA WPA MP 10.54.14

Right: Members of the crew of the *Dorothy G. Snow* struggle to nest a dory on a harsh March day in 1914. MMA WPA D 7

Opposite: Wooden pens assembled on the deck of the *Dorothy M. Smart* in March 1912 hold a substantial day's catch. The empty partitioned boxes at the top of the frame are "keelers" on which the crew dressed the fish. MMA WPA BE 11

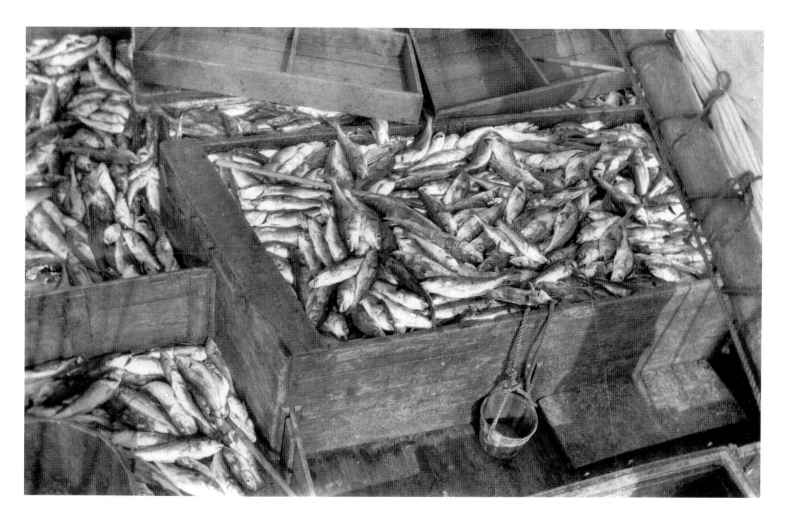

fully played out or hauled in as the dory rose and fell alongside. In rough seas, an hour of this would threaten to pull arms from shoulder sockets. After the tubs of trawl had been passed up, the dory dropped back toward the after deck pens. With the painter in the hands of someone on deck, the dory mates pitched the fish over the rail. As they did so, they called out "Two! Four! Six!" for Captain Ross had decreed that shares on this voyage would be distributed "by the count" — that is, according to the number of fish each dory took. Once empty, the dory was pulled back to the schooner's waist, hooked to the hoisting tackle, and hauled aboard. Anchors, buoys, and the like were taken out, thwarts and pen-boards lifted up and laid

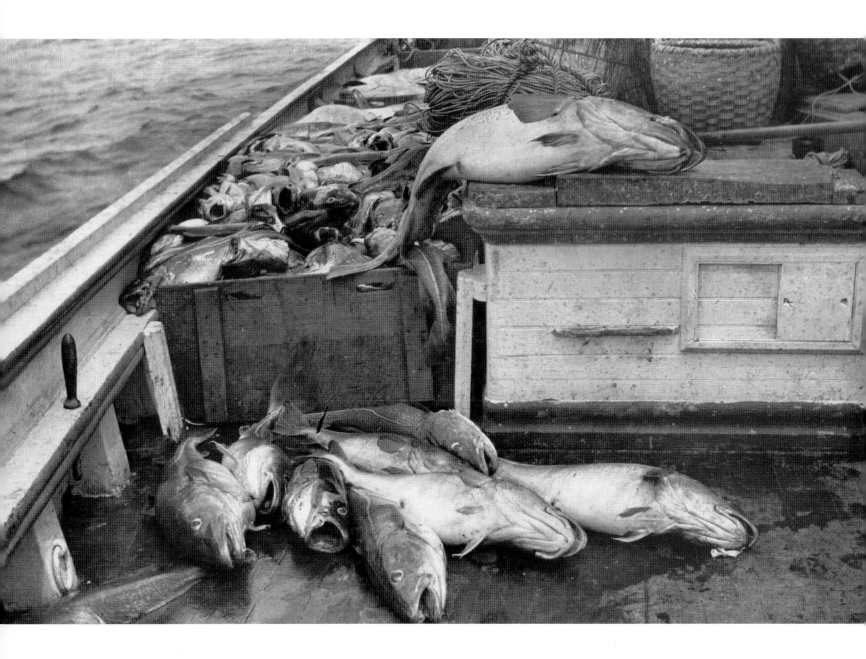

flat on the boat's floor, and the dory plug pulled to let water drain. The dory was then heaved back into the dory chocks. On a calm day, this would be simple work for the dory mates. But when the wind was up and the sea was running, it might require the hands of many.

From "dories over" to "dories in" took three or four hours. Captain Ross established a routine of making a morning set, having a mid-day meal aboard, then rebaiting trawl and sending the dories over again at two o'clock for an afternoon set. At five, the dories were retrieved again and the men sent down for supper. Only then did the crew turn to the task of dressing the day's catch, which on this voyage consisted of anywhere between 6,000 and 16,000 pounds of fish. Dress tables called "keelers" were placed across the fish pens between the rails on either side and the cabin house and gurry-kid. Handy beside each keeler was a large tub of salt water.

In each pen a man stood thigh-deep in fish and pitched them onto the tables. The "dress-down" gang called "throaters" and "gutters" took their places and when a fish was tossed on the table, one of the men would give its belly and throat a slash with a keen-edged knife and pass the fish over to the "gutter." This individual, his hands protected by canvas gloves, deftly ripped the intestines out and whirled them over the side. In the case of codfish, he snapped its head off. The gutted

fish was slung into the tub, allowed to remain and rinse in the water for a minute or so, and then was pitched out into one or other of the pens arranged around the main-hatch, to "drain." Here the cod, haddock and halibut were sorted out from the others and eventually pitch-forked down into the hold.

Below, men worked by flickering candlelight, shaving ice to line the fish pens and sorting and stowing the fish as it came down to them. Pen-boards, shelves, and vertical wooden divisions were used as temporary bulkheads to prevent layers of fish pressing down on those below. In fresh fishing, particular care and skill had to be exercised at this stage to ensure the catch reached shore in the most marketable condition possible. Up on deck, the crew washed everything down, sloshing sea-water over their boots and oilcloths. It would be after eight in the evening before everyone tumbled below for a mug up and retired, bone weary, to their berths.

And so the fishing went on every day from 2 September to 12 September, first in the Gully twenty-five to thirty-five miles south of Seal Island, then eastward to Roseway and LaHave Banks, some sixty miles offshore. One day was much like the next, but on Sunday, 10 September, on Roseway Bank, Wallace saw first-hand the risks the dory men ran. The day opened fair and the morning set was a good one. When the dories set off again in the afternoon, hopes were high for a repeat performance. No sooner had they set their trawls, however, than a heavy fog rolled in. Aboard the schooner, Wallace ran the hand operated fog horn as the captain and cook strained to see into the murk, rendered worse by fading light. Eight dories

Opposite: A prize catch of codfish fills the fish pens aboard the *Albert J. Lutz,* May-June 1913. MMA WPA C 3

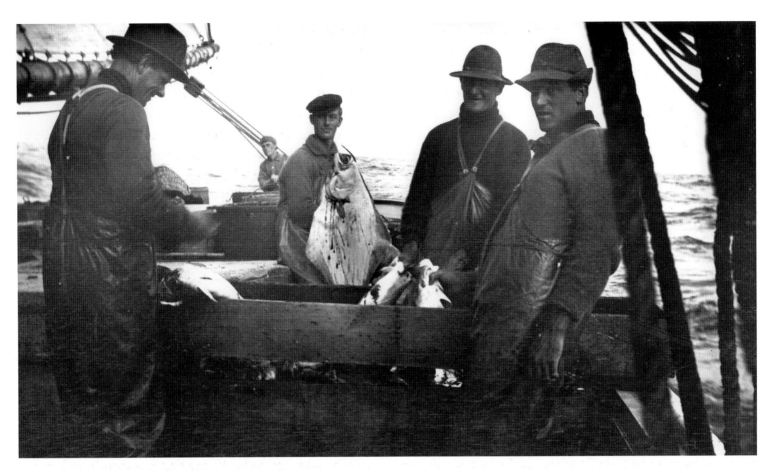

were found by supper, but the ninth remained unaccounted for as night approached. Torches were lit and crew climbed into the rigging for a better view. All were silent, straining to hear. "Suppose we don't pick them up before long, what'll they do?" Wallace asked. "Oh, we ain't far off the land hereabouts," a fisherman replied. "It would be a pull of thirty or forty miles in toward Cape Negro. So long's it ain't rough, they'd git in all right. They's a compass in every dory." Fortunately, timely dis-

covery saved the missing dory men from such a fate, or worse. Two days later, with all hands accounted for, the *Dorothy M. Smart* made for home with 110,000 pounds of fresh fish. Any catch over 100,000 pounds was considered good for a schooner the size of the *Smart*, but it was not exceptional for Captain Ross, who landed 1,676,915 pounds of fish in 1911, a record catch that cemented his reputation as a "high-line" skipper.

Wallace's subsequent fishing voyages aboard banks schoon-

ers adhered to the general pattern of his first. As he would learn on his next trip, in March 1912, on the *Smart* with Captain Arthur Longmire, some allowances had to be made for the harsh winter conditions. Skippers could not count on a full day of good weather, but had to take advantage of short windows of opportunity. One common strategy was to put dories over early, anytime after midnight. As Captain Ross explained it, "When you swing 'em over at two, three or four — 'specially during broken weather — the men have daylight ahead of them should it breeze or shut down thick. I'd sooner be caught with my dories astray in fog or snowstorm at four in the morning than at four in the afternoon." Another strategy was to limit the length of trawl set at any one time, in case it had to be hauled quickly in the face of a storm. With Captain Longmire, for example, dories went out with two tubs of trawl rather than three, and only set one at a time. In such a situation, the dory men did not bother attaching a trawl buoy to the first end of the single tub's line. Instead, they moored it with a large rock, a piece of iron, or even a mitten or sock full of stones, a so-called sling ding. They used an anchor only for the last or tub end, above which the dory would rest for twenty minutes or so before hauling up. As soon as this line was pulled up, the second tub would be set. If the weather remained good, the dory men would pull back to the schooner to get fresh tubs of trawl and repeat the performance. An al-

ternative was to under-run the trawl by carrying extra bait in the dory, rebaiting the hooks as the fish were taken off, and feeding the line back over. All of these strategies required the schooner to tend the dories constantly and the cook to offer meals almost continuously rather than at set times.

With both winter and summer shacking trips now under his belt, Wallace eagerly accepted Captain John Apt's invitation to join the *Albert J. Lutz* in search of halibut in the early summer of 1913. It is difficult to say what attracted Wallace more, the chance to go halibuting or to sail with Port Wade's respected captain. Wallace had seen Apt in action twice. The first time, Wallace had been on board the *Dorothy M. Smart* with Captain Harry Ross as it narrowly trimmed Captain Apt and the poorly prepared *Lutz* for the Brittain Trophy in 1911. The second time was for the August 1912 sequel, when Captain Apt's overhauled *Lutz* easily beat Captain Ross and the *Smart*. Captain Apt's victory in the second race was generally taken as proof of his pre-eminence as a sailor. He was considerably older than Harry Ross, having been born in 1867 on a farm at the tiny settlement of Waldeck Line, near Clementsport, in Annapolis County, Nova Scotia. He had run away to sea at age twelve, first sailing in coasting vessels as boy and cook, and later as a sailor in the Nova Scotia–West Indies trade. Like Captain Ross, he had received his first schooner commands while still in his early twenties, and by 1912 had been a skipper for twenty-two years. What distinguished John Apt from other captains, in Wallace's opinion, was the deep affection he had for his vessels and his love of sailing. "The *Lutz* was his pride; he owned part of her, and when she was abuilding, he spent much of his time in McGill shipyard in

Opposite: Standing thigh-deep in a fish pen, one crew member forks a halibut onto the dressing table, where three others stand ready to throat and gut the fish. Captain Ross looks on from the wheel. MMA WPA A 30

Captain Longmire
and the Bay Shore Crew

Wallace made only one trip with Captain Arthur Longmire and his Bay Shore crew, but he made lasting friendships with them, and the communities from which they sprang left a strong impression on him.

The Bay Shore of Annapolis County can barely be said to exist as a shore. North Mountain falls sharply to the waters of the Bay of Fundy, leaving little but cliff and the occasional rocky beach. Here and there, however, around slight indentations in the coastline caused by brief, swift brooks, small settlements sheltered behind breakwaters. Delaps Cove, Litchfield, Hillsburn, Parkers Cove, and Youngs Cove were home to a few close-knit families that fished, cut wood, and farmed what little land was available. The setting caught Wallace's imagination.

> In spite of it ruggedness and isolation, the Bay Shore to me was picturesque and inspiring. The air was charged with the odour of the spruce forests and the new-mown hay in the clearings, and one was lulled to sleep by the murmur of the surf on the beach. On windy nights, the darkness was sonorous with the sough of the gale in the trees, the thunder of the breakers and the clamour of boulders and gravel rolling in the wash.

The only road from the southwest rose more or less straight up The Hollow behind Port Royal and across the top of North Mountain to fall again to Delaps Cove. Wallace made the trip several times by buggy, getting out to walk when the trail was too steep. If the beauty of the setting inspired Wallace, the warmth of the people engaged him. His shipmates from the winter trip aboard the *Dorothy M. Smart* threw open their homes to him whenever he was down to Digby. He met wives, sisters, and children, attended the wedding of Primrose Halliday and his bride Elizabeth, and was never without a meal and a bed.

Wallace was also surprised to discover how prosperous these fishing communities were. The inshore boat fishery funnelled a steady income through local wholesalers such as the Longmire family to the Maritime Fish Corporation's Captain Howard Anderson, himself a native of Parkers Cove. Captain Arthur Longmire, whom Wallace found to be "a sterling character, unassuming, genuine," and his wife lived in a fine home with stained-glass doors salvaged from the wreck of the Allan Line's *Castilian* in 1899. As a youth, Longmire had sailed under Captain Anderson, and among his dory mates was John Apt.

Before 1912 was out, the fishermen of the Bay Shore and Digby suffered the loss of four of their number. Early in the morning of 23 December, the *Dorothy M. Smart* was lying

about sixteen miles southwest of Yarmouth Cape in the company of the *Albert J. Lutz*. Following a night set, the crew was dressing down the catch by torch light. The air was still, and Captain Longmire had the mainsail, foresail, and jumbo up to catch what little wind there was. The wheel was on a becket, unmanned. The forecastle gangway was open to the galley, where the cook was preparing breakfast, as were the hatches to the fish pens. The first warning that something was amiss was a sudden swell that caused the schooner to heel to leeward. Before anyone could react, a squall struck, sending the *Smart* over on its side. Water poured into the open hatches and down the gangway, endangering not just the men below but the vessel itself. Eight of the crew on the leeward side of the deck were thrown overboard along with the fish, gear, and a jumbled array of lines and sail. Three managed to grab on to the rigging; a fourth, Joe Hersey, drove his bait knife into the wooden keeler to stay afloat. As the schooner slowly righted, the remaining crew quickly dragged their companions on board. Four others were gone. Captain Apt, who had had a presentiment and had kept his men aboard and hatches closed, saw the *Smart*'s torches go out before the squall reached the *Lutz*. Dories went out searching for the missing men, but to no avail. Lost were Frank Daley, married with five children; Jesse Halliday, married; and Loran McWhinnie and Stewart Robinson, both single. Wallace wrote a letter to the *Digby Weekly Courier* expressing his condolences to the families and crew

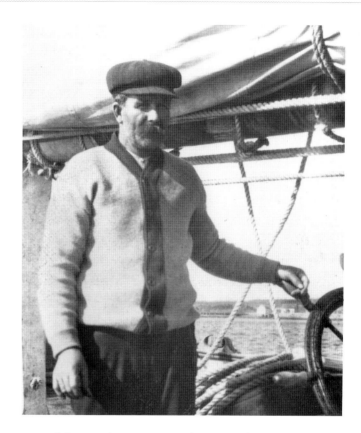

mates of the men lost. It was a sobering and personal lesson in the dangers of the banks fishery.

Captain Arthur Longmire. "He was a square-built, ruddy-faced man of around forty-five years, with a heavy black mustache and keen grey eyes, quiet of manner and soft-spoken." MMA WPA N-17,766

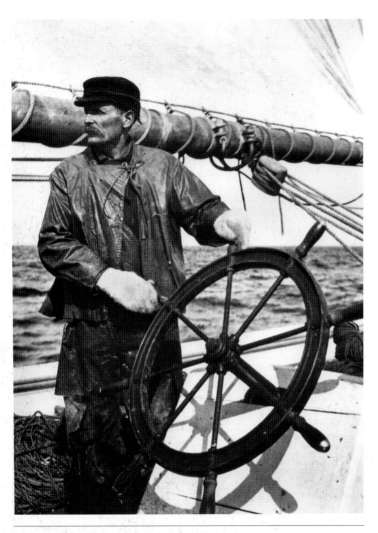

"Captain John D. Apt in his working rig at the wheel of the *Lutz*, May 1913." MMA WPA MP 10.54.4

Opposite: Dory mates from the *Albert J. Lutz* under-run trawl on Browns Bank, January 1915. The neighbouring dory is just visible in the distance. MMA WPA E 2

Shelburne, N.S., supervising her construction, selecting her spars, drafting her rigging and sail plans." Once completed, he kept the *Lutz* berthed at a wharf in front of his home at Port Wade on the Granville shore of the Annapolis Basin. It was here that Wallace joined him on 1 May 1913.

A halibut trip differed in a number of ways from a shacking trip to the home banks off southwest Nova Scotia. One was the distance and length of time involved. The best grounds for summer halibuting were on the distant Grand Banks or in the Gulf of St. Lawrence, a long haul from the port of Digby tucked away on the Bay of Fundy. Such trips consequently lasted one or two months. They were also risky, since finding halibut was an uncertain business. Fishermen could generally expect to come back from a shacking trip on the home banks with something. When looking for halibut, however, they gambled on the extremes of a "broker" or a "bonanza." Only "the best-heeled skippers" and "the most sporting-minded of crews" took the chance. Captain Apt was both well heeled and sporting minded. As for the crew, he had to cast his net more widely than his normal complement of Port Waders, many of whom preferred to spend the summer at home. To run eight dories, he found sixteen men from the Digby area, half of whom were middle-aged and had halibuting experience; the others were youngsters (one only sixteen) new to halibuting but not to dory longlining. In assigning dory mates, the captain paired a green hand with an old-timer. The captain, cook, and Wallace as spare hand made a total crew of nineteen. Their goal was the grounds off Anticosti Island in the Gulf of St. Lawrence, a destination with which Captain Apt was familiar from previous trips.

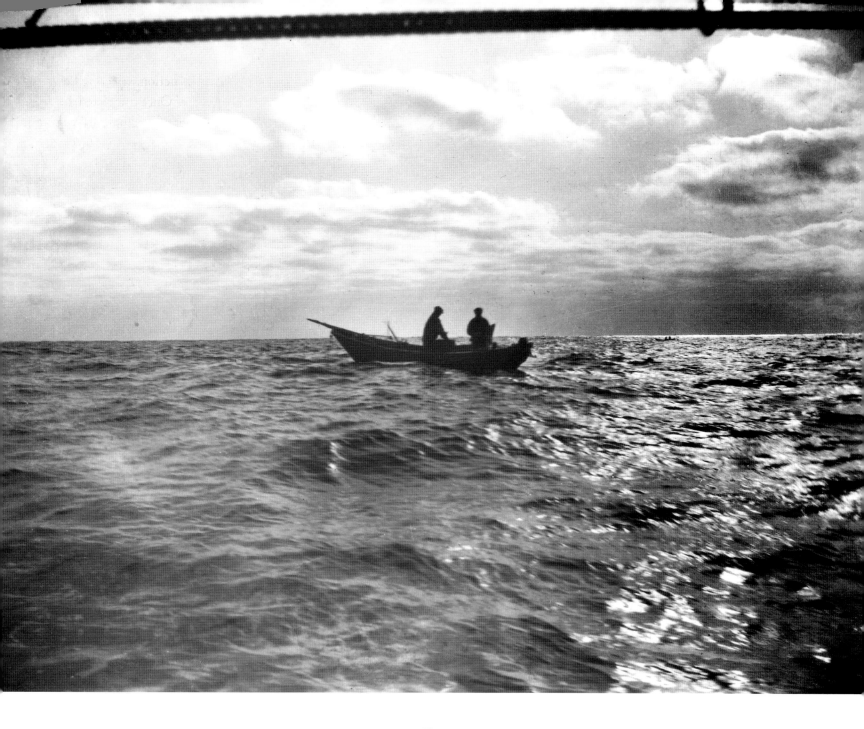

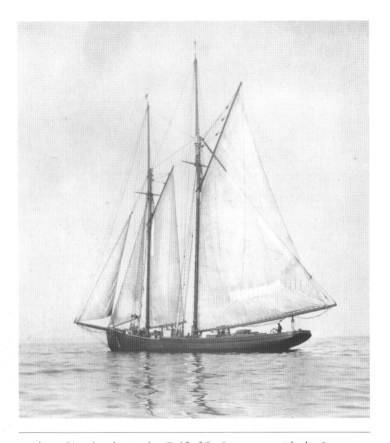

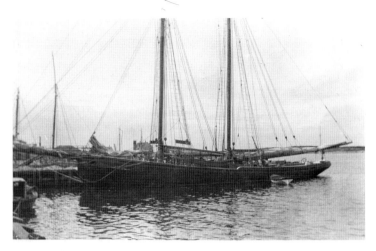

Above: "A calm day in the Gulf of St. Lawrence with the *Lutz* making little headway." The sail plan can be plainly seen: the mainsail hangs from the maingaff to mainboom, the foresail hangs from foregaff to foreboom, the jumbo hangs from the wire forestay to boom, and the "free-footed" — that is, without a boom — jib hangs from the wire jibstay. MMA WPA C 18

Right: The *Albert J. Lutz* in Canso harbour. MMA WPA C 14

The *Lutz* departed Digby on Saturday, 10 May 1913. It took the schooner four days to cover the 380 miles to Canso, the Maritime Fish Corporation's base in northeastern Nova Scotia. Here, Captain Apt was able to pick up thirty-three tons of ice in a few hours from modern freezers rather than wait days for slow delivery by country oxen as at Digby. Obtaining bait, however, was still a contest with other vessels to purchase from inshore boat fishermen, in this case located at the Magdalen Islands. The *Lutz* made its way through the Strait of Canso, only to be held up with more than a score of other schooners by adverse winds at Port Hawkesbury. Among those in harbour were the Boston schooner *Elsie* and the Lunenburg schooner *Delawana*, both of which would later participate in the International Fishermen's Trophy contests, the *Delawana* losing to the *Esperanto* in 1920 and the *Elsie* losing to the *Bluenose* in 1921. The small fleet set off on an impromptu race for the Magdalens and bait on the morning of Tuesday, 13 May. The *Lutz* out-distanced most of its rivals

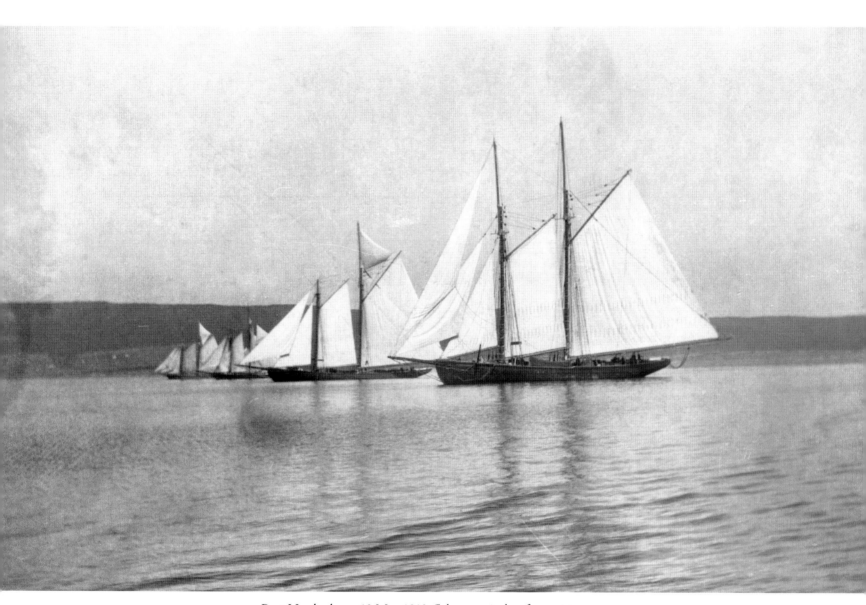

Port Hawkesbury, 13 May 1913. Schooners jockey for position as they set sail for the Magdalen Islands and bait. MMA WPA C 10

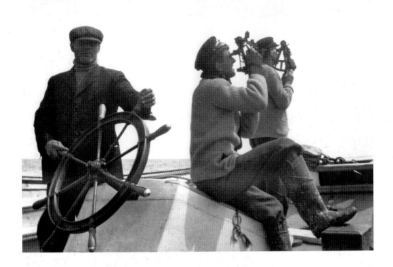

before night fell. It nevertheless took two days to find bait, and the schooner did not make Heath Point, at the eastern end of Anticosti Island, until Friday, 16 May. Here, calm winds gave Wallace and Captain Apt an opportunity to test their skills with a sextant.

At noon I got out my sextant, a good brass instrument with silver arc — it had been my father's — and took an observation for latitude. Captain Apt produced a venerable implement of ebony frame and ivory arc and "shot the sun." In working up the sight I proceeded to do so in the manner taught me by my shipmaster parent — adding or subtracting the various corrections for Dip, Refraction, Semi-diameter, Parallax and Index Error. John Apt, on the other hand, consulted a Belcher's Farmer's Almanac from which he got the sun's declination for the day; then, picking up a nail he scratched a few figures on the rusty pipe of the cabin stove. "Forty-eight fifty-three!" he announced briefly. "What do you make it?" "Forty-eight fifty-five," I answered. Then wondering how he ascertained the position so rapidly, I asked: "Say, Captain, what's this piece of stove-pipe mathematics you've been working?" "Oh, I just subtracted the altitude from eight-nine forty-eight and add the sun's declination for the day. That gives you the latitude right away. It has always worked out O.K. with me."

Now came the frustrating business of trying to catch the elusive halibut. The basic procedure was similar to that of a shacking trip: longline trawl was baited and laid from two-man dories. The size and tenacity of halibut, however, required that the groundline and gangens be made of heavier tarred cotton and the larger hooks of stronger Swedish steel. The gangens were also longer, almost six feet, and spaced twelve feet apart along the groundline instead of every two or three. As with regular shacking trawl, each shot was about 300 feet, or fifty fathoms, in length, and six or seven such shots were bent on to create a single line about 1,800 feet long with between 140 and 150 hooks. This line was so thick, however, that it could not be coiled into a tub; instead, it was placed on a "skate," a small painted square of canvas with a length of tying rope at each corner. In the relatively calm summer waters of the St. Lawrence, Captain Apt called for six such skates per dory,

Wallace and Captain Apt taking noon sights. MMA WPA C 5

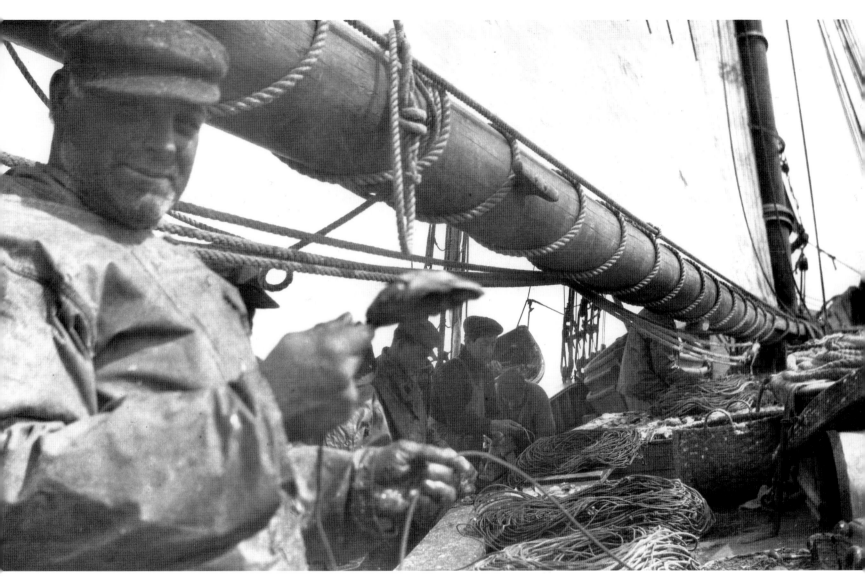

Ike Ellis baiting up halibut trawl. MMA WPA C 4

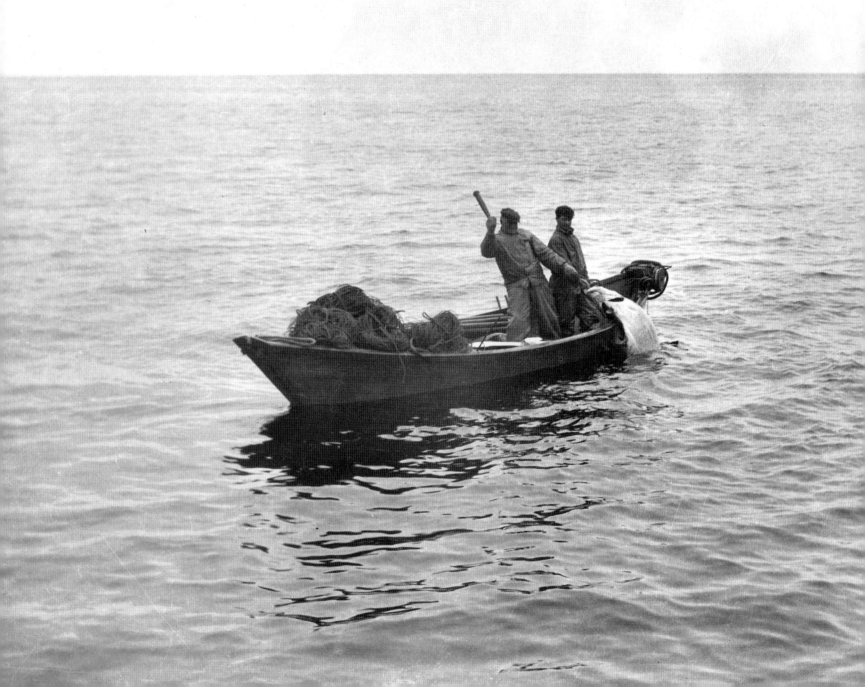

making a total length of about 10,800 feet of line and about 900 baited hooks. These were often left for whole mornings or afternoons, sometimes overnight, before being hauled back, all too often empty. For ten days the *Lutz* shifted back and forth from Heath Point at the eastern end of Anticosti to Ellis Bay at the western end, trying thirty-fathom depths inshore and up to a hundred fathoms offshore. On Sunday, 25 May, the crew made a set in forty fathoms: "Eight dories, sixteen men, 86,000 feet of line, 7,200 baited hooks, and the net result brought aboard for the Skipper to consider was eight codfish!" By 28 May, twenty-two days out of Digby, the total catch amounted to no more than 12,000 pounds of halibut and 22,000 pounds of cod for salting.

Above: Dragging a halibut into the dory. MMA WPA MP 10.55.13

Opposite: Ike and Elwood employ Wallace's priest to stun a halibut before boarding it. MMA WPA C 57

One bright spot in the middle of this dry spell was an eight-shot skate laid by cook Jerry Boudreau, still in apron and shoes, with Wallace as his dory mate. Their effort was met with some skepticism by the rest of the crew. To their insults, Jerry responded, "You guys don't know how to fish! So me 'n Fred's agoin' out to set a skate and show you how it's done!" After anchoring the trawl with an identifying buoy in the late afternoon, the pair left the line overnight. The next morning the odd dory mates returned to their line. They soon felt the halibut struggling below, resisting their efforts to haul up. The white flash of a 150-pound fish just below the surface her- alded Wallace's introduction to landing a halibut in a dory. While Jerry held the line, Wallace used a large, heavy wooden "priest" to stun their opponent. "It whirled around, thrashed and tugged frantically as my dory-mate hung on to the line like grim Death, and I pounded away savagely." With the fish eventually quieted, it was Wallace's job to employ a stout steel handhook to haul the halibut by the eye socket. The fish was far too heavy simply to hoist aboard. Instead, Wallace braced his feet on the gunwale and threw the weight of his body inboard, extending himself as he did so. "Canting the dory- gunnel until it was almost level with the water, we gave a heave and the great flat-fish slithered into the dory." Wallace then had to lash the fish's tail with rope to the thwart-strip in case it revived. "For a fighting fish can play hell in a dory — smack- ing thwarts and oars overboard, getting snarled up in the trawl, and almost knocking the fishermen into the water as they tried to pound it into blotto with the club."

With thirteen codfish to add to the tally, the unlikely duo returned to find a smiling skipper looking down at them from

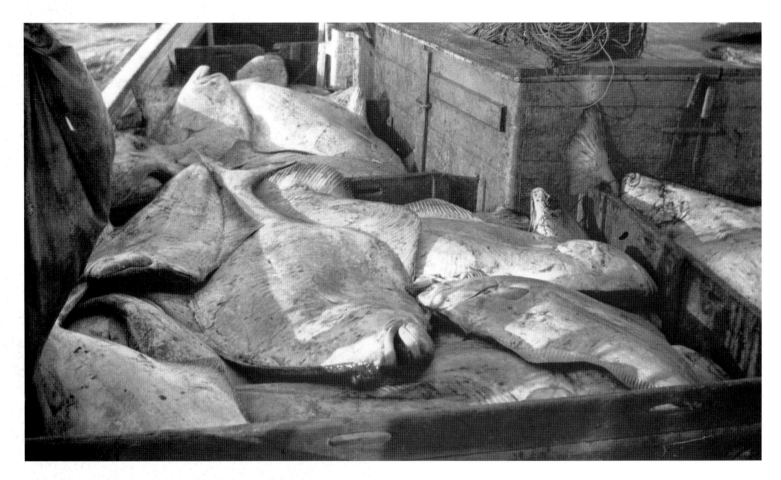

the schooner. "Well, boys, I think you are bringing us good luck." And so it proved over the next few days, as dory after dory was almost swamped with the weight of their catch, some towing large fish in the water behind them.

Success created its own problems on board. The halibut were too heavy to pitch up to the deck with a fork, and were instead hauled up by the spare hand (in most cases, Wallace) with the same body-straightening technique he'd used in the dory. In practice, with feet wedged on the rail, he fell back flat on the deck, using his body weight to drag the fish over the rail, usually to land on his chest. "Though I was oil-skinned and rubberbooted, it was a messy job hauling these big fish on top of oneself — covered as they were with black, gluey slime and sea-lice. With a lot of fish in the pens, one wallowed on one's back among them — like a hog in a mud-hole — as one hove them out of the dory and over the rail."

It did not help that the fish pens aboard the *Lutz* were designed for smaller groundfish such as haddock. The flat tails or side fins of the heavier halibut would frequently get under the lower edge of the pen-boards and lift them out of their slots, permitting a deck full of fish to slosh from the windward to leeward side of the deck with each roll of the vessel.

> Jerry and I, oiled up, were busy skidding around the deck with gaff hooks, hauling the weighty halibut about and re-stowing them. No sooner would we have everything set to rights, when the schooner would take a wild roll, dipping her rail under, and away would go half our fish into the lee scuppers and threatening to slide overboard. Then commenced the job again of lugging the heavy brutes of flat-fish across the deck and up into the weatherside pens.

It was exhausting work that pushed Wallace to the limits of his endurance.

On 6 June, after a month away from Digby, Captain Apt was sufficiently satisfied with the catch to turn for Canso.

Right: Wallace strains to control the weight of a large halibut snared by a steel hook through its eye socket; a younger member of the crew, up to his waist in fish, looks on. MMA WPA C 16

Opposite: The fish-pens of the *Albert J. Lutz* were designed for smaller, rounder fish such as haddock, and could not hold the heavy flat halibut when the schooner rolled. The fish are turned bottom up to prevent the blood seeping through the flesh and discolouring the white skin. MMA WPA C 15

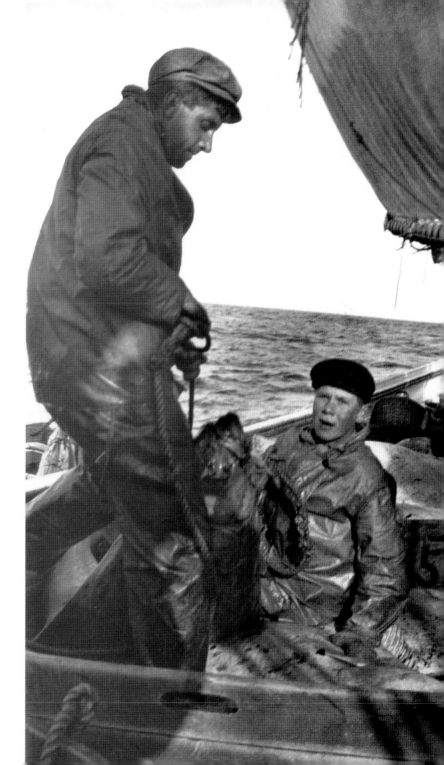

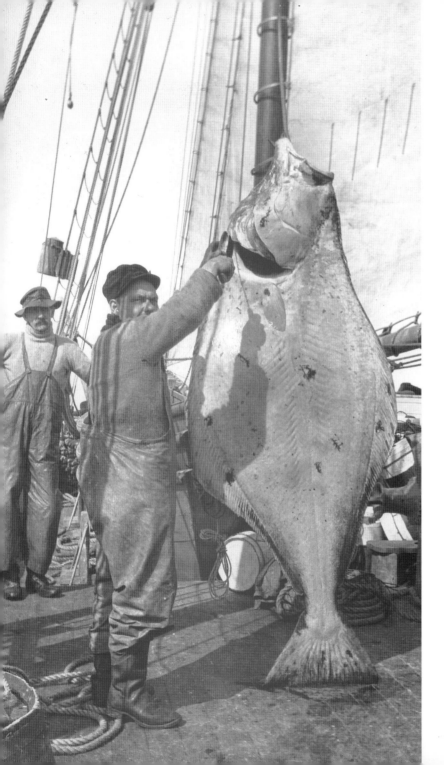

Halibut, being less watery and more firmly fleshed than other fish, could last longer on ice in the hold, but time was now running out. This made it all the more frustrating to find themselves becalmed on 9 June off the Judique Highlands on the west coast of Cape Breton. Wallace went ashore at Mulgrave to telegraph the Maritime Fish Corporation manager at Canso to send out the company's steam freighter *Inverness* to tow the *Lutz* to port. When the manager heard that the fish pens were full, he sent the steamer straightaway. When weighed off at Canso, the *Lutz* was found to have taken 81,000 pounds of fresh halibut and 15,000 pounds of fresh and 12,000 pounds of salt cod. This was the biggest trip of halibut by a Canadian schooner on the Atlantic coast to that date. (Some American schooners specializing in halibut had landed larger fares in Boston.) Each member of the crew earned $138 for the trip. Jerry Boudreau earned even more, for, in addition to his wages as cook, he also took home the earnings of his occasional sets with Wallace, who, as usual, refused to take a share or wage. If Wallace was to make but one trip halibuting, he had an experience of which to boast.

Left: Halibut taken by the *Albert J. Lutz* on the Anticosti grounds usually weighed between eighty and 100 pounds. A few were more than 200 pounds; this one weighed more than 300. Such fish were, however, too big to produce a marketable steak or cutlet, normally obtained by cutting the fish laterally across the body. MMA WPA C 17

Opposite: Wallace strikes a pose aboard the *Dorothy M. Smart*, March 1912. He frequently used this photograph to accompany his stories, with captions emphasizing that he spoke with the "authority of experience." MMA WPA BE 2

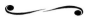

By the summer of 1913, Frederick William Wallace had made four fishing voyages aboard the banks schooners of Digby. These trips opened a window on a world few Canadians experienced or understood, unlike farming, lumbering, or even trapping. Wallace was one of a handful of writers and journalists who could speak of the fisheries from first-hand observation. Even more unusual, he had the photographs, drawings, and sketches with which to illustrate his accounts. And he had the talent to tell engaging stories and describe complex skills simply and clearly. He now found his footing as a freelance journalist, easily able to place his work in *Canadian Century, Saturday Night, Outing Magazine, Yachting,* and other journals. He also continued to write fiction, placing short stories in such men's magazines as *Adventure,* only now the stories were based on his own experiences, not his father's. He was now earning enough to continue his adventures. "I was doing fairly well in freelance work and making enough to help maintain the old home and mother, and was having a lot of fun besides. I had visions of writing novels and histories of seafaring, and wanted to be free to shove off at any time for a trip on salt water. Though I was then twenty-seven, I had no thought of getting married or of being shackled to a regular nine-to-five job." He now had not only the work he'd longed for but also the life.

Wallace's enthusiasm, knowledge, talent, and genuine admiration for those engaged in the fishery recommended him to the owners who sat in the boardrooms of Montreal and Toronto. He had already made the acquaintance of Maritime

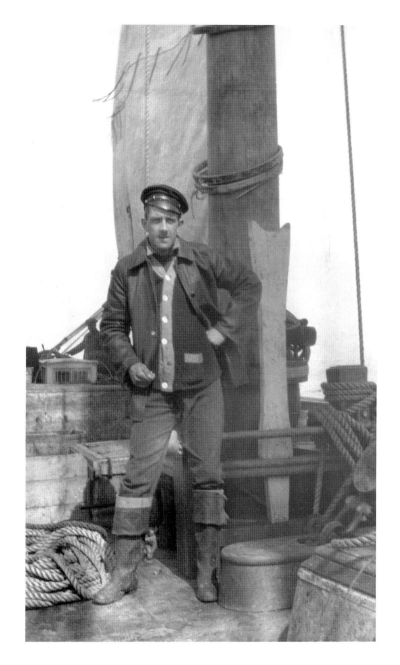

Mechanization

The schooners on which Wallace made his voyages used only sails, but mechanization was already underway. True, the use of auxiliary power in the banks fishing fleet was relatively rare. Gasoline-powered engines first appeared in schooners in the early 1890s, but they were expensive, temperamental, and often ill adjusted to schooner designs, and gasoline was dangerous to carry. Only when lightweight diesel engines were introduced in the second decade of the twentieth century did auxiliary power become cost effective, more reliable, and less hazardous.

Wallace first encountered an auxiliary-powered schooner, the American *Bay State*, on its maiden voyage, when the *Albert J. Lutz* stopped at Canso for ice in May 1913. The *Bay State*'s captain, Norman Ross, reported some trouble adapting to the engine. On the trip up from Boston, the vessel nearly ran aground because the exhaust pipe was fitted too close to the compass and caused an error of several degrees. Ross was nevertheless happy to show off what his twin Blanchard heavy-oil power plants could do, and invited Wallace and Captain John Apt of the *Lutz* aboard to witness the *Bay State* haul anchor and use the engine to manoeuvre out of the harbour. Unfortunately, he could treat his guests only to a series of muffled explosions, smoke, and a few coughs before the engine went silent. As the engineer offered excuses, the *Bay State* began to drift toward neighbouring craft. Ross lost his temper, "'Dam' and blast you and your

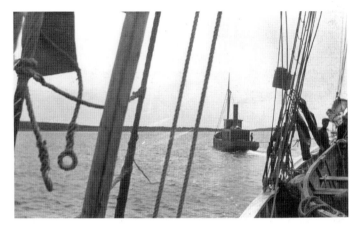

jeesly blank blank engine! I'll take her out under sail!" As they pulled away in the dory, Apt remarked dryly to Wallace, "They ain't got them diesel engines perfect yet."

The laughing companions pulling away from the *Bay State* probably realized that mechanization, not just in the form of schooner engines but of other aspects of the fishing industry, was a fact of life. Digby developed as a fishing community in large measure because the combination of fast and efficient transportation by rail and steamer permitted the marketing of its products, particularly fresh fish. The *Lutz* itself had just benefited from the new freezer at Canso that supplied ice in moments rather than the days. Every port, including Digby, used powered craft as tugs to ease schooners in and out of crowded harbours or push them out into the wind. Furthermore, gasoline-powered motorboats for use in the

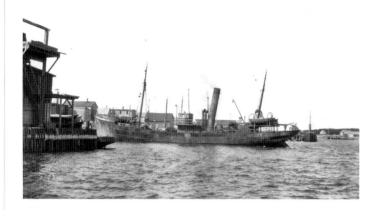

inshore fishery in and around Digby were common; the *Lutz* had one on board for the trip to the Gulf of St. Lawrence. Captain Apt fixed a one-cylinder, three-horsepower gasoline engine to the side of a dory to ferry or tow other dories when on the fishing grounds, a task at which it was remarkably successful. The motorized dory was once even used to pull the *Lutz*, at three miles an hour, when the schooner was becalmed off the Judique Highlands of Cape Breton.

Captain Apt recognized that banks fishing schooners would soon make the transition to auxiliary power and, in time, be replaced by fully motorized vessels. As early as 1897, A.N. Whitman and Son of Canso acquired the wooden steam trawler *Active* from Aberdeen, Scotland. This vessel and several others purchased from Britain over the next decade rarely proved able to handle the waters off Nova Scotia, especially in the winter. It was not until 1911 that the Maritime Fish Corporation introduced the first modern steam trawler, the *Cambodia*, and set it to work out

of Canso. The following year, three more were purchased from Britain. Despite bitter opposition from hook-and-line-fishermen, labour shortages and rising fish prices after the outbreak of the First World War made the steam trawler an important alternative. Wallace made his first voyage aboard such a trawler in March 1917, joining the Maritime Fish Corporation's *Rayon d'Or* at Canso. Built in 1912 in Britain for long-distance fishing off Iceland, the *Rayon d'Or* proved more than capable of handling winter conditions off Nova Scotia. In his seven voyages, Wallace had indeed caught the last age of unassisted sail.

Opposite: The *Albert J. Lutz* taken in tow by the Canso tug *Inverness*. MMA WPA C 37

Above, left: The steam trawler *Rayon d'Or* at Canso, March 1917. MMA WPA I 4

Above, right: A motorized dory speeding by the *Albert J. Lutz*. MMA WPA C 32

Fish's Alfred H. Brittain; later, he would meet the likes of Fred T. James of F.T. James Fish in Toronto, Arthur Boutilier of North Atlantic Fisheries in Halifax, and Fred Hayward from British Columbia. Wallace also became familiar with the Superintendent of Fisheries in Ottawa, William A. Found. "He had read some of my articles and was very cooperative whenever I approached him for information. This friendly interest was much to his credit, for in those days Ottawa officials were suspicious and 'cagey' in their attitude towards journalists and apprehensive of being made the subject of political attack."

Unknown to Wallace, these industry movers and shakers had recommended him to J.J. Harpell, owner of Industrial and Educational Press, Limited, whose publications included *Pulp and Paper Magazine*, *Canadian Mining Journal*, and *Canadian Miller* and *Grain Elevator*. Harpell wanted to launch a journal on Canada's fishing industry similar to *Fishing Gazette* in the United States, and he was looking for an editor to run the operation. In August 1913, he approached Wallace at the Maritime Fish Corporation booth at the Canadian National Exhibition in Toronto with the proposition. Wallace demurred. He was happy with the freedom that freelance journalism offered and didn't want to become an industry mouthpiece.

> I had no mind to switch too readily into the role of a propagandist for the fish trade. My main interest in fisheries was centred in the vessels and fishermen; the adventurous colourful background of the sea and ships and the material it provided in my chosen field. And I had no intention of giving that up for industrial promotion, technical education, and similar, what I considered, drab subjects aligned with trade journalism.

Harpell overcame Wallace's objections by the simple expedient of agreeing with him. Wallace would have complete editorial freedom, and he would be free to come and go as he pleased so long as the journal made its monthly deadline. Indeed, Harpell stressed that editorship of such a journal would justify and pay for the very kind of seafaring travel Wallace loved. Won over, Wallace spent the autumn of 1913 touring the fishing communities of the Maritimes, drumming up support for the magazine. Many people told him it couldn't be done or wouldn't last, but that was just the sort of challenge Wallace enjoyed. The fact that he had been to sea, knew captains and crew, and had fallen out of his berth in the early hours of a morning to reef sail or bait trawl was a major advantage in overcoming doubters.

The first issue of *Canadian Fisherman* appeared in January 1914, published from the Read Building in downtown Montreal. It was forty-four pages long, with six pages of advertisements, and featured the first of a three-part series by Wallace on his recent trip on the *Albert J. Lutz*, entitled "The Log of a High Line Halibuter," with "photographs by the author." The journal was almost immediately successful and played an instrumental role in generating interest in the formation of a Canadian Fisheries Association in February 1915, with Wallace elected Secretary-Treasurer. Wallace's subsequent experiences on Atlantic schooners were as an insider, a member of the business, no longer a vaguely eccentric "city feller."

Chapter Three
SAILING

Under time-honoured agreements, whether written or assumed, owners provided vessels that were well built and well maintained, while fishermen sailed the schooners and caught fish. Fishermen typically also carried the costs of victualling, ice, salt, bait, and wages for the cooks and spare hands. Time wasted, whether waiting for ice or laying trawl on a barren ground, was an expense for owners and fishermen alike. When a schooner was over fish, skippers were tempted to put the dories out and keep them out until the men's limits had been reached, and sometimes beyond. Once the holds were full, the need to keep the fish fresh meant pressing vessels to the brink of their capabilities to get the catch to market quickly.

In this masculine world of work, questions and complaints were suppressed, humour and endurance encouraged. Captains and crews bragged of the risks taken and overcome, the dangers barely survived, the runs to port in the teeth of adverse conditions. In defying their mortality, a few staked out a claim to immortality within their community. The names of such men and their vessels are still spoken of with respect in the literature of the banks fishery and in the halls of museums. But the risks fishermen and their captains ran were often imprudent and occasionally reckless, and luck was not always on their side.

The owners of the vessels on which Frederick William Wallace made his seven banks voyages were uniformly proud of their craft and maintained them well, in some cases superlatively so. And he was lucky: on none of his trips was a crewmember injured or lost. John Apt and Harry Ross had each already lost a vessel at sea, and at least seven of Wallace's crewmates would die on the banks, four in 1912 and three in 1919. A fine line existed between a voyage of adventure and one of tragedy. Trips aboard the *Effie M. Morrissey* with Captain Harry Ross in December 1912 and the *Dorothy G. Snow* with Captain Ansel Snow in March 1916 opened Wallace's eyes to the routine dangers of the banks fishery.

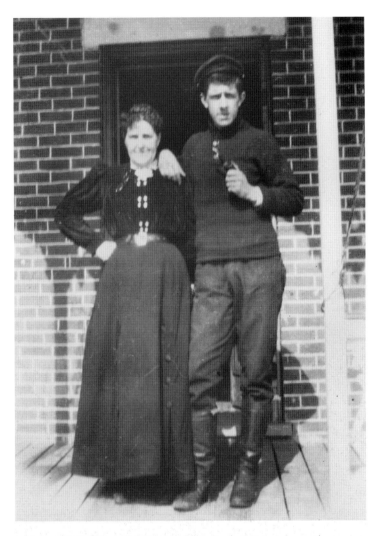

Frederick William Wallace and his mother, Frances, on the front porch of the family home at Hudson, Quebec, about 1911. Out from behind his desk, Wallace loved playing the role of the hard-bitten fisherman. Frances had had a lifetime of saying goodbye to the men of the household on their way to sea. MMA WPA MP 400.234.8

On 9 December 1912, two days before his twenty-sixth birthday, Wallace received a telegram from Captain Harry Ross inviting him to join the *Effie M. Morrissey* on a trip to the banks out of Portland, Maine. He was on a train east that evening. The immediate incentive was the mutual friendship established between the two men the previous summer aboard the *Dorothy M. Smart*. Ross clearly enjoyed the company and attention of the journalist determined to prove himself at sea, and Wallace admired the drive and ambition of the skipper determined to break into the ranks of the great captains. As an added attraction, the invitation offered Wallace an opportunity for a first-hand look at the New England fishery that so intimately involved the fishermen of Nova Scotia.

New England's large markets were crucial to the success of the offshore fishery of southwestern Nova Scotia. Access to these markets had been restricted in 1885 when the US government terminated the fishery clauses of the 1871 Treaty of Washington. In response, some Nova Scotia fishermen shipped as crew on American fishing schooners; numbers are hard to come by, but according to one dismal statistic more than half the fishermen lost at sea out of Gloucester, Massachusetts, in the 1890s were Canadian. Another response, made possible by *modus vivendi* privileges granted to the United States by Great Britain in 1888, was for Nova Scotians to purchase and operate US-registered schooners. In return for the payment of a modest licence fee, vessels registered in the United States could fit out, purchase supplies and bait, and ship crews from Canadian ports. As long as the schooners retained their US registry, they were permitted to land their catches in the United States duty free. Together, these strategies siphoned off

some of the best of Nova Scotia's captains and crews. What for many began as a seasonal or temporary line of work ultimately led to permanent migration.

The *Effie M. Morrissey* was one of a small number of American vessels owned by the fishing community of Digby. Designed by Captain George Melville McClain and built in 1894 at the James Tarr Yard of Essex, Massachusetts, for the large family firm of John F. Wonson Company of Gloucester, reputedly at a cost of $16,000, the *Morrissey* was named after the daughter of her first captain, William E. Morrissey. The vessel spent its first decade variously salt banking, seining, and handlining out of New England under a succession of famous skippers, including William's son, Captain Clayton Morrissey, who would race the *Henry Ford* against Angus Walters and the *Bluenose* in 1922.

In the spring of 1905, the Wonsons sold off all their seventeen schooners and dockside assets, and Captain Ansel Snow of Digby purchased the *Morrissey*. In 1909, Ansel sold the *Morrissey* to his brother-in-law, Frank Swett, of Marblehead, Massachusetts, who mortgaged it back to Ansel's older brother, Captain John Worster Snow. This paper shell game among family members did not interrupt Ansel's continuing command of the vessel. Typically, the *Morrissey* received a refitting and painting in June for a summer of salt banking, shift to winter rig in October for longline trawling, lie up from Christmas

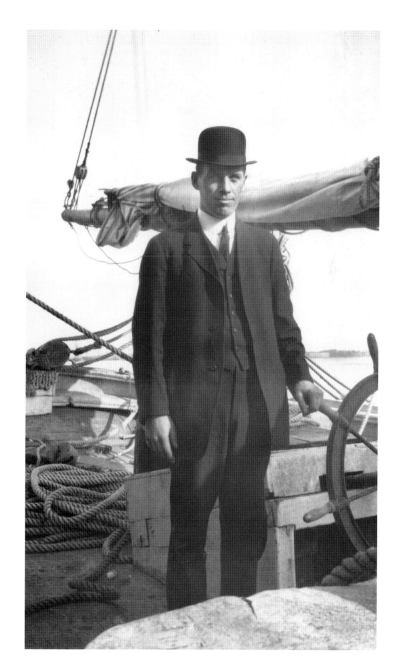

Right: Captain Harry Ross, in his best shore rig, stands beside the wheel-box of the *Dorothy M. Smart*, August 1911. When dealing with wholesalers and suppliers or simply walking the town, captains of the day dressed as the capable businessmen they were. MMA WPA B 11

to April, and finish with a spring round of longline trawling. This cycle of maintenance was all cash for the Digby area, and the *Digby Weekly Courier* directed pointed criticism at Ansel when he chose to lay up the *Morrissey* in Yarmouth for the winter of 1909-1910. Ansel gave up command of the *Morrissey* only when his family launched the more modern *Dorothy G. Snow* in August 1911. Harry Ross saw the opening, purchased an interest in the *Morrissey*, and took mastership in the spring of 1912, bringing along with him most of his crew from the *Dorothy M. Smart*.

Thus it was that Wallace, fresh from the Montreal–Portland train, found Ross aboard a tough looking vessel at Trefethen's Wharf early on the morning of 10 December. In winter rig, the "old plug of a vessel" showed all of its eighteen years of fishing: paintwork had vanished, rails and houses were scared, and the decks littered with everything from the cook's kindling to sacking and broken boxes. More than the wear and tear, the overall design of the *Morrissey* betrayed its age. The sharp bow supporting a long bowsprit and the mainboom projecting well over the stern taffrail were distinctive features of the clipper models of the 1880s and early 1890s. The great length of the spars was required to support a massive expanse of sail — in the case of the *Morrissey*, 8,323 square feet of canvas when the topmasts were in place. A long straight run of keel below the water line offered generous room for large catches of salt fish. Every plank and timber of the vessel's 120 gross tons was American oak, and the joints were of iron.

Though of dated design, the *Morrissey* and those like it were fast and powerful with the wind off the stern quarters. Sailing into the wind was another matter. The sharp bow was unresponsive in tacking, sometimes requiring a minute or more to bring the head from port to starboard or vice versa. The ship also had a tendency to plunge or "pitch pole" forward deep into the troughs of high seas, then rear up, exposing the keel as far as the base of the foremast. More disturbing was the danger of dealing with sails from the extensions of bowsprit and mainboom over the bow and stern. At the water line, the *Morrissey* was ninety-two feet long; the open deck was slightly longer at 106 feet. The sparred length was a staggering 152 feet. This meant that forty-six feet of bowsprit and mainboom had to be worked by men suspended in air over water, or under water if the vessel plunged. It was to remedy these deficiencies that Boston's Thomas F. McManus had designed the more modern round-bowed, long-decked, short-sparred, and raked-keeled classes of Indian Headers and semi-knockabouts, the models for the *Albert J. Lutz*, *Dorothy M. Smart*, and *Dorothy G. Snow*. Wallace's voyage aboard the *Morrissey* proved a seminar on the strengths and weaknesses of the clipper design.

The *Morrissey*'s crew were, if anything, in worse shape than the vessel. Portland's barbershops, poolrooms, taverns, and "other spots less respectable" offered an array of temptations to young men away from home with money in their pockets. The few who had made it back to the schooner by morning had established themselves in the cabin with a cylinder phonograph and several "long-necks" of rum. Those still unaccounted for had to be winkled out of their holes by the skipper. Ross asked Wallace along for company and to watch his back. Together they forced their way through a buffer of hangers-on determined to keep the bluenose fishermen captive until their pockets were empty. The crewmen, once located,

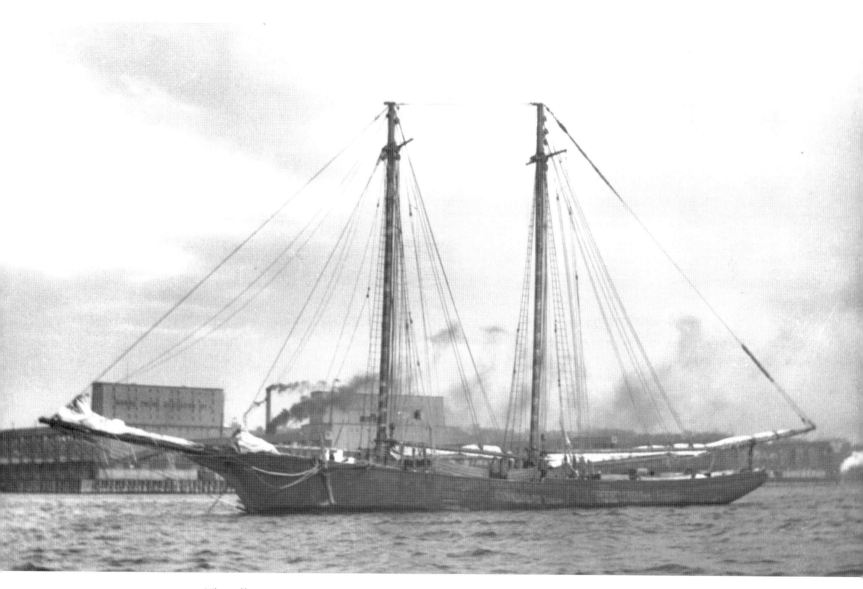

The *Effie M. Morrissey*, "an old plug of a vessel," in Portland harbour, December 1912. In winter rig with topmasts down and battered by eighteen years at sea, the clipper-bowed *Morrissey* was still an impressive sight. MMA WPA B 8

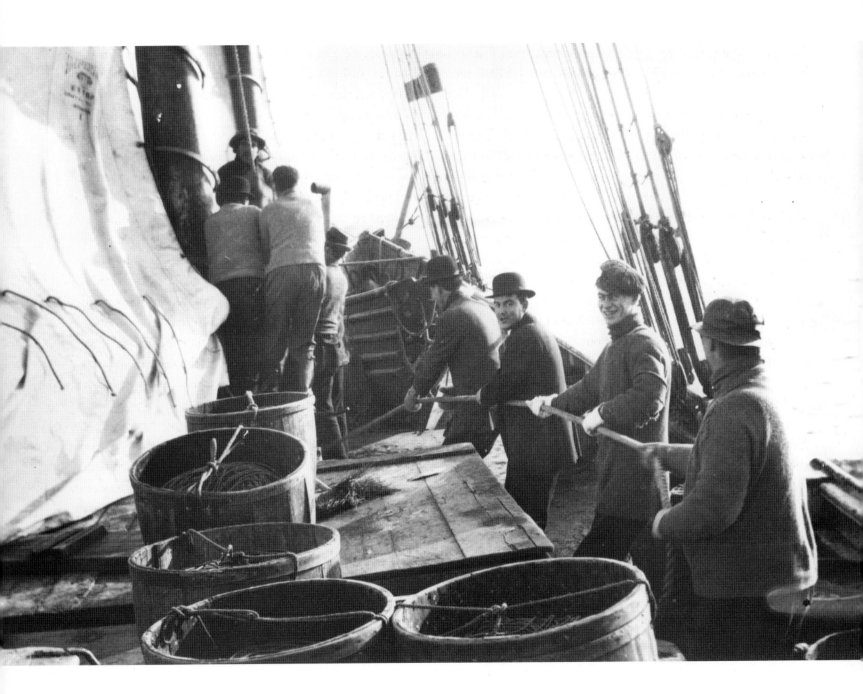

had then to be coaxed and cajoled out into the cold. The sobering threat of being left in Portland was enough to sway the last recalcitrant.

Not until after eleven was the gang of twenty-four, including Wallace, safely aboard the *Morrissey*. Captain Ross then wasted no time in getting underway and putting some distance between his men and the temptations of Portland. It was not, however, a pretty sight. After a small tug made fast alongside to shove the *Morrissey* from her berth, Ross called the crew to set sail. Some had changed to sea clothes, others remained clad in derby hats and starched shirts; all were in what Wallace describes as "great good humour." Their efforts to raise the mainsail and set the foresail, jumbo, and jib were embarrassing and greeted with laughter from the loafers dockside. Once clear of harbour traffic, Ross stood out through Peaks Island channel, and the men went below to resume their celebrations.

The morning was bright and cold, with a sharp breeze out of the southwest. As the *Morrissey* cleared the shelter of Cape Elizabeth around noon, the sails picked up the full weight of the wind over the starboard quarter. Heading east by south for the Lurcher Lightship off Yarmouth and the fishing grounds, conditions were right for McClain's clipper design to show its stuff. "I cal'late we'll wash her down," drawled Ross to Wallace, the two now alone on deck. "We'll make this old toothpick travel and show what she can do." The slight swell that initially ran behind the vessel now rose into a steep, breaking sea, crests flashing white in the glare of the noonday sun. The skipper eased the sails out over the port quarter to catch the full blast of the southwest wind, "every sail drawing so that a sledge-hammer would bounce off the canvas." A tremendous bow-wave arose and boiled aft around the widening hull only to clash with oncoming sea at the stern. The lee scuppers were occasionally awash, and the shore debris that had littered the deck was gone, including the cook's kindling. The *Morrissey* raced past Seguin Island, a distance of twenty miles, in an hour and a half, and past Monhegan Island in another twenty miles and another hour and a half. In the squalls, the taffrail log registered speeds of up to fifteen knots.

Despite the continuing party, the crew in the cabin and forecastle recognized that something extraordinary was going on outside. The occasional inquisitive head poked up the gangway to be met with a face full of sea and the jibes of the skipper. Challenged, one by one the men came up on deck to witness the *Morrissey* in full flight before the wind. The more reckless demanded their turn at the wheel. With an audience forming, Wallace had a stroke of photographic genius.

Opposite: Crewmen, some still in shore clothes of bowler hat and starched collar, others in sea woolens, set the mainsail, possibly aboard the *Effie M. Morrissey*, 10 December 1912. The four men at the base of the mainmast haul down on the maingaff throat halyard, the rope controlling the mast end of the maingaff. The chain of four others takes up the slack. In the foreground, unbaited tubs of trawl lie atop the baiting boards covering the gurry-kid. MMA WPA MP 10.55.22

It was an inspiring sight and I jumped below
to get my camera. It was just a cheap little box-
form type. To the Skipper I said: "I want to
take some pictures from the end of the bowsprit

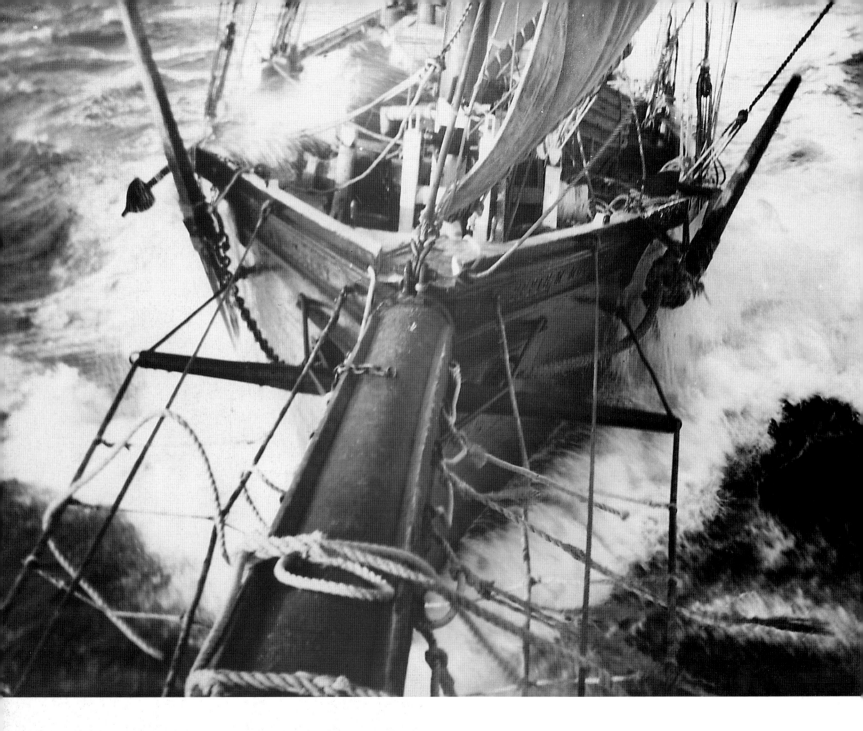

while she's going like this. Will you come out with me and hold me while I snap the photos?"

"Sure thing," he replied, and to the wheelsman he said: "Watch her now and don't let here be any funny business while we're out there!" The man stared at us with astonishment on his features. Taking a firm grip on the spokes, he nodded; "I'll watch her, Skipper!"

With oilskins and rubber boots on, we went over the bows and clambered out along the foot ropes of the *Morrissey's* lengthy bowsprit. Below our feet, the stem was shearing and ploughing the blue-green sea into a mass of glittering, thundering foam. From our perch, we could feel the vessel trembling throughout her hard-driven hull. And when she topped a big comber, we hung like bats to the jack-stay and caught our breaths as she swooped down into the sea with the suds boiling up and through the hawse pipes.

The Skipper grabbed the jib-stay and pulled himself up to stand on the extreme end of the bowsprit. I got up next and he held me around the waist in order that I might have my two hands free to handle the camera. I got one snap, when the helmsman let her come-to a little. The *Morrissey* listed to port and laid her whole lee side down. "The crazy scut!" growled Harry as we lurched precariously to leeward. But animated with the recklessness of the seeker after something novel, I made two snaps as she careened. "Did you get it, Fred?"

Opposite and right: The *Effie M. Morrissey* doing sixteen knots.
MMA WPA B 1, B3, B 4

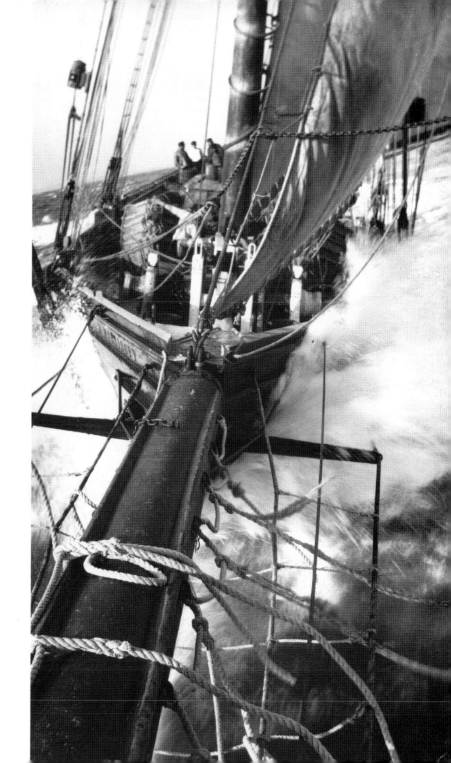

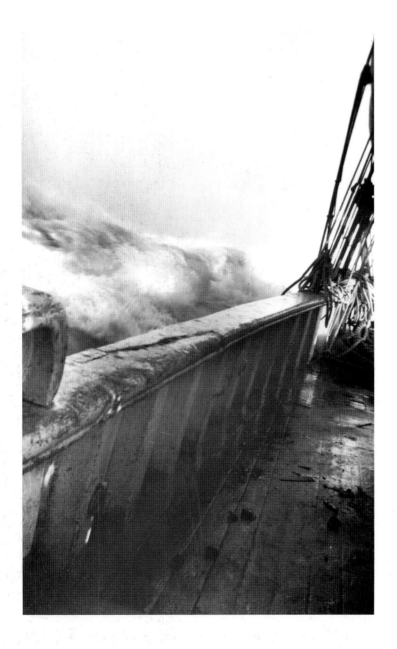

inquired Ross excitedly. "I sure did," was my reply. "Then let's get to hell out of this," he said hurriedly, "afore we get run under!"

We came in over the bows, drenched in salt water as she smashed into a comber. Aft we came to meet an audience who had been watching our efforts — called by the wheelsman who considered that both of us had taken leave of our senses. However, I got the pictures I wanted and they came out fairly clear under the circumstances.

Wallace was lucky to capture the moment when he did, for the wind out of the southwest immediately grew stronger still. Massive seas welled up behind the *Morrissey*, and dangerous combers swept around and then over the stern. Such was the force of the following sea that the over-driven schooner "began to look at her wake." The wheelsman, constantly braced to withstand the occasional burst of wave upon his back, found it harder and harder to control the vessel. The wind pressed the mainsail well out to port, where the mainboom frequently struck the cresting sea, arced under the pressure, and fell back, threatening to jibe, or swing out to windward. After two or three men refused a turn, the wheelsman called out "Hey, Skipper, Take this blame' wheel." Ross, affecting nonchalance, emerged from the cabin to investigate the patent log on the taffrail. Reading the dial, he shouted, "She's logged nigh sixteen this last hour. Who said the *Morrissey* couldn't sail."

Left and opposite: "Off Monhegan, Big Seas." MMA WPA B 5, B 2

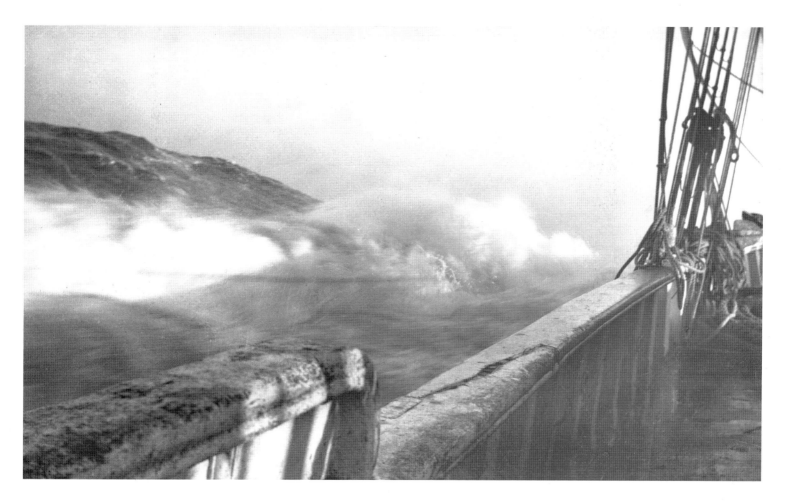

Having proved the point, Captain Ross ordered the mainsail and jib taken in. This was, however, past the point of prudence. Lowering the mainsail in a rolling and plunging sea is a difficult job when sober; it was a dangerous one in the condition of the *Morrissey*'s crowd. The crew hauled the mainboom aboard and set it in the wooden boom-crotch to hold it fast, but in the process lost control of the mainsail itself. The maingaff throat halyard slipped from their grasp, and no one had taken hold of the peak halyard downhaul, the two lines that controlled the upper spar from which the mainsail hung. As soon as the mainsail went slack, the maingaff swung violently back and forth high above the deck, "fetching up against the lee rigging with blows that shook the mast." Most of the sail collapsed in the sea over the port quarter, where it filled

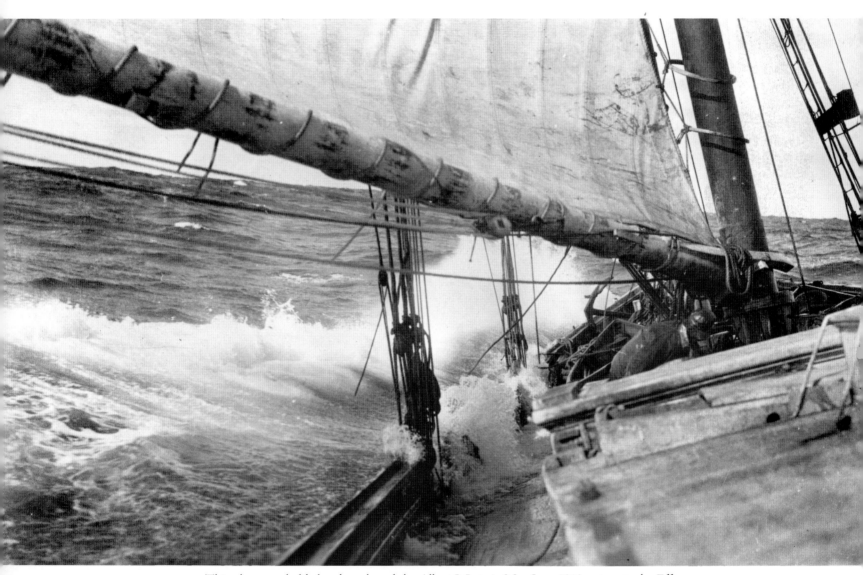

This photograph, likely taken aboard the *Albert J. Lutz* in May-June 1913, captures the *Effie M. Morrissey*'s situation on 10 December 1912. The mainsheets ease the boom out to port to catch the full force of a southwest wind coming in from the starboard. At this angle, the end of the mainboom risked striking the rising sea. MMA WPA MP 10.54.15

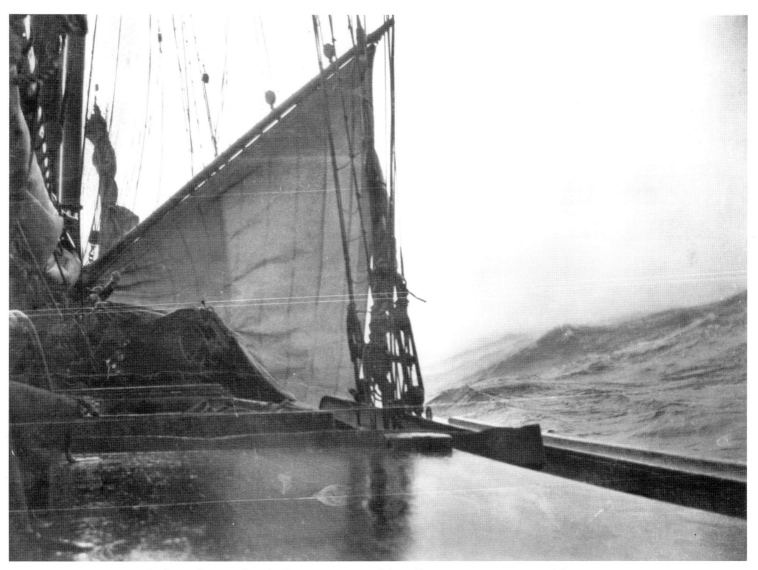

The foregaff jammed in the foremast rigging of the *Albert J. Lutz*, January 1915. This image gives a good sense of the difficulty the *Effie M. Morrissey* crew faced when they lost control of the much longer maingaff on 10 December 1912. MMA WPA MP 10.54.13

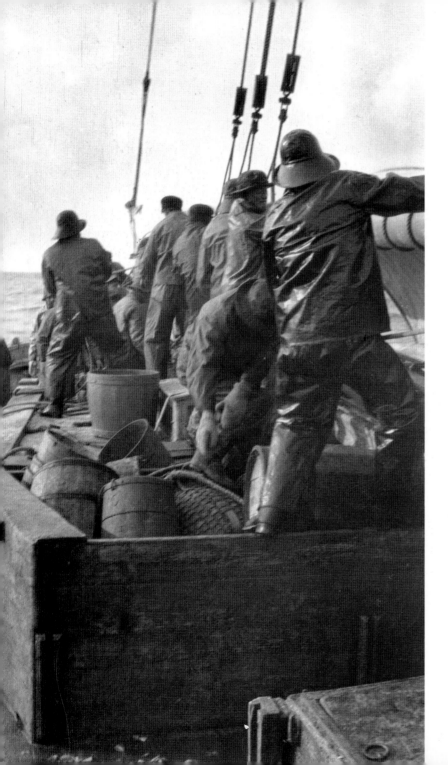

with water. Two men clambered eighty feet aloft to try and clear the spar, but the sight of the non-too-sober duo swaying above caused Ross to order them down. Thereafter it took all the strength and skill of twenty-two men to master the situation, pulling the sail aboard and beating the wind out of it. "But it was finally accomplished to the accompaniment of the Skipper's biting sarcasm and much lurid cursing on the part of the gang."

With the jib triced up and the mainsail finally made fast, the *Morrissey* raced on into the gathering darkness under foresail and jumbo. The crew retreated to the safety of the forecastle and cabin, to play cards, smoke, and sing. The overworked phonograph, held fast on the locker by two pairs of hands, played tunes by the likes of Ada Jones and Len Spencer:

> When I walk — I always walk with Billy,
> 'Cause Billy knows just where tew walk!

Meanwhile, on the deck outside, two watchmen, one steering and the other on lookout, stood their hour before exchanging with others for the comfort below.

Left: Stumbling for footholds atop the gurry-kid and cabin, the crew beat the wind out of the mainsail. MMA WPA B 23

Opposite: Stowing the mainsail outboard the stern taffrail, likely aboard the *Dorothy G. Snow* in March 1914, but capturing the situation on the *Effie M. Morrissey* on 10 December 1912. The enormous weight of the mainboom is carried by the topping-lift, the wire line running from the outer tip of the mainboom to the mainmast head, and lateral movement is restricted by the preventer chains and mainsheet blocks fixed to the rail behind the crew. MMA WPA B 22

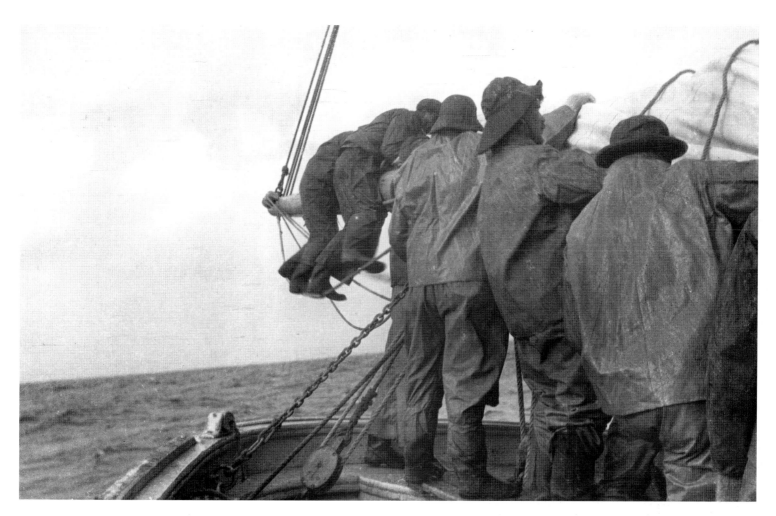

As the evening wore on, the winds worsened to gale force and the seas rose further. Waves now broke with such regularity over the stern quarters that the wheelsman tied a rope around his waist and was often submerged to his hips in water. His partner kept watch standing atop the cabin house with an arm through the stops of the furled mainsail. About midnight, the sea swept entirely over the cabin, ripping a leg out of the wheelsman's oilskins and smashing a dory in one of the nests of five forward. In response, Ross and Wallace ventured out and together stowed the jumbo, leaving the *Morrissey* to continue under foresail only. In this fashion, they passed the Lurcher Lightship at four in the morning. The skipper, finally accept-

ing that wisdom was the better part of valour, pressed on for the safety of Yarmouth harbour rather than wait out the storm atop the fishing grounds. At first light, the *Morrissey* rounded Cape Forchu and Cat Rock on the breast of an enormous swell, and at 7:30 a.m. dropped anchor in smooth harbour water amid a fleet of fishing schooners.

The *Morrissey* had covered the two hundred miles from Portland dockside to Yarmouth anchor in twenty hours, an average of ten miles an hour. It had been under all four lower sails (mainsail, foresail, jumbo, and jib) for only four hours, under foresail and jumbo for eight and a half, and only under foresail for seven and a half. Allowing for the time spent working out of Portland and into Yarmouth, the *Morrissey* had clearly been racing, reaching speeds of fifteen and sixteen knots during the last hour with the mainsail up. With southwest winds off the starboard quarter and a following sea, conditions had been right to demonstrate the speed inherent in the clipper-bow design. The voyage certainly provided the *Morrissey's* crew with grounds to brag to Digby friends aboard the *Albert J. Lutz* and *Dorothy M. Smart*, the Brittain Trophy contenders both then in Yarmouth harbour. "Give us a breeze of wind over the quarter and we'd run away from you both, old and all as she is," declared a man from the *Morrissey*. "Yeah, maybe you could at that," responded an old-timer from one of the other schooners, "ef your gang was well-primed with a skinfull of Portland rum."

A harsh northerly wind kept the *Morrissey* and nine other schooners bottled up in port for four days. When the wind finally eased and veered to the southwest on Sunday, 15 December, the *Morrissey* led the way down harbour in the early morning. Unfortunately, the schooner's exit from Yarmouth was less impressive than its entrance. Tacking in the narrows at low water, the *Morrissey* fetched up in mud at the side of the channel. Fast aground for six hours, the crew had to endure jibes shouted from the other schooners as they paraded by on their way to sea. Not until freed by the rising tide was the *Morrissey* able to move off to the northwest and the Lurcher shoals, the first dories going over at seven in the evening for a three-tub set of trawl. The barometer then fell overnight, and on Monday morning Captain Ross reluctantly returned with the rest of the fleet to Yarmouth to wait out a second blow. Conditions Tuesday morning were not much improved, but the skipper was now impatient and took the *Morrissey* out while the other captains kept their vessels at anchor. His risk was rewarded with three good sets that filled the pens with more than 30,000 pounds of fresh haddock and another 15,000 pounds of cod, hake, and cusk. The *Morrissey's* holds could easily manage twice that amount, but Captain Ross decided to make for Boston to cash in on the high pre-Christmas prices likely available there. So, on Wednesday, 18 December, the *Morrissey* swung off to the westward under four lowers in light rain with a slight southeast wind. Wallace's second adventure of the trip began.

Opposite: Shipmates gather aft to watch as Wallace scrambles up the foremast rigging to take their photograph. At the wheel is Oscar Comeau, with Captain Harry Ross, hands in pockets, standing behind. The mainboom crotch lies flat on the deck near the stern taffrail. Pen boards, rakes, and other equipment are jammed in the small space between the cabin and the gurrykid. MMA WPA B 6

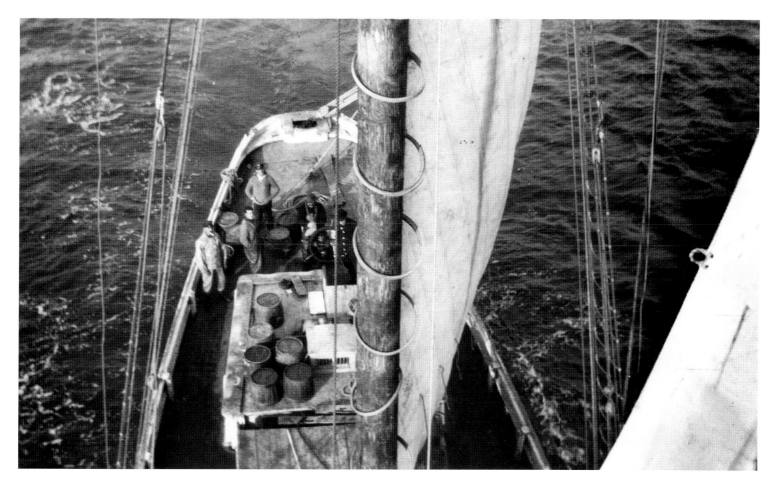

The *Morrissey* made good time overnight, and by noon Thursday was just fifty miles short of the Boston Lightship. To the southwest, however, the sky was ominous. The wind fell and so did the barometer. "Dinner was over and the crowd were lazying below. The Skipper and two watch-mates were on deck. After a hearty meal, we were all set for an afternoon of sleep, gossip or a quiet game of cards." It was not to be.

"Tumble up you fellers!" called Captain Ross. "Squall acoming. Stand by!"

When Wallace reached deck he saw to the south "a black wall into which the sea merged." A horizontal white line materialized out of the gloom, the track of the squall speeding along the surface of the water. A timber-laden, three-masted schooner nearby received the first blow and disappeared from

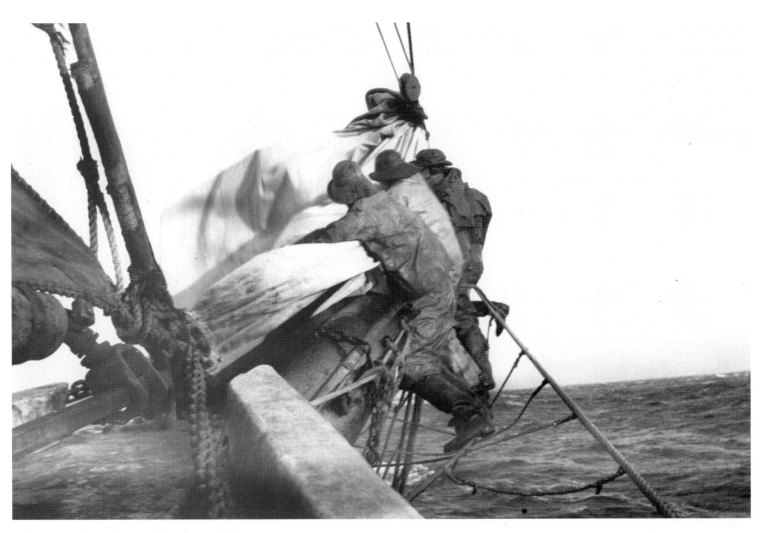

view in a flurry of spray and rain. "Then we got it." The main-boom swept across the deck and crashed against the leeward rigging, and the *Morrissey* rolled down to the rail. "The squall flickered out almost as quickly as it came and left us rolling to a devil's orchestra of crashing booms and flogging sails. But the respite was brief. From the S.W. it came ahowling and settled down to a steady succession of squalls from that quarter." Despite the strain and clatter, Ross's inclination was maintain sail as long as there was a chance to carry it, edging the *Morrissey* along during the forenoon. But the closer Boston's

T-Wharf came, the worse became the squall's battering. By late afternoon, the lee rail was so far under it was threatening to sweep the starboard nest of dories over the side. Ross took the hint and ordered the mainsail and jib furled.

Wallace, crawling out on the foot ropes, joined the effort to muzzle the jib.

> Together with five other men, I went out on the bowsprit to stow the jib after the downhaul and sheets had been manned. The canvas was flogging so violently that the stout bowsprit whipped like a sapling. On the foot ropes of the *Morrissey's* lengthy spar we rose and fell dizzily as we clawed at the harsh canvas and rolled it up. When she dipped down, we hung on with every finger a fish-hook as the foaming water rose up to our knees.

With the jib settled, the entire crew tackled the mainsail, demonstrating greater concentration and efficiency than they had

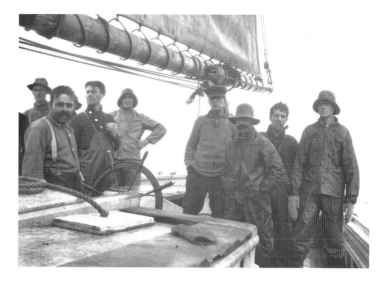

Right: With the catch cleared away, the crew of the *Effie M. Morrissey* assemble aft for a smoke and a photograph. Captain Harry Ross, at the wheel and with cigar in hand, keeps his eyes on the horizon. MMA WPA B 12

Opposite: Making the jib fast. "At times we were soaring skyward like an air-plane in a take-off and one could glance aft and see the vessel down in the hollow of the sea and the white welter of her wake over the following comber. Then, with a sensation like a swift elevator dropping ten stories, the bowsprit would swoop down until the water foamed and swirled up to our knees as we stood on the foot ropes." Wallace apparently passed his camera to a crewmember to record the scene. MMA WPA B 19

on the outbound trip from Portland. In place of the mainsail, they attached a small triangular riding sail and, under storm canvas (riding sail, reefed foresail, and jumbo), the *Morrissey* got underway. Before such a wind, however, even this sail proved too much. When tacking, the sheet-blocks holding the trailing edge of the riding sail became unhooked from the stern taffrail, and the flapping canvas parted from all restraint save its halyard. With the weight of the wooden sheet-blocks at its tip, the flailing riding sail stripped the wooden mast hoops, sending them flying, and thrashed against the rigging. "'Grab her when she comes down!' bawled the Skipper. But when she came down on the quarter in a wicked swing, and the flying sheet-blocks smashed on the planking making a dent in the wood an inch deep, most of us ducked hurriedly under the mainboom. There were no grabbers." Only after easing off the wind were the crew able to rescue what remained of the sail and its gear.

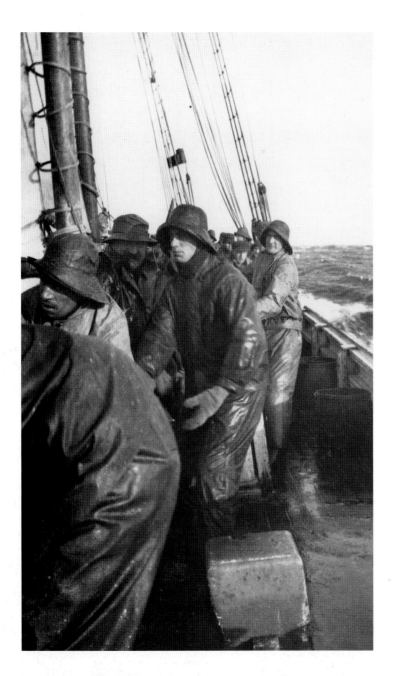

Under reefed foresail and jumbo, the *Morrissey* once again appeared to be under control and on course for Boston. The crew, including the captain, went to shelter below, leaving Oscar Comeau at the wheel with his dory mate Forman Outhouse on lookout. Those in the cabin hauled out the overworked phonograph, while up in the forecastle the cook began to prepare supper. Their world suddenly turned upside down with a terrible lurch.

> The man who was holding the phonograph took a header into a lee bunk and every fellow to windward was hurled across the cabin to sprawl down on the lee lockers and into the berths. Suit-cases, ditty-boxes, pillows and blankets, came flying out of the starboard bunks and piled on top of us — thrown in a sprawling heap of humanity to loo'ard, cursing and shouting. There was a frightful creaking of the vessel's hull and she could be felt twisting like a basket under pressure. A great crashing and roaring sounded on deck; the daylight was blacked out, and down the skylight and gangway poured the frigid Atlantic — filling the cabin a foot deep and almost choking us with the steam and ashes which blew out from the blazing hot stove.

A big sea had struck along the whole length of the *Morrissey* and rolled it half over. The chaos subsided only as the schooner slowly worked its way back to something approaching upright. Those in the cabin scrambled on deck to find Oscar with his arms through the wheel-spokes and Forman tied to the stops on the furled mainsail. Forward in the forecastle, the scene

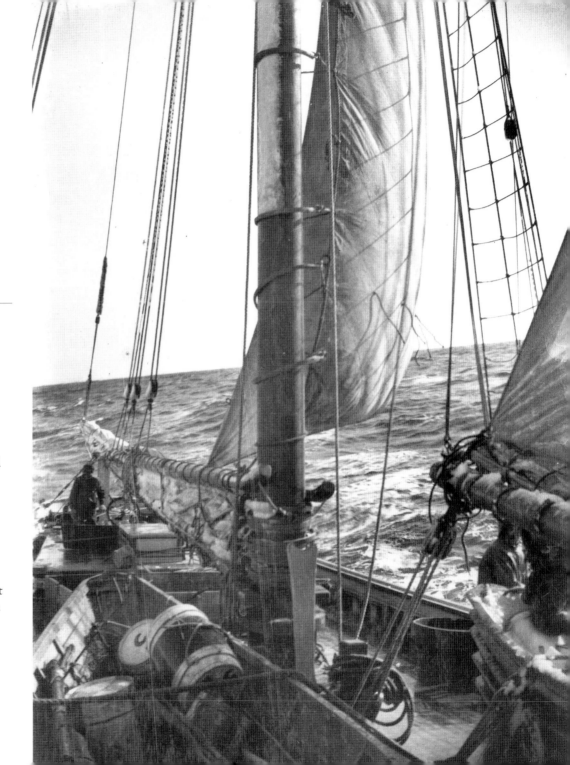

Opposite: Effie M. Morrissey crewmen haul on the mainsheet, a line attached to the trailing end of the mainboom, to bring the enormous spar and its flogging sail within reach of the wooden boom-crotch, just forward of the taffrail, for securing. In a heavy wind and plunging sea, this task required enormous strength and coordination. Most of the crew sport traditional souwesters, but the mustachioed member centre-left is wearing a Cape Ann hat. MMA WPA B 20

Right: "Under Storm Canvas" was taken aboard the *Albert J. Lutz* in January 1915, but it captures the situation aboard the *Effie M. Morrissey* on 19 December 1912, just before the failure of the riding sail sheet blocks and tack line. The mainsail has been furled, sandwiched between the maingaff and the mainboom, and in its place a small triangular riding sail, also known as a trysail or storm sail, has been raised. MMA WPA C 6

"The Log of a Record Run" (or *"Mary L. Mackay"*)

Wallace's record December 1912 run aboard the *Effie M. Morrissey* was one of his perennial tall tales. The story, the photographs, and the achievement appeared again and again in his journalism, the images, in particular, demonstrating the courage of the man behind the camera as much as the men in front. The trip was also the inspiration for his shanty, "The Log of a Record Run," first published in *Canadian Fishermen* in June 1914. "It was just a 'Come-all-ye' doggerel, but it must have appealed to some of the East Coast fishermen for one of them picked it up and put a tune to it and it got spread around." Indeed, years later, Nova Scotia folklorist Helen Creighton collected it under the false impression that it was "traditional." Wallace enjoyed informing her of the true authorship before she published it in *Songs and Ballads from Nova Scotia.* Wallace changed the name of the schooner from the *Morrissey* to the *Mary L. Mackay* to avoid giving offence to his shipmates. "However, I need not have worried on that score for most, if not all of them, would have been delighted to have been identified with the escapade — so I was told." As with most shanties, the words changed over the years; the version given here is the 1914 original.

Come all ye hardy haddockers that winter fishin' go,
An' brave the seas upon the Banks in stormy wind an' snow.
To all that love hard drivin' — come an' listen to my lay
Of the run we made from Portland on the Mary L. Mackay.

We hung the muslin on her, as the wind began to hum;
Twenty reckless Nova Scotiamen, 'most full of Portland rum.
Main and fores'l, jib an' jumbo, on that wild December day,
And out from Cape Elizabeth we slugged for Fundy Bay.

We slammed her to Monhegan as the gale began to scream,
And the vessel started jumpin' in a way that was no dream,

With a howler o'er the taffrail, boys, we steered her sou'west away,
Oh, she was a hound for runnin' was the Mary L. Mackay.

Storm along! an' drive along! an' punch her through the rips!
Never mind the boardin' combers an' the solid green she ships!
"Just mind yer eye an' watch yer wheel!" the Skipper he would say.
"Clean decks we'll sport to-morrow on the Mary L. Mackay!"

We lashed the hawser to the rack and chocked the cable box,
An' tested all the shackles on the fore an' main sheet blocks.

The steward moused his pots an' pans and unto us did say,
"Ye'll get nawthin' else but mug-ups on th' Mary L. Mackay."

The sea was runnin' ugly an' th' crests were heavin' high,
An' th' schooner simply scooped them 'til her decks were
 never dry.
We double griped the dories as the gang began to pray,
For a breeze to whip the bits from out the Mary L. Mackay.

Then we warmed her past Matinicus and the skipper hauled
 the log.
"Sixteen knots! Lord Harry! Ain't she jest the gal to jog!"
An' the half-canned wheelsman shouted, as he swung her
 on her way,
"Just watch me tear the mains'l off the Mary L. Mackay!"

The rum was passing merrily an' the gang were feelin' grand,
With long-necks dancin' in our wake from where we cleared
 the land.
But the skipper, he kept sober, and he saw how things might lay,
So he made us furl the mains'l on the Mary L. Mackay.

Under fores'l and her jumbo we tore wildly through the night,
An' the roarin' white capped surges in the moonshine made
 a sight.
To fill your heart with terror, boys, and wish you were away
At home in bed, and not aboard the Mary L. Mackay.

Over on the Lurcher Shoals the sea was runnin' strong.
In foamin' angry breakers — full three to four miles long,
An' midst this wild Inferno, boys, there soon was hell to pay,
But they didn't care a hoot aboard the Mary L. Mackay.

To the box was lashed the wheelsman, as he steered her through
 the gloom,
An' a big sea hove his dory-mate clean over the main-boom.
It tore the oil pants off his legs an' we could hear him say,
"There's a power o' water flyin' o'er the Mary L. Mackay!"

The skipper didn't care to make his wife a widow yet,
So he kept her off for Yarmouth Cape, with only fores'l set.
An' past Forchu that mornin' we shot in at breakin' day,
An' soon in shelter harbor lay the Mary L. Mackay.

From Portland, Maine, to Yarmouth Sound, two-twenty miles
 we ran
In eighteen hours, my bully boys, now beat that if you can.
The gang, they said "'Twas seamanship!" The Skipper, he
 kept dumb,
But the force that drove the vessel was the power of Portland
 rum.

Decoration by Frederick William Wallace for "Return of the
Ships," *Canadian Century*, 1910.

resembled the chaotic mess in the cabin, but with kitchenware and supper thrown into the mix. The cook had narrowly missed serious injury "when a barrel of flour burst through a locker door and smashed down on him as he lay in a muddle of water, pots, kettles, ashes and potatoes."

"As is the custom at sea, the whole thing was taken as a joke," but Captain Ross wasn't risking any more such knockdowns. Giving up on Boston, he ordered a course northeast for Portland.

With a more cooperative wind and sea, the crew settled in again to sleep as best they could as a snowstorm developed outside. Visibility was limited, so the wheelsman decided to follow the lights of the Boston-to-Portland steamer into the harbour. Unable to keep up, he lost the steamer's lights and suddenly came up against the white breakers off Cape Elizabeth. Faced with dashing the schooner to pieces, the wheelsman jibed the vessel over. Once again, crew in cabin and forecastle found themselves hurtling through the air. Worse, this time the jumbo parted in shreds, leaving the schooner under the inadequate expanse of reefed the foresail. In the frozen dark, the crew threw themselves on the mainsail and jib, smashing at ice to free the canvas in order to maintain way.

With the big sails back up, Captain Ross felt, rather than steered, his way into Portland at two in the morning. The quiet and calm of the harbour that Friday, 20 December, was a stark contrast to the roiling sea just outside its embrace. "The electric signs were flashing on buildings ashore, the honk of auto horns sounded across the harbour, and the reflections of arc lamps on the wharves spun spirals of light on the black mirror of the water."

Surveying the damage to the schooner the next morning, the spare hand found that the foregaff was completely fractured. Had it split following the loss of the jumbo, the schooner would have been without sail in the face of oncoming breakers. The fare in the *Morrissey*'s pens was small, but its value was high: $1,500. The bad weather that more than once had endangered the schooner had kept its competitors in port. Out of the owners' share of $375, $100 went straight to the purchase of a new riding sail, jumbo, and foregaff. The crew, who were fishing by the count, received about $40 each after the expenses of bait and the like were deducted. It was a good Christmas.

It was a much more experienced Frederick William Wallace who shipped aboard the *Dorothy G. Snow* with Captain Ansel Snow in March 1916. Age twenty-nine, he was now Editor of *Canadian Fisherman* and Secretary-Treasurer of the Canadian Fisheries Association, a much-published author of short stories and a novel, and a wartime member of the 39th Battery, Canadian Field Artillery, Canadian Active Militia, based at Montreal. On his own since the death of his mother Frances in January 1915, Wallace had recently become engaged to Viola Waters of Westmount.

The demands of business and family meant that running off on a fishing voyage was becoming increasingly difficult to schedule and justify. This time, however, he had a unique justi-

Opposite: "All that was left of the jumbo." MMA WPA B 7

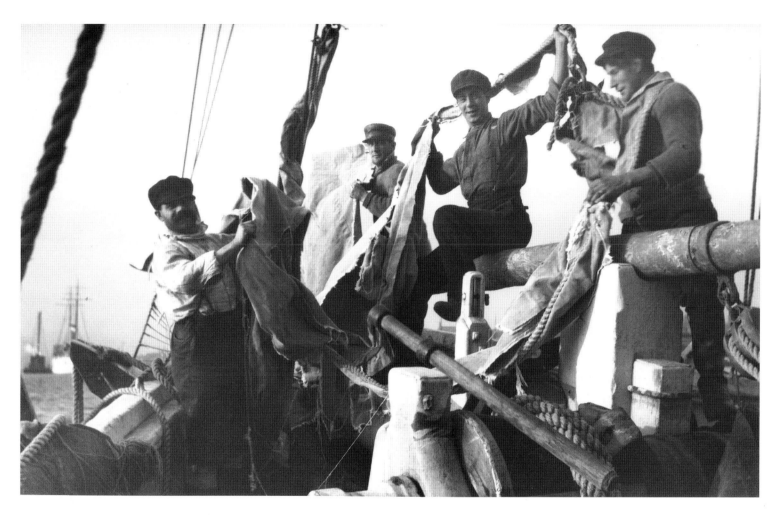

fication. At the beginning of March, over a lunch of broiled haddock in a Montreal restaurant with Wallace's brother-in-law Tom Hood, Secretary of Royal Securities Corporation, the ubiquitous Alfred H. Brittain, and Will Gladwish, a proprietor of a camera and photography supply firm, the subject had turned to the high price of fish. Wallace told his table-mates that the price of fish was more than justified by the dangers and uncertainties of the banks fishery. "You have no conception of what it is like at times." Out of this casual observation came Gladwish's sudden proposition that Wallace leave immediately for the banks with a motion picture camera to show city-dwellers in central Canada what it took to bring

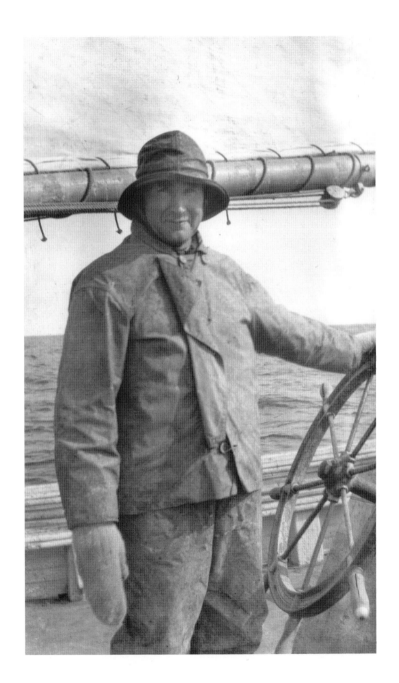

fish to market. Those around the table came up with $500 to cover the cost of purchasing and developing 3,000 feet of film, and Gladwish promised to loan the camera and provide a crash course in its use. "If you bring back the bacon," said his companions, "we'll make a fortune out of such a picture, for it has never been done so far."

On Saturday, 11 March, Wallace arrived in Digby to join the *Dorothy G. Snow* on what would prove to be his last voyage aboard the banks schooners. Both Captain Snow and the vessel were familiar to him from a trip he had made to the banks in March 1914. Born in Digby in 1870 on Lighthouse Road just beyond the Racquette, Ansel was the youngest of four sea captain Snow brothers, the others being John Worster, Joseph E., and William. Ansel's father died when he was two and his mother when he was six. Under John's leadership and the steadying influence of two sisters, Georgina and Mary Josephine, the family had held together and made a living from the water at their doorstep. Ansel began working the basin as a dory fisherman by the age of nine, and was a captain at nineteen. By the turn of the century, the Snow brothers individually or collectively owned and operated a succession of schooners, including, for a time, the *Effie M. Morrissey*, and Joseph had established an independent fresh and smoke fish business at the Racquette. The brothers also began to build their own schooners. John was the largest shareholder in the *Wilfred L. Snow*, built at McGill shipyard in 1905 and named after his youngest son. It was the first Digby schooner

Captain Ansel Snow at the wheel of the *Dorothy G. Snow*, March 1914. MMA WPA D 1

constructed with the auxiliary power of a gasoline engine, although the temperamental machinery was subsequently removed in 1908. The *Loran B. Snow* was built in Lunenburg in 1906 for Joseph, again named after a youngest son. It was also for Joseph that the McGill shipyard built the *Dorothy G. Snow* in 1911, named for his youngest daughter.

Like the *Albert J. Lutz* and the *Dorothy M. Smart*, the *Dorothy G. Snow* was based on models of American schooner designer Thomas F. McManus. The traditional clipper-bowed schooners so common in the 1880s had two basic sorts of problems that McManus sought to overcome. Their long, shallow straight keels combined with overmasting and excessive sail plans to constrain manoeuvrability and increase the ship's pitching movement when sailing at right angles to the waves of a heavy sea. Worse, the long bowsprits and mainboom projections over the stern taffrail were inherently dangerous for anyone attempting to muzzle or furl the jib, jumbo, and mainsail in rough seas. McManus's solution, according to his biographer W.M.P. Dunne, was to introduce a short, deep, rockered keel (deeper aft) and extend both the bow and stern from the waterline. This would reduce turning resistance when tacking, "creating a commercial hull that would come across the wind in seconds, faster than most contemporary racing yachts." It would also reduce the plunging motion that had dragged so many men off the projecting bowsprit and mainboom.

McManus's first successful design incorporating his new ideas was the Indian Head class of 1898. This was the model on which both the *Lutz* and the *Smart* were based, although Wallace consistently and mistakenly refers to them as "semi-knockabouts." Faster and more agile than previous schooners and less prone to deadly plunges, they represented an enormous step forward in design. They retained the distinctive long bowsprit, however, with all its attendant dangers. McManus remained convinced that only the complete elimination of the bowsprit would end the risk fishermen ran when furling the jib and jumbo sails. This goal he achieved in the first of a new "knockabout" model, the *Helen B. Thomas*, launched at Essex, Massachusetts, in 1902. The key was to move the wire jibstay from the tip of the bowsprit inboard to join the forestay at the head of the bow itself, permitting all work on the jib to be done standing on the deck.

Unfortunately, the new design's restricted carrying capacity initially made it unpopular with ship owners. The *Alcyone*, built for Harry Short by McGill in 1904, was only the second schooner of the type and the first in Nova Scotia, and it was not until around 1910 that the knockabout model was refined sufficiently to become popular. In the meantime, McManus took a step back and produced the "semi-knockabout," of which the *Dorothy G. Snow* was an example. With this design, McManus shifted the forestay along which the jumbo ran back several feet from its normal terminus on the bow. This, in turn, permitted him to pull back the jibstay a corresponding distance, thereby drastically shortening but not eliminating the bowsprit. The resultant fast, agile, and safer schooners proved popular. Many in Digby hoped for a race between the *Dorothy G.* and either the *Lutz* or the *Smart* to compare the sailing qualities of the Indian Head and the semi-knockabout, but "the contest never came off, for both her owner and her skipper were more interested in fishing than racing."

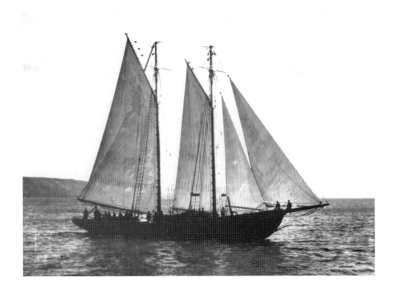

By the time Wallace joined the *Dorothy G. Snow* at Digby, the vessel was showing signs of a hard winter. The decks and rigging were sheathed in ice, paint was long gone, and dories had scarred the sides. The previous trip out, a foresail had been lost, and there hadn't been good fishing in weeks. Wallace had sailed with most of the crew before, a "hard-driving" gang of twenty-two, most of them brothers or relatives. All were keenly interested in the prospect of being filmed, and there was much speculation about who would be the "star" actor.

Prospects for both fishing and filming certainly looked good as the schooner stood out of the Gut on the afternoon of Sunday, 12 March, under the four lower sails in a fresh northwest wind. The fine weather was not to last. The barometer fell overnight, and Captain Snow prudently took the *Dorothy G.* into Westport harbour, Brier Island, to sit out the storm. It was not until Friday, St. Patrick's Day, that the gale blew

**Logbook of the Ship "Dorothy G. Snow,"
Nova Scotia, Ansel Snow, Commander,
from Digby, Nova Scotia, to Browns Bank,
sailed 12 March 1916, arrived 25 March 1916**

CREW

Ansel Snow, Master	Handford Daley
Will Murphy, Spare	Ellard Stanton
Sylvine Doucet, Cook	Peter Muise
Harry Hayden, Fisherman	Enoch Campbell
Thos. Kinghorn	Wilson Munro
Geo. Kinghorn	Dug. Campbell
Andrew Tebo	Harry Boudreau
Phil. Handspiker	Leon Muise
West. Hudson	Monty Muise
John Porter	Mark Muise
Bruce Porter	Mell'n Hudson

Frederick William Wallace Papers, Volume 3,
Journals and Logbooks, Item 24

Left: The *Dorothy G. Snow* in winter rig clearly illustrates the key feature of the McManus semi-knockabout model. Moving the forestay several feet aft of the bow meant that the crew did not have to leave the deck when furling sail. Paul Yates took this photograph, probably shortly after the launch of the *Dorothy G. Snow* in 1911. MMA PY MP 10.56.1/2a

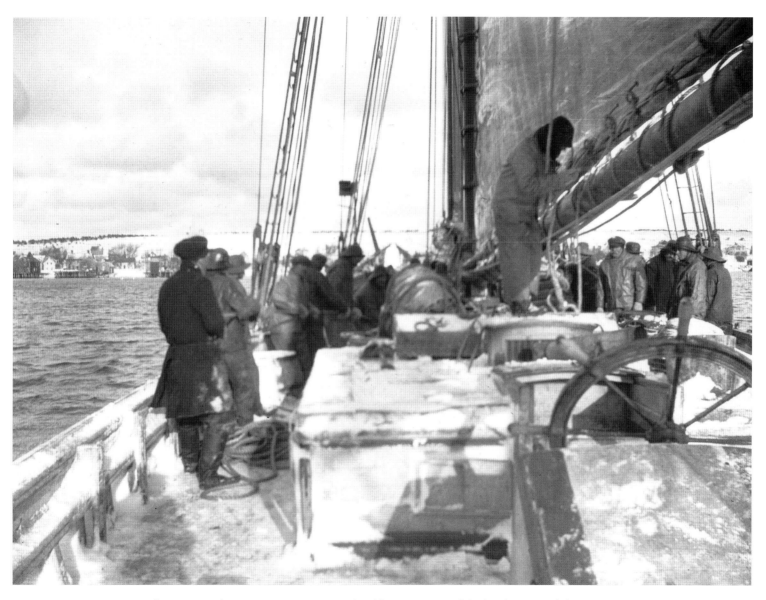

"Getting underway, Westport, Brier Island." On ice-covered decks, the crew of the *Dorothy G. Snow* wrestle with the main throat halyard, slowly raising the maingaff. MMA WPA H 27

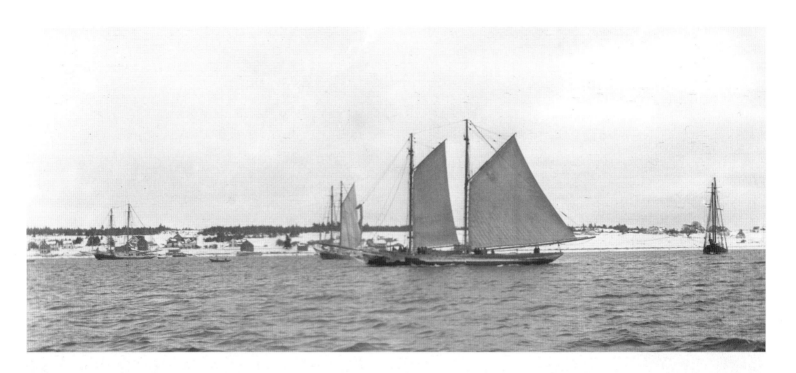

itself out at last. The *Dorothy G.* worked out of the harbour, but made it only as far as Cape Forchu before running into yet more hard weather. Captain Snow ordered the mainsail taken in, and overnight the *Dorothy G.* rode out a snowstorm under riding sail, reefed foresail, and jumbo. The next day, prudence again dictated that the snow-and-ice-caked vessel make for port, this time anchoring off Sandy Point in Shelburne harbour. Seven days out and not a single tub of trawl had been set.

On Sunday, 19 March, Captain Snow took the *Dorothy G.* out once again, this time making the northeast edge of Browns Bank, crowded with schooners despite the weather. But with light fading and the wind rising, he could do no more than

heave-to under the foresail and jumbo. And so matters persisted all the following day. Tuesday morning, the sun broke bright and clear and the wind subsided sufficiently to put the dories over for the first time. The first task was to smash a solid coating of ice off the dory nests, but before the crew started

Above: In the bleak waters off Sandy Point, Shelburne harbour, four schooners wait for a break in the weather. In the meantime, dories are over for visiting. MMA WPA H 4

Opposite: The American semi-knockabout *Gov. Foss,* built the same year as the *Dorothy G. Snow,* passes the *Albert J. Lutz* in January 1915, heading for its New England home under four lower sails. MMA WPA H 29

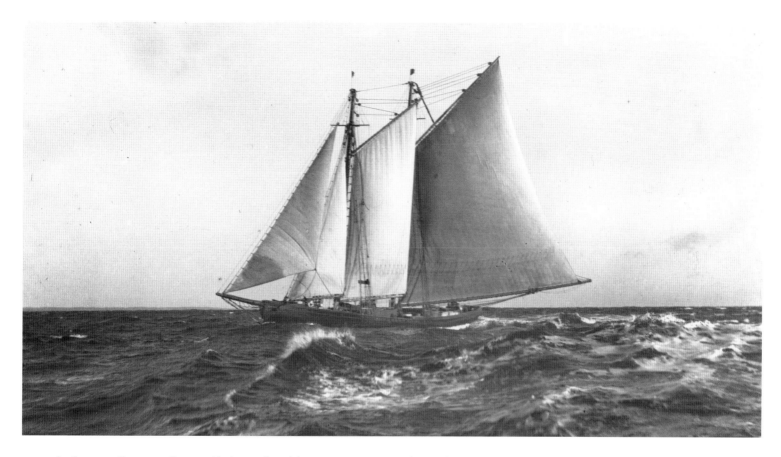

in with their mallets, Wallace called out, "Hold on a minute! We've got to make a picture of this." "By Gorry, yes!" replied the skipper. "If we can get this on the screen, it might put the price of fish up another cent a pound."

Getting the picture was not easy. Gladwish had supplied Wallace with an English Williamson cine-camera, "a heavy and cumbersome affair of mahogany and brass the size of a small suitcase." In order to thread the camera with film, Wallace had to improvise a makeshift darkroom. This he did by tacking two heavy blankets over a bunk in the cabin. He then crawled into the space with the bulky camera, a 200-foot roll of film in a tin, and a small ruby lamp with a candle in it. While two of the crew grasped his legs to prevent his rolling about, Wallace set to work. When the candle in the ruby lamp threatened to set the highly inflammable film alight, he threw it out. "The motion of the schooner, the nauseating stench of bilgewater, the sickening odour of the emulsion on the film, combined with the absence of air, and the heat within

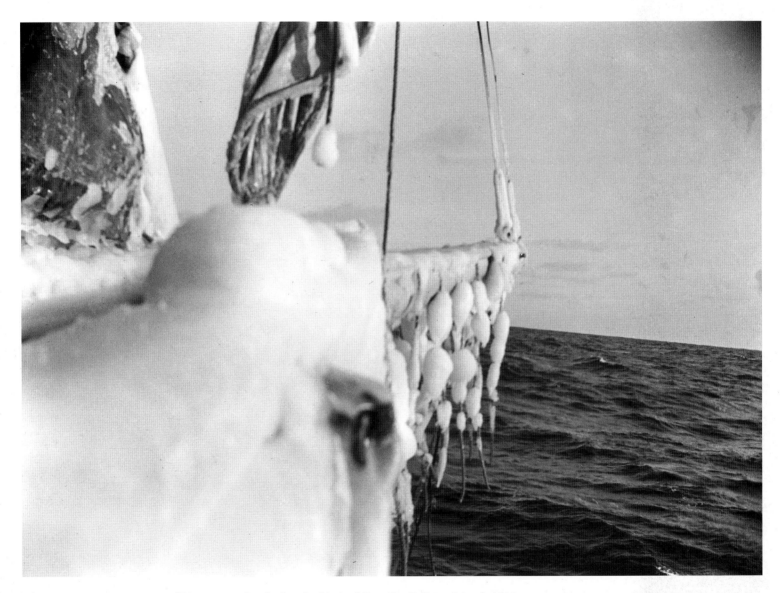

"Bowsprit and rails sheathed in ice." *Dorothy G. Snow*, March 1916. MMA WPA H 19

Opposite: Iced up on Browns Bank. *Dorothy G. Snow*, March 1916. MMA WPA H 2

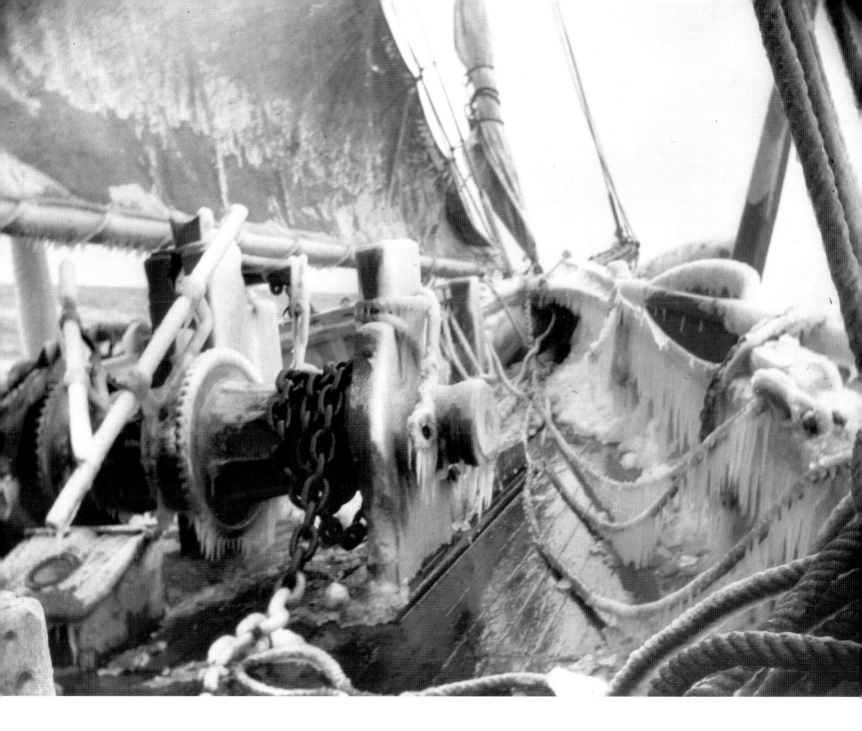

the cramped quarters of the blanket-screened bunk, made my stomach turn. A minute or two more and I would have been retching." Whatever the hardship, at last the camera and the weather were ready.

Throughout the day, Wallace took shots of dories departing and arriving, dories out on the sea, fish being pitched aboard and dressed down. Captain Snow manoeuvred the schooner around so that the sun was in the right position for the camera, and the men participated enthusiastically. The action was good but the fishing results were not. Ten dories, each laying three tubs of trawl, produced little more than 9,000 pounds of fish. Worse, several tubs of trawl were lost in the fast-running tide. After a rough night, another set early on Wednesday morning resulted just 3,000 pounds of fish.

In the angry wind and water, the dories wallowed
and lurched alongside the rolling and diving schooner.
The half-frozen fish were forked out of the watery
slush in the dory-pens onto the slushy deck of the
Dorothy Snow. Snow plastered everything and froze
where it struck. The vessel was in a gloomy, cheerless
mess — snow, ice, and the muck of fish and old
baits over rails and cabin-houses. Alongside, the
men leaped over the rail from their bucking dories,
cursing, damning the weather, and swearing.

Three of the five frames that remain from *Seamen Courageous*, the film Wallace shot aboard the *Dorothy G. Snow* in March 1916. MMA WPA H 13

The captain wanted them all back in before he lost them in the snow and failing light. The men did not know it, but they had caught the last fish on that trip. Dories were griped down fast, loose gear stowed away, and all canvas tightly furled as the schooner prepared for yet worse weather under nothing more than a double-reefed foresail.

Hove-to in the darkness of Wednesday night and Thursday morning, watchmen spent anxious hours cleaning off side lights to make the *Dorothy G.* visible in the dark to other vessels on the banks. Again and again, the crew were called out to bear torches to ward off other schooners. "It was hardly worthwhile pulling one's boots off when bunking-up, since we were jumping out on deck the best part of the night. Every vessel in our near vicinity that was driving down from windward was a potential menace of collision and probable destruction." Around midnight, the watch heard a siren "bellowing like a bull-calf in a bog." A steamer hove-to in the darkness like the rest of them, all too close for comfort. "The whole of the Browns Bank fleet seemed to be driving or drifting to leeward and past us in the blackness and thick snow. We were thankful when the tardy daylight came."

Morning did not improve the weather, and the *Dorothy G.* and its neighbours found themselves facing a gale that would last into Friday. "For fifty hours of blow and snow we drifted back and forth across the Bank on alternate tacks under the two-reefed foresail." Over the shoal waters of Browns Bank the sea turned ugly, throwing up waves the like of which Wallace had never before experienced. "Some of our fellows declared they were the biggest they had ever seen in all their going fishing." This presented a challenge to the would-be movie-

maker. With four fishermen and Captain Snow in attendance, Wallace shifted the movie camera to the top of the cabin house. "One of the fellows held the camera steady while another held me around the waist. The two others were stationed at each side of me with oilcoats ready to ward the sprays off the apparatus." The skipper kept the schooner as even as was possible under the circumstances. "With my eye glued to the focusing tube, and watering in the keen wind so that the lashes froze together, I'd hear the Skipper shout; 'There's a big fellow coming, Fred! Get that on . . . Gorry, she's as big as a house! Hold on a bit, Fred! I see the Father of all Seas amaking up. See it? Get him, Fred, get him! Did you get that one?'" And so it went. During the day, Wallace ran off a thousand feet of film, including a shot of another schooner drifting past.

She was a Boston knockabout under two-reefed
foresail and jumbo. One moment she would
subside in the hollow of a big roller with nothing
but her masts and sails visible; then she'd top
the crest as gracefully as a gull and plunge down
into the valley of sea again. It made a grand and
impressive sight in that rough and wintry water.

By late Friday, with Wallace almost out of film and the weather showing no signs of improvement, Captain Snow decided that continuing the trip was futile and turned the *Dorothy G.* for Shelburne. They reached Sandy Point in the early hours of Saturday morning, 25 March. Wallace and his precious camera and film were rowed ashore to the Gunning Cove station of the Halifax and Southwestern Railway for the trip

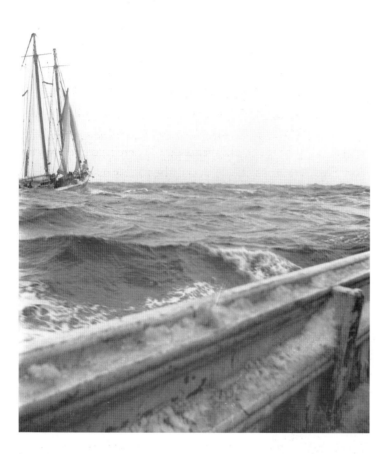

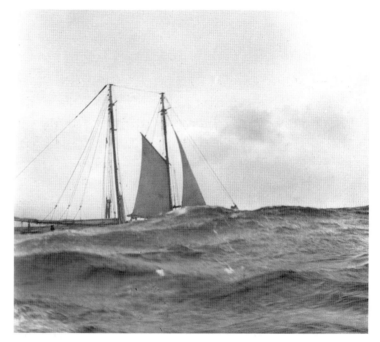

film with the idea of selling the negative. "Then, in some unaccountable manner, the original negative disappeared. To this day, I have no knowledge of where it went to." The crew of the *Dorothy G. Snow* did not do much better. Fourteen days out of Digby produced just 12,000 pounds of fish, not enough to cover the cost of the food. It was a frustrating close to an exciting chapter in Wallace's life.

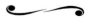

home to Montreal. Gladwish was thrilled with Wallace's film. Newspaper critics praised the resulting movie, entitled *Seamen Courageous*, as an exciting portrayal of the fisherman's working life. One of the first public showings took place in Digby, where it ran for several days at the local movie house. The investors, however, made no profit, most of it going to the film distributors. Wallace and his friends decided to withdraw the

Left and above: Hove-to in a gale on Browns Bank.
MMA WPA H 11 and H 21

122

Monty Muise

Monty Muise, one of Wallace's shipmates aboard the *Dorothy Snow*, suffered the ordeal of being adrift in a dory for three days in wintertime. Wallace described him as a "stalwart, ruddy-faced Acadian from Yarmouth County, and as tough in physical fibre as they make 'em." Here is his story.

It shut down thick o' snow on a Sunday afternoon when I was out single dory trawlin' from a vessel. I lost sight of her and she lost me. I had no food with me, but I had a little water in the dory-jar. When I saw no sign of the schooner, I figured I'd better start pullin' in for the land. It was awful rough at times and I'd have to knock off pullin' and git to bailin' the water out of the dory. It was freezin' cold too, and the dory was icing up, and I'd have to knock the ice off'n her every now and again — it was makin' so heavy.

On the We'nsday afternoon, I sighted a three-mast schooner close by and I pulled towards her. They saw me and came to the wind. I pulls alongside and throws them my painter. The Skipper asks me if I was able to git aboard myself,

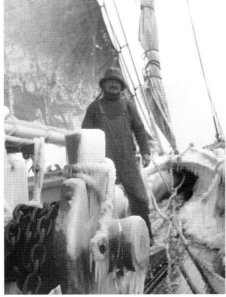

Monty Muise. MMA WPA H 25

otherwise he'd have me hauled up in a bowlin'. I said I was able to climb aboard. I got up and over the rail of the schooner and I asked the Skipper to fetch my dory on deck cos' they were goin' to cast it adrift. I told them that if they sighted a fishin' vessel, I'd like to go off to her in my own dory. Well, I told 'em I'd been adrift for three days with no grub and no sleep. The Skipper wanted me to turn in, in his cabin, but I said I'd sooner go in the galley, after a bite to eat, as it was warm there and I as perishin' cold. After I had some soup and coffee, I stretched out on the locker in front of the galley stove and tried to sleep. But I couldn't seem to do so, nohow. I'd got out of the way of sleepin'. A little while later, I comes out on deck and sees the land about five miles off. It was about Shelburne. I asks the Skipper to put my dory over and I'd pull in. He alters course and goes in aways, and they puts my dory over. I pulls all the way up to the head of the harbour, more'n ten mile. But there was ice all around the shore. In tryin' to haul my dory up on the ice, I fell through and got all wet. But I got her up at last and walked into town, where I got fixed up.

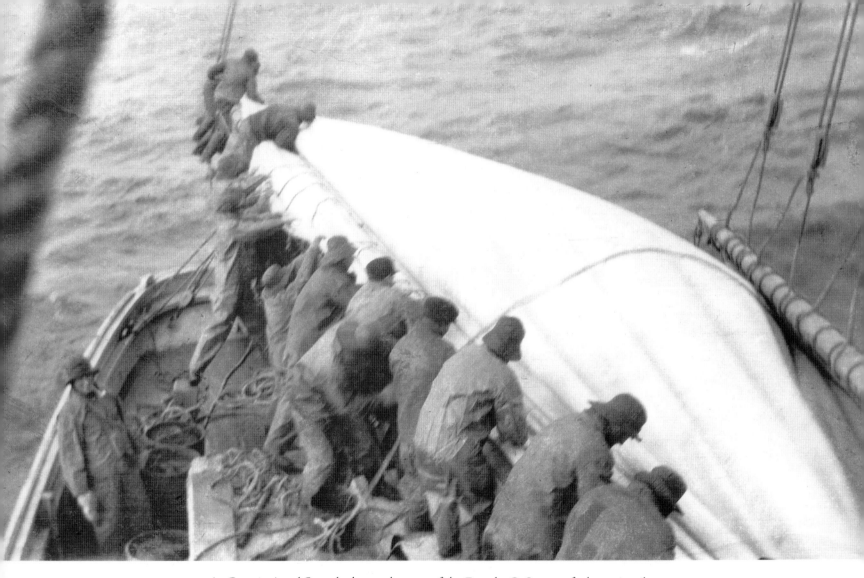

As Captain Ansel Snow looks on, the crew of the *Dorothy G. Snow* reefs the mainsail. The mainboom has been hauled in and the foregaff lowered so that there is sufficient slack in the big sail to permit the crew to furl the lower portion as far as the reef points. Keeping the wind from billowing the free portion of the sail was always tricky. Even though the *Dorothy G.* was a modern semi-knockabout, men still had to go out over the stern taffrail on mainboom foot ropes to furl the mainsail. MMA WPA H 38

The March 1916 voyage aboard the *Dorothy G. Snow* was the last Frederick William Wallace would make to the fishing banks on a working schooner under sail. If the young journalist who travelled to Digby in August 1911 was now a self-confident professional, it was because of his seven trips with the likes of Captains Harry Ross, Arthur Longmire, John Apt, and Ansel Snow, and crew mates like Judson Handspiker, Jim Tidd, Oscar Comeau, Monty Muise, and all the rest. From them, he acquired a foundation on which he would build for the rest of his career as an editor, journalist, writer, and occasional advisor to governments. More than that, however, young Fred's experiences aboard the *Dorothy M. Smart*, *Effie M. Morrissey*, *Albert J. Lutz*, and *Dorothy G. Snow* were his belated coming of age. One has only to compare the unshaven man in the cloth cap on the ice-covered deck of the *Dorothy G. Snow* in March 1916, with the young man in the straw boater aboard his father's steamer in Montreal harbour in 1907 to see the changes his experiences had wrought.

Frederick William Wallace aboard the *Dorothy G. Snow*, March 1916. MMA WPA H 20

Wallace in Print and on Film

Frederick William Wallace was first and foremost a journalist in need of a good story. In the banks fishery, he found it. As a freelancer, he placed his accounts, inevitably accompanied by compelling photographs, in such magazines as *Canadian Century*, *Canadian Countryman*, *Outing*, *Yachting*, *Canadian Magazine*, and *Saturday Night*. After becoming the editor of *Canadian Fisherman*, he had a more secure outlet for his articles. "Log of a High Line Halibuter," the story of his voyage on the *Albert J. Lutz*, was serialized over the first three issues, January to March 1914, followed in May by "Haddocking on Brown's Bank," the story of his voyage on the *Dorothy G. Snow*. He also continued to place similar stories in related magazines such as *Sailor*. The professional high point was the publication of "Life on the Grand Banks: An Account of the Sailor-Fishermen Who Harvest the Shoal Waters of North America's Eastern Coasts," in *National Geographic Magazine* in July 1921.

A journalist first, Wallace's parallel career as a writer of fiction was a close second. It was, in fact, as a short story writer that Wallace first made his way into print in 1908. Over the next three years, a steady stream of sea stories, poems, shanties, and the like appeared in many of the same magazines that published his journalism. Beginning in 1911, however, he began to draw on his own experiences, rather than those of his father, for his stories. The best of these new stories appeared in the pages of *Adventure*, beginning with "Bank Fog" in October 1912. Eleven were collected and published in book form in 1916 under the title *The Shack Locker: Yarns of the Deep Sea Fishing Fleets*, complete with pen illustrations by the author. By then, Wallace had already written his first and best novel, *Blue Water: A Tale of the Deep Sea Fishermen*. Composed over the winter of 1913 following his return from the December voyage aboard the *Effie M. Morrissey*, *Blue Water* was published in London and Toronto in 1914, and reprinted in 1920, 1922, 1924, and 1935. The novel's hero, Shorty Westhaver (the maiden name of Captain Apt's wife Lila), is clearly modelled on Harry Ross, and the cast of characters is loosely based on the likes of Judson Handspiker and Jim Tidd. The settings include the small communities of the Bay Shore, the town of Digby, and the fishing ports of New England. A second novel, *The Viking Blood: A Story of Seafaring*, published in 1920, opens with a revealing account of growing up in Glasgow and thereafter centres on a fishing community much like Lunenburg. Wallace's later fiction moves back toward his father's days of deep-sea sailing and his own research into Canada's wooden shipbuilding industry, and rarely reflects the experience of the bank fishery. This includes two more collections of short stories, *Salt Seas and Sailormen* (1922) and *Tea from China* (1926), as well as a third novel, *Captain Salvation* (1925), which opens with a rather unflattering account of the town of Digby.

Two of Wallace's novels were made into feature-length movies, *Blue Water* and *Captain Salvation*. The former was produced by Canadian-born Ernest Shipman, who selected projects with a local appeal to win financing from the community. This was a method that had served him well in small centres elsewhere in Canada, and in August 1922 he established New Brunswick Films Limited at Saint John, hoping to raise $90,000 to film *Blue Water*. Wallace, who was paid an undisclosed but likely modest sum for the film rights, was enthusiastic, and arranged to have Captain Ansel Snow and the crew of the Digby schooner *Robert and Arthur* participate. Faith Green was engaged to dramatize the novel and David Hartford to direct. The yet-to-be famous Montreal-born actress Norma Shearer was one of the stars. Although Shipman was unable to raise the full amount required, filming began in the unlikely month of October. Not surprisingly, the production encountered cold, rain, and fog, and retreated to indoor sets at the St. Andrews Roller-Rink. Eventually the entire cast and crew quietly left town to complete filming in Florida. The resultant film was given private viewings to the Saint John investors in January and February 1923, but it was not until April 1924 that a public showing was

arranged for two packed houses in the city. Wallace, who wrote that he saw a preview in New York, was happy with the result, particularly "that the story itself was faithfully followed." Unfortunately, Shipman discovered, as did many other independent producers, that it was difficult to get distribution rights through American distributors who were under the increasing domination of the giant Hollywood studios. The film went into a vault in New York and subsequently disappeared. Norma Shearer, who won an Academy Award in 1930, was quoted as saying that *Blue Water* was a "film I would rather forget." In contrast, *Captain Salvation* benefited from a 1927 production by Metro-Goldwyn-Mayer. The director was Canadian-born John S. Robertson, and the lead was Sweden's famous star of silent films, Lars Hanson. Widely distributed across the United States, the film received uniformly good reviews from magazines such as *Photoplay* and from the Hearst newspapers, which had serialized the novel. Unfortunately, however, that film, too, has disappeared. Add to this the loss of Wallace's own *Seamen Courageous*, and the record is particularly disappointing.

Title page from *The Shack Locker*

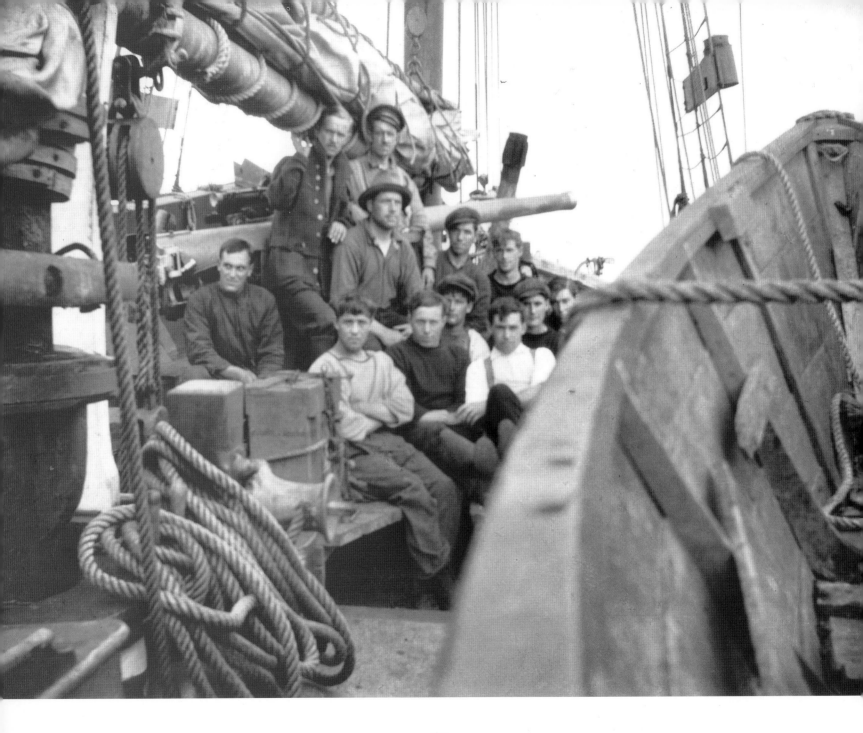

EPILOGUE

Frederick William Wallace caught the Digby schooner fleet at its all-too-brief apogee. The closer proximity of Yarmouth and other ports on Nova Scotia's southwestern shore to the fishing banks constantly drew off men and vessels from Digby and the Fundy Shore, as did the higher wages of New England. In 1912 Captain Howard Anderson sold the *Alcyone* to owners in Lockeport, Shelburne County, and in 1915 the *Wilfred L. Snow* was sold to the Yarmouth Trading Company. The *Effie M. Morrissey*'s appearances at Digby became increasingly infrequent, and in 1914 the vessel was sold to owners in Newfoundland to haul coal and salt from Sydney, Nova Scotia.

The effects of the First World War increased the rate of attrition. By 1916, the initial benefit of higher wartime fish prices was overborne by shortages of skilled fishermen, lost either to the services or to the higher wages to be earned in freighting.

Opposite: Crew of the Q-ship *Albert J. Lutz*. Captain Wallace stands to the right, Engineer J.S. Saunders to the left. Saunders later transferred to the Royal Air Force and was killed in a training accident at Camp Borden in June 1918. MMA WPA J 9

The *Dorothy M. Smart* was tied up in June 1916 for want of a crew, despite then Captain Arthur Casey's offer to guarantee wages of $50 a month and "everything found" — that is, with fishing gear, salt, and food thrown in. That same year, the *Cora May* was sold to owners in Jamaica. In 1917, the *Albert J. Lutz* and *Dorothy G. Snow* went to new owners in Halifax, and the *Loran B. Snow* was sold to Yarmouth owners for the West Indies trade in 1918. By the end of the war, only the *Smart* remained of the fleet Wallace encountered at Digby in August 1911, although the inshore fishery remained active.

Harry Ross was not one to wait around in a backwater. As captain of the US-registered *Effie M. Morrissey*, he was in and out of Portland, Gloucester, and Boston more often than Digby, and by 1913 he moved his family to Dorchester, Massachusetts. Many of his crew, including Georg Dreimann and Judson Handspiker, followed him. After the sale of the *Morrissey*, Ross took command of the Yarmouth owned, US-registered *Morning Star* and quickly became known as a "high-line" captain, landing record hauls in New England. In later years, he became famous for landing a different sort of cargo. When Prohibition was

introduced in the United States in 1920, Harry Ross was one of the first to freight liquor from St. Pierre into American waters, and became so successful a rum-runner that he owned a small fleet of specialized craft for the trade. He died at Boston in 1953. Two of his brothers were less fortunate. In August 1919, the *Francis A.*, sailing out of Yarmouth, hove-to in a fog off Sable Island to dress down fish and was cut in two and sunk by the Belfast steamer *Lord Downshire* Among the five killed were the *Francis A.*'s captain, Percy Ross, and his brother Ensley.

Another untimely death was that of John Apt. While on a halibuting trip off Cape Sable in October 1915, Captain Apt was taken seriously ill. The crew of the *Albert J. Lutz* rushed their skipper to port, and physicians from Granville Ferry and Digby diagnosed appendicitis. He was carefully taken aboard the steamer *Granville* for the short trip across the Bay of Fundy to Saint John for surgery, but he died on 12 October shortly after his operation. The news shocked the close-knit fishing community of Digby, the *Digby Weekly Courier* carrying the story on the front page. In a letter of condolence to the *Courier*, Wallace wrote, "One had but to grip him by the hand and gaze into his kindly grey blue eyes to experience the feeling that one had known him for all time." Captain Apt was survived by his wife Lila and seven children, four daughters and three sons. Among the captain's possessions was the Brittain Trophy, which he won in 1912 and never had to defend. Lila kept the trophy until 1936, when she gave it to daughter Hattie Lucille, who lived in Marblehead, Massachusetts, with her husband Malcolm Nichols. In 1963, in response to an inquiry in the *Courier* as to the trophy's whereabouts, Mrs. Nichols wrote

to say it was in her possession. She subsequently donated the trophy to the Maritime Museum of the Atlantic at Halifax in a ceremony attended by George W. Lutz, the grandson of Albert J.

Captain Ansel Snow remained active in the banks fishery through the 1920s, shifting to a succession of schooners sailing out of Yarmouth, Gloucester, and Boston. His daughter Ruth, in an interview in 1990, remembered that her father would come home to Digby for five or six days between voyages. "My mother used to get his clothes ready for the next trip. My twin brother Roy and I didn't want him to go. We used to take his big clothes bag right around to the barn and hide it. We used to cry, oh, cry terrible to think he was going to go away again." Other times, Ansel's wife Ella would take the train to Yarmouth to meet him. Ansel died at his home in Digby on 23 April 1937.

Captain Arthur Longmire similarly kept active as a skipper. After John Apt's death, he commanded the *Albert J. Lutz* until the vessel's sale in 1917. He then had the auxiliary-powered *A.W. Longmire* built at Hillsburn, and sailed it out of there and Yarmouth through much of the 1920s. He died at Hillsburn in 1930.

As for the four schooners aboard which Frederick William Wallace sailed, perhaps the most extraordinary story relates to the wartime experiences of the *Albert J. Lutz* and the *Dorothy G. Snow*. In October 1916, the German submarine U-53 brought the war to Canada's doorstep, sinking vessels off the Atlantic coast, including the *Christian Knudsen*, aboard which Wallace had made a short trip in 1907. These depredations inspired Wallace to write to G.J. Desbarats, Canada's Deputy

Minister of Naval Service, to suggest that fishing schooners could be modified as so-called Q-ships to carry hidden guns and, in their innocent disguise working on the banks, lure U-boats to the surface and destroy them. He received a letter of acknowledgement, but there the matter rested. Then, in early 1917, a notice came across his desk at *Canadian Fisherman* announcing that the *Lutz* and *Snow* along with four other schooners had been sold to owners in British Columbia to engage in the halibut fishery. Wallace knew this to be unlikely and suspected the naval authorities were about to act on his advice. Suddenly possessed with an urge to "get in on the game," Wallace contacted the authorities and asked to serve on one of the schooners as a navigator. Much to his surprise, on 12 June, he received a telegram appointing him captain of the *Lutz* and requesting that he appear at Halifax a few days later. Dropping his editorial work for *Canadian Fisherman* and his Canadian Fisheries Association burdens in the lap of J.J. Harpell and assuaging the worries of Viola, his bride of a year, Wallace rushed to Halifax to oversee the installation of two thirty-horsepower diesel engines driving twin screws and the mounting of a twelve-pounder quick-firing gun behind a screen of dummy dories.

With a crew made up of a naval officer, nine Newfoundland Naval Reservists, a cook, and an engineer, newly minted Captain Wallace soon had the *Albert J. Lutz* on station out of Sydney. From June to September 1917, the *Lutz* was offered up to tempt German U-boats, often in the vicinity of Anticosti Island. This setting brought back many memories for Wallace, particularly of his friend Captain John Apt and the scattered crew with whom he had searched these same waters for halibut only four

years before. In the event, there were no U-boats and the only excitement came from a little fishing and gunnery practice. On one occasion, the latter caused Wallace serious injury.

> The gun had been trained pointing aft and I stood but a foot or two away from the line of fire. The cartridge-wads struck me in the face, and I was sensible of the hot flame belching from the muzzle of the gun less than forty feet away from where I was standing. The terrific concussion deafened me and almost knocked me down. Being fired so far inboard, and with the muzzle depressed at such a low angle, the discharge had no room to expand with the sails and rails confining the explosion. Part of the lining inside the ship's rails was split; the canvas of the false dories burst, and every man on deck was stunned, and deafened for many hours.

As a likely consequence, Wallace was left with a punctured left eardrum and partial sight in his left eye. It was with some relief that he was called to Ottawa in September to fill the position of Secretary of the Fish Committee established under the Dominion Food Controller, W.J. Hanna. The experiment with Q-ships ended shortly thereafter.

The *Albert J. Lutz* did not long outlast the Q-ship experiment. In January 1918, the schooner was sold to Abraham Moulton, a member of a Burgeo, Newfoundland, merchant family, who took the engines out and set the vessel to coastal trading. On Tuesday, 23 June 1919, the *Lutz* left Sydney under the command of Captain Joseph Johnson with a load of coal

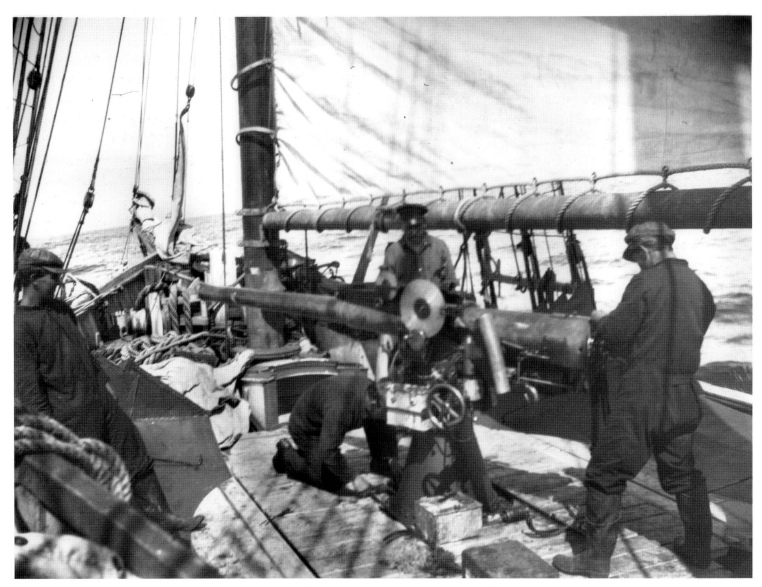

The crew of the Q-ship clears the twelve-pounder quick-firing gun for action. MMA WPA 10.54.7

for Newfoundland. By Saturday morning, the schooner was about seventy miles southeast of Cape Broyle, Newfoundland, when a heavy squall struck without warning. The vessel sank so fast that the cook could not escape the forecastle and was drowned. The rest of the crew made it to the dories, but did not have oars and were forced to use the thwarts as paddles. In this fashion, they managed to make land twenty-four hours later. Thus was lost the first and favourite of the four schooners on which Wallace sailed.

The *Dorothy G. Snow*'s career as a Q-ship was no more eventful than that of the *Albert J. Lutz*, but its subsequent life was much longer. Sold in January 1918 to owners in Montreal, the *Dorothy G.* went through the hands of several merchants and companies through the 1920s, sometimes fishing out of southwest Nova Scotia ports and other times carrying cargo to the north, including a load of furs from Hudson Bay to St. John's in September 1921. During the Prohibition era, the American consul in Yarmouth suspected the *Dorothy G.* of being used as a rum-runner, and researcher Harold Simms has established that the Sweeny family of Yarmouth counted the vessel as one of several it owned for that purpose. When Prohibition ended in 1933, the *Dorothy G.* went back to fishing out of Yarmouth. In 1939, Henrique Rose of Providence, Rhode Island, and Manuel Coelho of Jersey City, New Jersey, purchased the *Dorothy G.* and transferred the schooner to its new homeport of Cape Verde the following year. There, under a succession of owners, the *Dorothy G.* was renamed the *Bemvinda*, the *Nova Sintra*, the *Kary Allah*, the *Tangal*, and finally, in 1959, the *Maria Sony*. It was as the *Maria Sony* that, in June 1959, the schooner ran into a hurricane while en route from the Cape Verde Islands to Providence. It needed the assistance of a tug to make port, and the owner was then forced to tow the *Maria Sony* to New Bedford for an overhaul before the return journey could be attempted. Setting out in the middle of November, the schooner was hit by another hurricane and disabled. Fortunately, a passing Norwegian steamer, the *Rio de Janeiro*, came upon the *Maria Sony* and took it in tow as far as Bermuda, where the schooner was declared unfit for sea. Tied up while its owner tried to find the money for yet more repairs, the *Maria Sony* was spotted by Graham McBride, a Digby native aboard a Royal Canadian Navy ship in port. He recognized the *Maria Sony* as the *Dorothy G. Snow* and took several remarkable photographs of the one-time pride of the Digby schooner fleet. After ten months in Bermuda, the *Maria Sony* was finally fit for the return trip to the Cape Verde Islands. There, it remained restricted to coasting trade for another seven years, finally sinking at Ponta do Creoulo on the Island of Santa Luzia on 16 March 1977. In 1987, Cape Verde issued a postage stamp in honour of the *Maria Sony*.

The *Dorothy M. Smart*'s career as a Digby fishing schooner lasted longer than any of the others. The Maritime Fish Corporation continued to operate it through 1922, but then it too became involved in rum-running, its American owners hiding behind dummy Canadian companies. In 1923, the *New York Herald* named the *Smart* as one of the foreign ships in "Rum Row" off New York harbour, and the following year the vessel's name appeared in a US Coast Guard report. In 1925, the Coast Guard Cutter *Gresham* found the *Smart* in distress off New York, the crew declaring they had been shanghaied into participation in rum-running. Whatever the truth of their

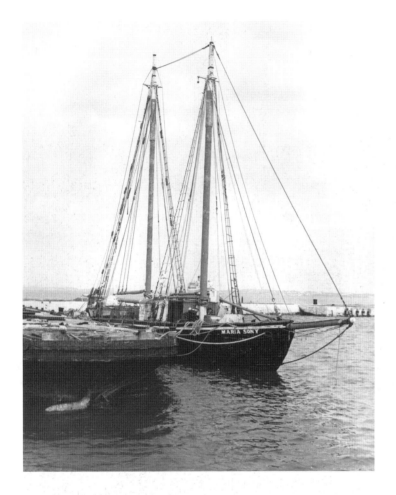

Captain Thomas Hardy and his crew managed to row ashore for the night. They returned the next day only to find the schooner submerged. The sails were salvaged but the *Smart* was written off.

Of the four schooners on which Wallace sailed, the most remarkable in terms of longevity and fame was the *Effie M. Morrissey*. The *Morrissey*'s active life as a fishing and coasting vessel on the Atlantic coast came to an end in 1924, when Captain Bob Bartlett purchased it for use in Arctic exploration. During the Second World War, it became an Arctic supply ship for the US government. This second career came to a close in 1948, when the *Morrissey* was sold to Henrique Mendes, a veteran captain in the Cape Verdean packet trade. For more than thirty years, the schooner, renamed the *Ernestina*, moved goods and people back and forth across the Atlantic between Cape Verde and the United States. In 1982, the *Ernestina* was repatriated by Cape Verde to the people of the United States, "with the stipulation that she be used for educational, cultural, and community development purposes." Today, the *Ernestina* is a floating and operational educational ambassador for the Commonwealth of Massachusetts, based at New Bedford State Pier. As with Canada's *Bluenose II*, maintenance poses a constant financial problem, but the extraordinary life of the *Effie M. Morrissey/Ernestina* is now well into its second century.

When his work as secretary of the Fish Committee in

story, the *Smart* was seized and subsequently sold at auction, likely back to the same owners. Over the next five years, the *Smart* ran in and out of trouble with American authorities, but on its final voyage it was engaged in the mundane task of shipping salt cod and haddock from Ingonish, Nova Scotia, to Gloucester. On 10 June 1930, as the *Smart* neared Cape Negro, Shelburne County, it went aground on Black Rock.

Left and opposite: The *Dorothy M. Smart*, renamed the *Maria Sony*, sits derelict in Bermuda in 1960. MMA MYP MP 10.56.12 and MP 10.56.13

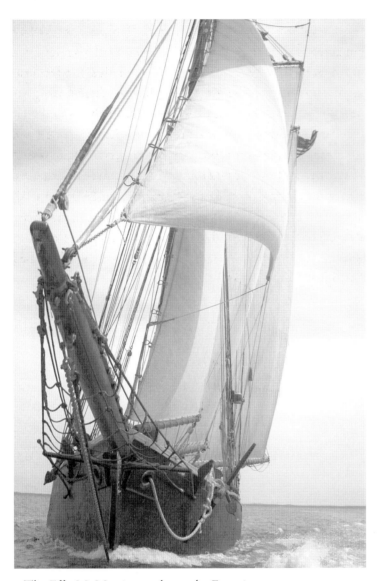

The *Effie M. Morrissey* today as the *Ernestina*. New Bedford Office of Tourism & Marketing

Ottawa came to end in March 1919, Frederick William Wallace resumed editorship of *Canadian Fisherman* (his name never having been removed from the masthead) as well as his position as secretary-treasurer of the Canadian Fisheries Association. These roles still permitted, indeed required, a significant amount of travel, and Wallace voyaged aboard steam trawlers on both the Pacific and Atlantic coasts and toured the Great Lakes fisheries. In October 1920, one of the last great square riggers, the *Grand Duchess Maria Nicolaevna*, appeared in Montreal harbour, and Wallace seized the opportunity to hop aboard as a passenger for a three-month trip to England.

Around that time, Wallace determined on a "somewhat monumental task," namely, "to compile a historical record of the shipbuilding and ship-owning era of the square-rigged merchant marine which at one period flourished in Quebec and the Maritime Provinces of Canada." He began his research in Canada, but soon discovered that much of the information was to be found in the United States. Then, in 1921, he unexpectedly received an offer to move to New York to become editor of the US magazine, *Fishing Gazette*. For the next six and a half years, he worked out of New York, expanding his knowledge of the fishing industry and his circle of contacts and friends. In 1924 appeared the first edition of his most famous work, *Wooden Ships and Iron Men: The Story of the Square-Rigged Merchant Marine of British North America*, followed by *In the Wake of the Windships* (1927), *Record of Canadian Shipping* (1929), and *Under Sail in the Last of the Clippers* (1936). In 1928, Wallace returned to Canada and resumed editorship of *Canadian Fisherman* as well as various roles within the fishing industry, including a period as president of the Canadian

Fisheries Association. By then, the days of Frederick William Wallace's sea-going adventures were over.

Wallace's personal life saw its share of sadness. His wife Viola suddenly died in February 1918, less than two years after they were married. By 1920, Wallace had married Viola's sister Ethel and apparently adopted her daughter, but Ethel died just as unexpectedly in New York in December 1927. Shortly after his return to Canada, Wallace married for a third time, to Laurie Lucrezia (Lou) Stinson, and became stepfather to her daughter Dora-Jean and son Walter. He had no natural children of his own. Wallace's professional life, however, continued to prosper. In 1918, J.J. Harpell moved his publishing plant to Sainte-Anne-de-Bellevue, about twenty-two miles outside Montreal, and established Gardenvale, a community for his workers. Shortly after Wallace returned in 1928, he and one or two others took control of the business and established a new publishing firm, National Business Publications. Wallace remained as editor of *Canadian Fisherman* until his retirement in January 1953. With retirement, he turned his mind to writing an autobiography. Given all he had done, there was a great deal about which he could have written. In the event, what he wanted to stress most was his life as a *Roving Fisherman*, his personal experiences aboard the commercial fishing vessels of Canada and the United States. In a volume of 512 pages, almost 400 were devoted to the years between 1911 and 1917. Where did he begin? He began with the first Fishermen's Regatta of Southwestern Nova Scotia, held on that long-ago warm August day in 1911. Frederick William Wallace died on 15 July 1958.

ACKNOWLEDGEMENTS

Research for this project began as long ago as the early 1990s with the assistance of two internal research grants from Mount Saint Vincent University. Work on the enterprise was then set aside in favour of another book and delayed still further by the unexpected opportunity to fill the position of Visiting Foreign Professor at the University of Tsukuba, Japan, between 1996 and 1998, and then again between 2001 and 2003. Returning to Frederick William Wallace after such a long absence had something of the quality of rediscovering an old friend and, in those who rendered assistance, old friends. Not least of the pleasures in finally bringing *A Camera on the Banks* to press is the opportunity it provides to thank those who helped in ways both personal and professional.

In the United Kingdom the staffs of the Guildhall Library, London, the National Maritime Museum, Greenwich, the General Register Office for Scotland, Edinburgh, the Strathclyde Regional Archives and Mitchell Library, Glasgow, and the Dumfries Archive Centre, Dumfries, were unfailingly solicitous. The staff in Dumfries, for example, issued me with a hard hat so that I could continue working during their renovations. George Rountree of the Govan Reminiscence Group was kind enough to spend a day walking me through the neighbourhoods in which Frederick William Wallace was raised, pointing out what survives among so much that is new. Above all, I must thank Sam and Jean McColm, owners of Cairngarroch Farm, Mull of Galloway, for two magical explorations of the boyhood home and community of Captain William Wallace; my memories remain fresh.

The museums and archives of New England are a treasure trove for those exploring the banks fishery. The Peabody Essex Museum at Salem and the Cape Ann Historical Museum at Gloucester, Massachusetts, were particularly useful in my search for other photographers interested in fishermen when Wallace was most active. Andrew W. German of Mystic Seaport Museum, Mystic, Connecticut, provided excellent advice and direction, as did the well-known ship modeller Erik A.R. Ronnberg, Jr., of Rockport, Massachusetts. We are fortunate that one of the schooners on which Wallace sailed, the *Effie M. Morrissey*, survives in the guise of the *Ernestina* and sails as the official vessel of the Commonwealth of Massachusetts out of New Bedford. I was permitted to clamber out to the end of the bowsprit while the schooner was safely tied up in port and can only wonder at the men who would do so in a bucking sea. Finally, as luck would have it, my explorations crossed those of Harold G. Simms of Norwell, Massachusetts, an independent

researcher delving into the career of his shipbuilding ancestor, Amos Pentz, of Shelburne, Nova Scotia. Harold shared his findings and his home, and I am very grateful.

In Canada, it was a pleasure to work at the National Archives in Ottawa and the Maritime History Archive in St. John's. Charles Armour has a surprising collection of relevant material at the Dalhousie University Archives and provided excellent advice. The key repository for this project is, of course, the Maritime Museum of the Atlantic in Halifax, home to the Frederick William Wallace Papers and Photo Archive. It was a joy to work with the people of the MMA, who, under-funded and short-staffed, manage wonders. Mary Blackford, David Fleming, and Marven Moore saw me through the early years of the project, Dan Conlin, Lynn-Marie Richard, and John Hennigar-Shuh through the latter. In addition to these institutions and their staffs, a significant number of individuals provided advice, information, and leads over the years. Carman Bickerton of Ottawa shared research notes and his extraordinary knowledge of the banks fishery. In Halifax, Clary Croft helped me track down the music for "The Log of a Record Run"; John Doull of John Doull Booksellers was inspirational; Chris Hoyt ably fashioned two maps for the book, funded by an internal grant from Mount Saint Vincent University; and Graham McBride permitted me to use his photographs of the *Maria Sony* and others by Paul Yates in his possession. Interviews also played a role in the research for this book. Gerald Handspiker, Leon and Walter Longmire, and Bucky Snow assisted me in learning more about their respective families and the fishing community of Digby and the Fundy Shore. Descendants of Frederick William Wallace provided otherwise unobtainable insight into his family life and were courteous and supportive. In particular I wish to mention Susan Dennison of Vancouver, Alexander Hood of St. Catharines, Ontario, Franga Stinson of Montreal, and Tim Wallace of Hudson Heights, Quebec. Mary Parker, widow of Captain John Parker, North Sydney, Nova Scotia, was also informative about Wallace, who in his later years was often their summer guest.

My initial attraction to this project was inspired by an academic question: what would a historical narrative look like if one began with photographs rather than documents, put images rather than words at the centre of the tale? Frederick William Wallace's photographs provided a remarkable test case, and they drew me into the foreign realm of schooners and fishing. Lacking expertise of my own, I had to rely on others for guidance in the terminology and working of rigging, dories, and trawl. Graham McBride provided more than one tutorial on managing a schooner under sail, and Dan Conlin, Lynn-Marie Richard, and David Walker read the entire manuscript and saved me from a number of embarrassments. Those that remain are, of course, my responsibility alone. I would like to thank the people at Goose Lane for their patience, advice, and expertise, particularly Editorial Director Laurel Boone, Art Director and Production Manager Julie Scriver, and Publisher Susanne Alexander. Barry Norris did an excellent job of copy editing, clarifying and tightening with sensitivity.

Finally, I would like to thank Yukiko Asada, my wife, for her understanding and support.

A NOTE ON SOURCES

The starting point for all research related to this project is the Frederick William Wallace Papers (FWWP) held by the Maritime Museum of the Atlantic (MMA), Halifax, Nova Scotia. The most important source therein for the life and career of Captain William Wallace is the "Biography of William Wallace, Master Mariner" (Vol. 2/9). I checked this account against standard records of Scottish vital statistics, as well as Crew Agreements and Official Log Books of the British Board of Trade, available in part at the Maritime History Archive, St. John's, Newfoundland and Labrador, and in part at the National Maritime Museum, Greenwich, England. Numerous references to the Wallace family's life in Glasgow exist in the FWWP, the most important items being young Fred's notebooks for 1900 (Vol. 4/1) and 1902–1903 (Vol. IV/3); his later reflections, "Incidents of Ships, Sailing Ships I Have Known" (Vol. III/1); and "Memory Is a Tricky Thing" (Vol. VI/5). Supplementing these sources are the Registers of Births and Deaths in the General Register Office for Scotland, Edinburgh; Glasgow Post Office Directories; and the home addresses given in Captain Wallace's crew agreements. Portions of young Fred's school career can be confirmed in the Copeland Road Public School Admissions, 1889-1910, and the Lorne Street Public School Log Book, 19 February 1894 to 30 December 1903, at the Strathclyde Regional Archives, Mitchell Library, Glasgow. Joseph A. Rae, ed., *The History of Allan Glen's School, 1853-1953* (Glasgow: Aird and Coghill, 1953) indicates the kind of instruction Fred would have received at that institution. The opening chapters of Wallace's novel *Viking Blood* (Toronto: Musson, 1920) are suggestive of the family's life in Glasgow.

The FWWP contain numerous references to the Wallace family's move to Hudson, Quebec, in 1904 and Frederick William Wallace's subsequent life as a clerk and freelance writer. For a curriculum vitae that commences in 1902, see "*Canadian Fisherman & F.W. Wallace: History & Biography, 1949*" (Vol. V/10). Other important items are: "Canadian-American Connections of Wallace Family" (Vol. III/1); "The Log of a Beachcomber, August 12, 1909" (Vol. III/3); "Logs of the Dogwatch and Campfire" (Vol. III/9); "Cartoons, Sketches, and Anything, by F.W. Wallace, 1906-1908" (Vol. V/1); and two charming and informative letters written by Wallace to his nephew Alexander Hood, 10 October 1945 and 27 October 1948, in Correspondence (Vol. XIII/C).

Wallace saved copies of most of his early freelance journalism, which are scattered throughout the FWWP. The most common

journals in which he published between 1908 and his first voyage out of Digby in 1911 were *Canadian Century, Canadian Magazine, Cruiser, Dominion Magazine, Rod and Gun in Canada*, and *Yachting*. I compiled a bibliography of Wallace's early published work and deposited it in the Library of the MMA. The account given in Chapter 1 of the Wallace family's life in Scotland as well as later in Hudson, Quebec, is based on my more fully documented "Frederick William Wallace: The Making of an Iron Man," *Journal of the Royal Nova Scotia Historical Society*, Vol. 4 (2001): 84-107.

Wallace recorded his seven voyages aboard the banks schooners of Digby in three general ways. First, there are his original logbooks in the FWWP for five of the seven trips: *Dorothy M. Smart*, August-September 1911 (Vol. III/14 & 22); *Smart*, March 1912 (Vol. III/13); *Effie M. Morrissey*, December 1912 (Vol. III/25); *Albert J. Lutz*, May-June 1913, none; *Dorothy G. Snow*, March 1914, none; *Lutz*, January 1915 (Vol. III/6); and *Snow*, March 1916 (Vol. III/24). He also charted the voyages of the *Smart* in 1911 and 1912, and the *Morrissey* in 1912, on a large-scale nautical map (Vol. XI/1). His general notes on the voyages are: "Lecture Notes: Deep-Sea Fishing" (Vol. II/6) and "The Banks Fishing Fleet of Digby & Yarmouth" (Vol. III/1). Second, Wallace published contemporary accounts of all seven voyages in a variety of magazines and journals: *Smart* 1911 in *Saturday Night* (March 1912); *Smart* 1912 in *Saturday Night* (May 1912); *Morrissey* 1912 in *Canadian Countryman* (February-March 1913) and *Sailor* (1920); *Lutz* 1913 in *Canadian Fisherman* (January-March 1914); *Snow* 1914 in *Canadian Fisherman* (May 1914); *Lutz* 1915 in *Canadian Fisherman* (March-April 1915) and *Sailor* (1920); and *Snow* 1916 in *Fishing Gazette* (April 1922). He published his collective experience in the July 1921 issue of *National Geographic Magazine*. In addition, accounts of his experiences appear in fictional form in his novel, *Blue Water* (Toronto: Musson, 1914) and in short stories that appeared first in *Adventure* magazine and were later collected and published as *The Shack Locker* (Montreal and Toronto: Industrial and Educational Press, 1916). "The Log of a Record Run" was first published in *Canadian Fisherman* (June 1914). Finally, Wallace used these unpublished and published sources as well as his tenacious memory to write his extraordinary autobiography, *Roving Fisherman* (Gardenvale, QC: Canadian Fisherman, 1955).

I supplemented Wallace's records of the period by reference to other primary sources, both manuscript and published. The Canadian Censuses of 1901 and 1911 were particularly useful, and the National Archives of Canada's shipping registers for Digby were consulted in microfilm at the Archives of Dalhousie University. The *Digby Weekly Courier* was scanned from 1908 to 1922, and specific later issues of 24 October 1963, 30 June 1966, and 8 August 1990. Also scanned were *Canadian Fisherman* from 1914 to 1922, and *Fishing Gazette* from 1922 to 1928. One extraordinary piece of primary material is the *Effie M. Morrissey* itself, which survives as the *Ernestina* at New Bedford, Massachusetts. The Ernestina Commission web site is an excellent source of information on the long career of this storied schooner.

Although little has been written about the career of Frederick William Wallace or about the Digby fishing community of the early twentieth century, the Atlantic fisheries in general and schooners in particular have drawn the attention of a number of researchers both within and without academia. Howard I. Chapelle's *The American Fishing Schooner, 1825-1935* (New York: W.W. Norton, 1973) has long been the foremost authority on the subject. For a better understanding of the Indian Head, semi-knockabout, and knockabout designs, however, we now need to turn to W.M.P. Dunne's *Thomas F. McManus and the American Fishing Schooners* (Mystic, CT: Mystic Seaport Museum, 1994). Harold Simms's *One Hundred Forty-One Wooden Ships, 1872–1922* (Charleston, MA:

privately printed, 2004) is an extraordinary study of the vessels built by his ancestor, Amos Pentz, at the McGill Shipyards in Shelburne, Nova Scotia, including the *Lutz*, *Smart*, and *Snow*. Older works also remain fascinating; these include Albert Cook Church, *The American Fishermen* (New York: W.W. Norton, 1941); Joseph E. Garland, *Down to the Sea* (Boston: David R. Godine, 1983); and Gordon W. Thomas, *Fast & Able* (Gloucester, MA: Gloucester 350th Anniversary Celebration Inc., 1973). On the fishing industry generally, see B.A. Balcom, *History of the Lunenburg Fishing Industry* (Lunenburg, NS: Lunenburg Marine Museum Society, 1977); Carman Bickerton, *A History of the Canadian Fisheries in the Georges Bank Area* (Ottawa: Government of Canada, 1983); Ruth Fulton Grant, *The Canadian Atlantic Fishery* (Toronto: Ryerson, 1934); Joseph Gough, *Fisheries Management in Canada, 1880-1910* (Halifax: Department of Fisheries and Oceans, 1991); and Wesley George Pierce, *Goin' Fishin'* (Salem, MA: Marine Research Society, 1934). A special word needs to be said about Andrew W. German's *Down on T Wharf* (Mystic, CT: Mystic Seaport Museum, 1982), which, in its use of photographs taken by Henry D. Fischer in the early twentieth century, was an inspiration. On the subject of the *Dorothy M. Smart*'s career as a rum-runner, see Geoff and Dorothy Robinson, *It Came by the Boat Load* (Summerside, PEI: privately printed, 1983). On the introduction of trawlers, see B.A. Balcom, "Technology Rejected: Steam Trawlers and Nova Scotia, 1897-1933," in James E. Candow and Carol Corbin, eds., *How Deep Is the Ocean?* (Sydney, NS: University College of Cape Breton Press, 1996). On the making of *Blue Water* the movie, see David Goss, ". . . Saint John's bid to be a little Hollywood," *Atlantic Advocate* (August 1983); and Peter Morris, *Embattled Shadows* (Montreal: McGill-Queen's University Press, 1978).

Finally, I benefited from interviews with Mary Parker, July 1993; Gerald Handspiker, 8 September 1993; Leon and Walter Longmire, 23 March 1994; and Bucky Snow, 18 April 1994. Members of the Wallace family have been uniformly supportive and informative over the years; in particular, I must mention Susan Dennison, Alexander Hood, Franga Stinson, and Tim Wallace.

All unacknowledged quotations in the text and captions are from Frederick William Wallace's published works.

SELECTED BIBLIOGRAPHY

Manuscript and Published Primary Sources

Canadian Fisherman. 1914-1922.

Crew Agreements and Official Log Books of the British Board of Trade, available in part at the Maritime History Archive, St. John's, Newfoundland and Labrador, and in part at the National Maritime Museum, Greenwich, England.

Digby Port Registers, Microfilm, Dalhousie University Archives, Halifax.

Digby Weekly Courier. 1908-1922.

Fishing Gazette. 1922-1928.

Frederick William Wallace Papers, Maritime Museum of the Atlantic, Halifax, Nova Scotia.

Glasgow Post Office Directories.

Registers of Births and Deaths, General Register Office for Scotland, Edinburgh, Directories, Mitchell Library Glasgow.

Taylor, M. Brook. [Bibliography of early published works by Frederick William Wallace]. Collection of the Maritime Museum of the Atlantic.

Publications by Frederick William Wallace

This list includes Wallace's major books and articles related to the banks fishery.

"Around Our Coasts: Pen Pictures of Canadian Seafaring." *The Sailor* (1920). Offprints of six parts of this series, undated and unpaginated, are in the Wallace Papers at the Maritime Museum of the Atlantic.

"The Atlantic Fisheries." *Saturday Night* (9 March 1912): 6-7; (16 March 1912): 6; (23 March 1912): 6.

"The Black Cat: A Yarn of the Canadian Fishing Fleet," *Canadian Century*, 28 October 1911, 6-7.

Blue Water. Toronto: Musson, 1914.

Captain Salvation. Toronto: Musson, 1925.

"Fishermen's Regatta of Western Nova Scotia," *Canadian Century*, 2 September 1911, 14-15.

"The Haddockers: Life with the Winter Trawlers of Nova Scotia." *Canadian Countryman* (22 February 1913): 16-18, 28; (March 1913).

"Haddocking on Brown's Bank." *Canadian Fisherman* (May 1914): 140-145.

In the Wake of the Windships. Toronto: Musson, 1927.

"The Log of a High Line Halibuter." *Canadian Fisherman* (January 1914): 20-24; (February 1914): 54-59; (March 1914): 78-81.

"Life on the Grand Banks: An Account of the Sailor-Fishermen Who Harvest the Shoal Waters of North America's Eastern Coasts." *National Geographic* (July 1921): 1-28.

"The Log of a Record Run." *Canadian Fisherman* (June 1914): 173.

"Making a Movie of Winter Fishing: Filming the Work of Deep Sea Fishermen on a Bank Schooner in Hard Weather." *Fishing Gazette* (April 1922): 36-38.

Record of Canadian Shipping. Toronto: Musson, 1929.

Roving Fisherman. Gardenvale, QC: Canadian Fisherman, 1955.

"The Sail Carriers." *Yachting* (June 1913): 397-399.

The Shack Locker. Montreal and Toronto: Industrial and Education Press, 1916.

Salt Seas and Sailormen. Toronto: Musson, 1922.

"The Toll of the Cresting Seas." *Canadian Magazine* (September 1913): 469-476.

"Steam Trawling for the Canadian Consumer: How Our Fish Are Caught on the Sable Island Bank." *Saturday Night* (27 July 1918): 4, 8.

Tea from China. Toronto: Musson, 1926.

The Viking Blood. Toronto: Musson, 1920.

"To Western Bank on a Steam Trawler: The Log of a March Trip on a Modern Canadian Steam Fisherman," *Canadian Fisherman* (June 1917): 232-235.

Under Sail in the Last of the Clippers. Toronto: Musson, 1936.

"Winter Fishing on Brown's Bank." *Saturday Night* (4 May 1912): 4, 16; (11 May 1912): 4-5; (18 May 1912): 4-5; (25 May 1912): 8-9.

"Winter Fishing: The Log of a Hard-Luck Haddocking Trip," *Canadian Fisherman* (March 1915): 88-90; (April 1915): 105-111.

Wooden Ships and Iron Men. Toronto: Musson, 1924.

Secondary Works

Balcom, B.A. *History of the Lunenburg Fishing Industry.* Lunenburg, NS: Lunenburg Marine Museum Society, 1977.

_____. "Technology Rejected: Steam Trawlers and Nova Scotia, 1897–1933," in James E. Candow and Carol Corbin, eds., *How Deep Is the Ocean?* Sydney, NS: University College of Cape Breton Press, 1996.

Bickerton, Carman. *A History of the Canadian Fisheries in the Georges Bank Area.* Ottawa: Government of Canada, 1983.

Chapelle, Howard I. *The American Fishing Schooner, 1825-1935.* New York: W.W. Norton, 1973.

Church, Albert Cook. *The American Fishermen.* New York: W.W. Norton, 1941.

Dunne, W.M.P. *Thomas F. McManus and the American Fishing Schooners.* Mystic, CT: Mystic Seaport Museum, 1994.

Garland, Joseph E. *Down to the Sea.* Boston: David R. Godine, 1983.

German, Andrew W. *Down on T Wharf.* Mystic, CT: Mystic Seaport Museum, 1982.

Goss, David. "Saint John's Bid to Be a Little Hollywood." *Atlantic Advocate* (August 1983).

Gough, Joseph. *Fisheries Management in Canada, 1880-1910.* Halifax: Department of Fisheries and Oceans, 1991.

Grant, Ruth Fulton. *The Canadian Atlantic Fishery.* Toronto: Ryerson, 1934.

Morris, Peter. *Embattled Shadows.* Montreal: McGill-Queen's University Press, 1978.

Pierce, Wesley George. *Goin' Fishin'.* Salem, MA: Marine Research Society, 1934.

Robinson, Geoff and Dorothy Robinson. *It Came by the Boat Load.* Summerside, PEI: privately printed, 1983.

Schooner Ernestina web site, http://www.ernestina.org.

Simms, Harold. *One Hundred Forty-One Wooden Ships, 1872-1922.* Charleston, MA: privately printed, 2004.

Taylor, M. Brook. "Frederick William Wallace: The Making of an Iron Man." *Journal of the Royal Nova Scotia Historical Society* (2001): 84-107.

Thomas, Gordon W. *Fast & Able.* Gloucester, MA: Gloucester 350th Anniversary Celebration Inc., 1973.

IMAGE CREDITS

The maps on pages 10 and 13 are by Christopher Hoyt. Most of the photographs were taken by Frederick William Wallace and are in the Wallace Photo Archive of the Maritime Museum of the Atlantic (MMA WPA). Wallace's drawings are in the Wallace Papers in the archives of the Maritime Museum of the Atlantic (MMA WP). Photographs on pages 14, 15, and 114, taken by Paul Yates, are in the collection of the Maritime Museum of the Atlantic (MMA PY). The Yates photographs on pages 11, 12, and 13 are from the private collection of Graham McBride of Halifax, Nova Scotia (MYP).

INDEX